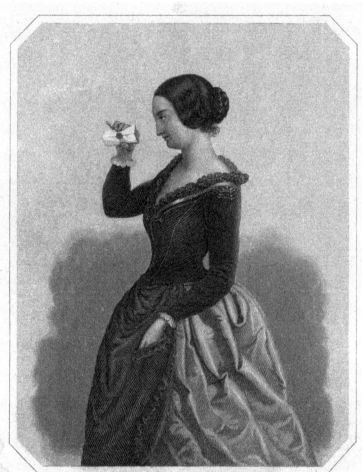

Stahlstich v. Carl Mayer's Kunst-Anstalt in Nürnberg.

Marion

Curiosity

WORDS ON PICTURES

ROMANA JAVITZ AND
THE NEW YORK PUBLIC LIBRARY'S
PICTURE COLLECTION

EDITED BY
ANTHONY T. TRONCALE

PHOTO | VERSO

New York 2020

For information about permission to reproduce selections from this book, write to:
Permissions, Photo Verso Publications, LLC
140 Seventh Avenue, Suite 3C New York, NY 10011

Library of Congress Publication Data

Names: Troncale, Anthony T., editor/author. Cline, Jessica, author.
Title: Words on Pictures: Romana Javitz and the New York Public Library's Picture Collection
Anthony T. Troncale
Description: First edition. | New York: Photo Verso Publications, LLC, 2020. |
Includes bibliographical references, appendix and index.

Identifiers ISBN 978-1-7346409-0-8 (hardcover)
Identifiers ISBN 978-1-7346409-1-5 (ebook)

Subjects: LCSH: Javitz, Romana, 1903-1980. | Public libraries—Services to Business and
Industry. | Public libraries—Services to institutions. | Pictures in libraries. | Libraries and
schools. | New York Public Library. | Libraries and Mass Media. | Branch Libraries. |
Libraries—Organization. | Libraries—Statistics. | Libraries—Exhibitions. | Public libraries
– United States. | Special libraries – Collection development. | Special libraries – Use
Studies. | Public libraries – Circulation and loans. | Federal aid to libraries – United States. |
Documentary photography – United States. | Photography – Collections. | Abbott, Berenice,
(1898-1991). | Cahill, Holger, 1887-1960. | Cline, Jessica. | Doud, Richard Keith. | Evans,
Walker, 1903-1975. | Lange, Dorothea, 1895-1965. | Libsohn, Sol, 1914-2001. | Troncale,
Anthony T. | Yampolsky, Robert, 1920-1987. | Carnegie Corporation of New York. |
Massachusetts Library Association.

Photo Verso Publications LLC: New York, NY

to Connie

Table of Contents

Preface

In the parable of the blind men and the elephant, each man feels a different part of the animal — a tusk, the trunk, a foot — and describes the elephant from his limited perspective. They disagree on what an elephant is. But, on hearing the story we learn that many different views of an object can help us see a more complete picture. If we have never seen an elephant, how do we know what it looks like? The New York Public Library Picture Collection functions to help you see information on a subject. The pictures it collects provide a different perspective than a textual document, and it gathers information from a variety of sources to help complete the view. Picture Collection librarians began finding images for researchers 105 years ago and organized them into files by subject. This mission blossomed under the leadership of librarian Romana Javitz (1903-1980). For 40 years (1928-1968) she asserted the value of pictures as documents of importance to the contribution of information collected by libraries.

The reports, letters, and papers assembled here span from 1929 to 1965 and contain the documentation of Javitz's effort to provide material to researchers seeking information. The importance of seeding the historian's search extends their value. They also note collaborators and assume audiences that will need encouragement to understand the enduring usefulness of images removed from their original contexts — their books, their frames, their government files. A connection is made here between the library and its researchers. As evidence to Javitz's effort, artists who became stalwarts of the American art canon browsed and borrowed from the collection regularly in their time and still do. Walker Evans published articles with these materials, while Andy Warhol borrowed advertisements clipped from magazines to create his Coca-Cola paintings. More recently, the multidisciplinary artist Taryn Simon undertook photographing pictures drawn from the collection grouped by subject heading. All the while set designers look for images to authentically replicate the feel of a time period, students discover patterns for costume design, and artists continue to seek source material. The annual report for 1933 notes that, "The Collection has the individuality and emphasis of the public it serves."

Pictures have the ability to represent a time and transcend it simultaneously. It is a function the Collection itself tries to master. Javitz wrote in *The Organization of Pictures as Documents*,

"Although a book becomes out of date, or its text outlives its usefulness, the illustrations often remain valid indefinitely. It is important to keep this in mind and learn to use illustrations that have appeared in ephemeral or outdated texts. In all times since the beginning of printing, the production and distribution of copies of illustrations, the pictures in book and broadside, in the pages of fashion, in caricature and in scientific literature, have wielded a deep penetrating power over all kinds of people. We can hardly comprehend the immenseness of the tool that pictures form."

The Picture Collection continues to lend pictures that were added to the collection in the 1930s while also collecting pictorial material published currently in books and magazines. It still uses a variation on the subject heading list developed by Javitz as its basis for the organization of pictures.

The dedication of the team of people that supports the Picture Collection and the researchers it serves makes working here special and rewarding. Each annual report speaks to the group effort given to develop and maintain this collection. The report from 1939 tells of the staff and an extra 32 relief workers from the Works Progress Administration arranging and filing one million pictures and continuing to develop "the catalogue for subject headings." In 1950 the annual report praised the "pioneer work of the staff with documentary pictures" in the development of the picture archive. These reports exclude solitary efforts by any one person as Javitz continually testifies to the power of collaboration and teamwork. She notes how everyone is working together to support the preservation and dissemination of visual culture, or plainly, a good idea.

Javitz worked her entire career in the service of helping people find and understand visual information. Her agenda was the documentation of America through visual mediums and resources. These documents that Anthony Troncale has gathered bear witness to Javitz's determined, if not celebrated, dedication to this essential library service.

Jessica Cline
Supervising Librarian
New York Public Library Picture Collection
May 2, 2020

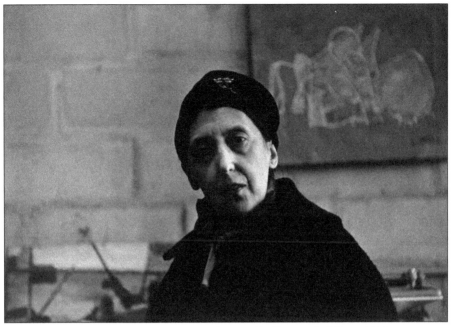

Romana Javitz visiting Ben Shahn's studio, Roosevelt, NJ. ca. 1953.
Sol Libsohn. Yampolsky Collection

Introduction

The New York Public Library's Picture Collection has been circulating photographs, clippings, prints, and postcards to the public for over 105 years. It is a free picture reference service used by many important industries that need visual resources for their work. Still operating out of the Stephen A. Schwarzman Building at 42nd Street, the Picture Collection remains an important resource for teachers, historians, designers, and illustrators, as well as artists and photographers. It is, at almost 1.5 million images, considered an encyclopedia of pictures that encapsulates the age of mechanical reproduction.

The texts presented here are the work of Romana Javitz (1903-1980), who, as superintendent of the Picture Collection from 1928 to 1968, was the chief advocate for the organization and circulation of pictures to the public in the country. It is

through her essays, speeches, and professional writing that we can witness history best.

The media companies located in New York City during these years, with all their productive exuberance, generated massive amounts of printed media on paper, much of which ended up in the Picture Collection's stock. This picture stock became a form of visual evidence of the cultural and commercial output of any given decade. What the Picture Collection did was to classify these images as subjects and to allow the public to repurpose them into new documents, new meanings, new ideas.

The records of the Picture Collection that Javitz and her predecessors and successors preserved offer a window into the cultural use of pictures for more than 100 years. It will remain an important resource for historians and students for years to come. This historical record is largely complete and housed at the New York Public Library's Manuscripts and Archives Division. It is a testament to the work of the Picture Collection's administrators and staff who over the years served the visual needs of their clients: businessmen, artists, teachers, librarians, and the general public at large.

The first text presented, *On Pictures in a Public Library*, is the introductory chapter of a thesis Javitz wrote in 1939 to qualify as a Grade 4 Librarian[1]. Here Javitz makes the case to her superiors, and to the library profession in general, about the importance of the use of pictures in a public library setting. In clear and understandable prose, Javitz lays out the roles and distinctions between pictures as art and as documents. This paper shows that, after 10 years as supervisor of the Picture Collection, Javitz had a firm grasp of the semantics revolving around the functional use of printed pictures and the emerging dominance of photography and cinema as an important visual resource. While addressed to her fellow librarians and administrators in the New York Public Library system, Javitz's thesis acts as an introduction for readers into the realm of the use of pictures as documents.

Following this thesis is a decade's worth of the Picture Collection's annual reports for the years 1929 to 1939. These reports, intended to bolster and support her constantly underfunded department, are written by Javitz in her concise and precise reportage. They are important to today's teachers and historians as they are full of

1 New York Public Library Archives. Committee on Circulation. May 5, 1939. RG6. "Eligible List for promotion to Grade 4. Miss Javitz has been superintendent of the Picture Collection since September 1928. She attended Hunter College and had thorough training in the fine arts at the Pennsylvania Academy of Art in Philadelphia, Cooper Union, and the Art Students League. Miss Javitz is an expert in her field and her organization and development of the Picture Collection shows constructive and creative ability. As a thesis for the Grade 4 she has submitted part of a manual (*Pictures in Print*) to be called *"On Pictures in a Public Library"* ... Miss Javitz is recommended for the eligible list for Grade 4."

circulation statistics, sources of donations and provenance, and references to the use of the Picture Collection by the NYPL Branches, and by its varied constituency. During the 1930's the use of the Picture Collection reached its peak. The 1937 circulation of its stock reached an all-time high of 870,398 pictures. These reports show that the Picture Collection was a primary source for artists finding work, developing their talents, and finding inspiration in their respective fields.

Javitz wrote a letter to Holger Cahill (1887-1960) in 1949 recounting the development of the idea behind the *Index of American Design*, one of the first Federal Art Projects to be initiated in 1935. Cahill, who was the FAP director from 1935-1943, was writing an introduction for Erwin O. Christensen's *The Index of American Design* (New York: Macmillan, 1950) and asked Javitz to recount the origin of the idea. The *Index of American Design* was the answer to two pressing needs: one was to fill large gaps in the historical American record of folk arts, crafts, and design and the other was to provide relief to out of work illustrators and artists. Drawings, watercolors, and photographs would record everything from iron railings to furniture, toys to tools, kitchens to carpentry. Administered by Ruth Reeves, Carl Tranum, Phyllis C. Scott, and Frances Pollack, it was a Federal jobs program that worked. The *Index* soon sprouted offices in 34 states across the West Coast, Rocky Mountains, Midwest, South, New England, and New York. Today, the *Index* renderings are now fully digitized and presented on the National Gallery of Art's website where it still serves researchers, scholars, and the public.

In 1941, NYPL director Harry M. Lydenberg approached the Carnegie Corporation for funds to allow Javitz time off from her regular duties to craft a manual for the classification and arrangement of picture collections. In order to proceed, Javitz, writing to Franklin F. Hopper, who succeeded Lydenberg as director in 1941, insisted that she would need to first write:

"a comprehensive presentation of the background of the subject content of pictures... and provide a formulation of a theory of organization for printed pictures."[2]

The Organization of Pictures as Documents is the result. Javitz did not complete the larger goal of establishing a comprehensive subject headings list for visual materials, but she did manage to produce a framework which others might adopt. The result was a flexible and eclectic assortment of broad divisions based on *Regions, Styles, Types, and Year*, with subheading arrangements depending on the subjects' geographical,

2 Picture Collection Records, 1896-1999. Manuscripts and Archives Division, The New York Public Library. New York Public Library Archives. See Carnegie Grant 1940-1943, b.1 f. 10 and *Organization of Still Pictures as Documents*. b. 3 f. 8

stylistic, or chronological identities.

With the Carnegie Corporation paper fresh in her mind, Javitz was ready to present her ideas and positions to the professional librarians of the day. The Massachusetts Library Association invited Javitz to speak at their Boston convention on January 28, 1943. Her speech, *Words on Pictures* is reprinted here from the Massachusetts Library Association Bulletin of that year. In this speech Javitz comes close to predicting the availability of pictures on the internet by saying:

"...photographs and films... will be available for the public who will probably be able to study them in book-size individual projection devices." 2 Carnegie Corporation of New York Records. Rare Book and Manuscript Library. Columbia University Libraries. Series III, Box 267, Folder 2. Javitz to Hopper, interim report on the progress of the work of preparing a manual on the classification of documentary pictures, September 30, 1941.

Javitz's speech makes a nice accompaniment to the annual reports from 1940-1953, which follow. They clearly reveal the extent to which the Picture Collection contributed to the war effort, both at home and on the front lines. Later, during the postwar boom of the late 1940's and early 1950's, these reports show how Javitz was again confronted with renewed demands on the picture stock coming from radio, cinema, television, publishers, and advertisers.

Romana Javitz became fast friends with many photographers, designers, illustrators, and artists of her day. She was particularly fond of the photographer Sol Libsohn (1914-2001) who cofounded, along with Sid Grossman (1913-1955), the Photo League. In a never before published interview, Javitz reveals her own curiosity about photographers through questions like: "What can a photographer give to a painter?" and "What is the photographer's eye?" Libsohn's replies and ruminations offer us a glimpse into his own artistic and photo-documentary aims in capturing windows and storefronts and his psychological portrayals of circus clowns.

Around 1964, Robert Yampolsky (1920-1987), a former curator at the New York Public Library's Pforzheimer Collection, recorded a casual conversation with Javitz while they looked over print samples. Published here for the first time, the Yampolsky interview allows Javitz to freely expound on the history of the Picture Collection, the intellectual underpinnings for its organization, and her take on art, artists, museums, and the public.

Yampolsky, the grandson of the anthropologist Franz Boas (1858-1942), was one of Javitz's closest associates late in life and her caretaker until her death in 1980.

The is some evidence in the Javitz archive that she and Yampolsky were collecting examples for a book on the history of illustration. Javitz would eventually bequest to Robert Yampolsky her personal collection of art, books, prints, photographs, and correspondence (cited here as the Yampolsky Collection). The examples presented throughout this publication show her keen eye for visual detail, documentation, history, and humanity.

As part of an oral history program initiated by the Smithsonian Institution's Archives of American Art, Richard Doud interviewed Romana Javitz on February 23, 1965. It is her most detailed discussion on record about the role of documentary photography and its effect on users of the Picture Collection and on society in general. Javitz also has particularly strong opinions about how museums tried to integrate photography into the realm of art. While she accepts the inclusion of photography into museums, she believed the use of the word documentary was a "painful" but necessary term for describing the medium in this context.

A large part of the interview focuses on the Farm Security Administration photographs and photographers, many of whom she knew well. To her, the addition of the FSA duplicates to the Picture Collection did more than enrich its files, it also underscored the rich potential of photographs that were produced without an overriding commercial agenda. The FSA files were a "yeast" which, when absorbed as a group, produced unadulterated insights and fresh perspectives on America.

Over the years the Picture Collection maintained an almost depository function, accepting any type of illustrated matter into its files. Appendix I provides a list of important photographic collections that were eventually transferred to other research divisions within the New York Public Library. Three Picture Collection heads from that period, Diane Powers, Mildred Wright and Constance Novak deserve credit for transferring these large groups of photographs to these respective divisions where they are preserved and in some instances digitized and now available to a global audience.

Appendix II is designed to demonstrate the breadth and depth of the 100 years of outreach activities by the Picture Collection. A chronology, drawn from the Library's *Staff News*, (published from 1911-2001 in 91 volumes) lists all manner of programs, exhibits, lectures and radio programming produced for both the staff's professional development and the public's benefit. A compendium of newspaper and magazine coverage of the Picture Collection follows with 100 years of reportage about its famous files.

In 1967, Ben Shahn presented the American Institute of Graphic Arts Gold Medal to Romana Javitz in recognition of her years of service to the public. Yet despite being well known in her time, soon after Javitz retired in 1968 her name largely receded from history.

Javitz's legacy should be revived and she should be recognized as the visionary she was. It is hoped that this book will move that needle a little forward toward that goal. It is also hoped that Javitz's words will live on to instruct others in the ways of seeing pictures objectively. The impact of today's image-immersed social media has yet to be fully understood. We are relying more and more on information that we see and consume visually. It is important to have the ability to discern between truth and obfuscation, reportage and propaganda, fact and fiction, information and misinformation, within the digital realm. With the words and wisdom of Romana Javitz, future consumers of visual culture will have a historical precedent to meet the challenges ahead.

Anthony Troncale

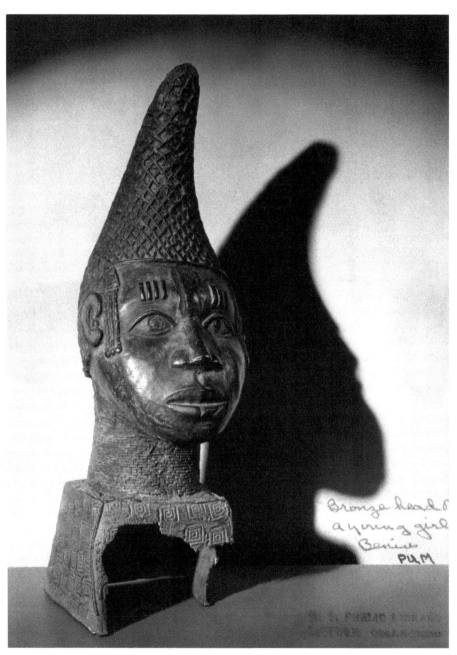

Bronze head of a young girl. Benin. Photograph by Reuben Goldberg. ca. 1939.

Chapter One

On Pictures in a Public Library[3]

Pictures are clearly part of a picture library. There is a contradistinction to an art museum in the function and selection of pictures for a library picture collection. In a museum of art, a picture is an original rendering in any medium, the resulting impression or print where the original is on wood, on stone or on metal. All graphic productions which depend on interplay of design and plan, elimination and creative selection are potential members of the stock of a museum of art. The contents of such a museum are selected appraisals of what is best in the art productions of the human race. The picture contents of a general library are printed pictures and represent a universality of tastes and no judgement on them.

To illustrate the difference, consider the allocation of artworks of the so-called primitive peoples. These carvings, drawings and sculptures, those of the African and the Mayan, are found almost exclusively in the ethnological collections of the museums of natural history, as in the Peabody Museum at Harvard University. Meanwhile, the public has been exposed to the findings of the anthropologists (Boas, Benedict) to the modernist movements in painting and sculpture. We now see that there is to be derived from the art of these "uncivilized" peoples for the same aesthetic satisfactions we derive from the art of the European. Benin bronzes and Incan silver belong in the chronology of the history of art as does a Goya etching and the Parthenon. Since the art museum must first examine and weigh each item in the light of test-proven standards of taste, one fails to find in its collections enough to stimulate a self-dependent voyage of discovery. You will not find the art of the African or Prehistoric man in the museum of art.

But the library, functioning as an unbiased organization of document has had for years the arts of all peoples and of all places (as described in texts and illustrations) classified without a superstructure of critical prejudices and standards of discrimination. African Art, Cubism, Picasso and the South African Bushman have been and are freely available with equal emphasis and presentation, presenting a true index to the potentiality of the library's role as the source of guidance to enlightenment.

3 Javitz, Romana (1903-1980). *On Pictures in a Public Library*. 1939. TMS. 7 p. Picture Collection records, Box 3, folder 7. Manuscripts and Archives Division, The New York Public Library Archives.

A museum by its pictures functions as an arbiter of taste and answers the question of what is best in art. A library with its printed words and pictures serves as a disinterested but conscientious factual recorder of all phases of artistic production.

The museum selects and appraises as works of art; the library collects and organizes as documents. Pictures in a museum function as art. They have been selected and displayed to inculcate aesthetic appreciation, to give pleasure and motivate culture. Pictures in a public library are made available to stimulate the individual to study the records, to evaluate for himself, to come to his own conclusions without a stipulation by the library concerning ends to which the materials are to be used. The museum, patently, directs and limits the function of its pictures to that of the development of taste and the awakening of aesthetic sensitivity. The library, unlimited, influences more aspects of our lives. Pictures in a library function as social documents, as educational complements, as fact-finding background for either propaganda or the creative channels of the theatre, literature, the dance and the cinema.

A picture collection in a public library should be an organized collection of material classified objectively for its individual content. It should include along with pictures of the accepted and proven art, every type and kind of two-dimensional picture which is or may be of human interest or is potentially provocative of ideas. Theoretically such a collection should be free of an imposed weight of precedent or aesthetic consideration in the selection of its stock of pictures. Tireless attention should be given to comprehensiveness in subject matter included, in the addition of factually precise information, in the thoroughness and practicability as well as the simplicity of the classification adopted. Above all the organization and development of a documentary picture collection depends on imaginative, creative, far-sighted editing.

What is a documentary picture? Calling a picture a document is describing its function. When it is being used as a source for facts such as of methods or techniques, when it presents a style, a realistic appearance of an object, a being or a place, when it is giving the onlooker facts of size and proportion, texture or color, age or period, delineates the pattern or the shape, then, the picture is functioning as a document. It does not interpret inner meanings, nor expose spiritual undercurrents; it tells no entertaining story. A documentary picture does not uplift, moralize or excite aesthetic satisfaction. Ideally, pictures for documentary use would be drawn or photographed with that use in mind.

If pictures were made with no other end in view, their use would be unlimited. When a picture is made for a single specific use, it is apt to be a distortion of fact conditioned by the demands of its users: in a propaganda use, in a commercial advertising campaign, in a political campaign, wherever an immediate purpose makes demands the truth is colored and factual appearances clearly distorted. A true picture has many lives; a teacher may whet a pupil's desire for learning with the same picture which a legislator may use as a basis for social change; an artist may use it to gather some historical facts from which a mural may be designed. Otherwise, if the picture had been made for limited educational purposes some elements would have been eliminated to prove some academic untruth. If the artists had painted the picture, he may have distorted the appearance to appease his sitter's desire for flattery. A good document intends to record truthfully what is visible to the human eye and the camera eye. It will depend upon a keen observation of detail and a sense of the whole appearance; it will have textual values; the confines of the picture will include the human relations and background relative to the subject and an indication of the period and place.

A pictorial record is a factual rendering in the mediums of the graphic or plastic arts or in still and motion photography. The main consideration is that of clearness and truthful fact with no value added for qualities of beauty or other aesthetic elements. If pictures of all of the art of the world were collected, organized by classification and cataloguing into a subject-indexed file, it could all function as document. Unless a drawing, painting or sculpture has its basic appeal in its beauty, for the ideals it realizes or the emotion it arouses, unless some quality is present which has made that work of art rooted in the life of its time and so of all later centuries, the drawing painting or sculpture has as main use its subject content. It may be the faithful rendering of the ephemera of the artist's day or it is an interesting document of the beginnings of some technological discovery of our century.

Most prints popular in the past have outrun their life as works of art but do not outlive their usefulness as records of the costume of their day. Much of the art in our museums has lost its value to our educated eyes. The moving pictures and the still photograph have enriched our visual experience so generally that our taste has improved rapidly, and we can see in these paintings valuable subject content but little to satisfy our cultural needs. Egyptian wall paintings, the art of the Vermeers and de Hoochs, Hogarth and Rowlandson are all rich mines for documents of the life of their day.

Factual or realistic representation has been the goal of most artists of the past. With the development of photography, the artist realizes that the camera came frighteningly near that goal. So near that the artist was driven to protest loudly the superiority of his "art" over that of photographic "craft". Then came the moving picture film and projection machines which went further and further until it achieved the animated cartoon, adding a time element to drawing. At first all photography was considered art but only when it departed far enough from factual representation to look unintelligible and hence easily labeled as artistic. In the consideration of the valuating of photographs we forget that from the earliest times a large proportion of all "art" produced has concerned itself with faithful recording in clear cut unmistakable delineation of the appearances of things and the human scene.

If we had been taught to read art as we read history and not stare at all art hoping for an inspired ecstasy, finding instead a good and lively account in those paintings and drawings and prints of the life, costumes, sins and pleasures, merriment, labor, birth, and death, all of the life of the earth often in terms of the minutia of household or regal court, we would not be bewildered by the onrush of candid camera pictures today.

Photographs, as well as art, may be considered first from the subject point of view. If within the confines of a photograph, there is found elements which validate a work of art, that photograph is art. The slow appreciation of the cinema as an art form may be laid at the oversight of dual but compatible functions of all art, of all pictorial productions. While the moving pictures document and record realistically that which we have seen, experienced and heard, nevertheless they are designed and produced under the same basic principles which condition all other types if pictorial composition. Consideration of any film discovers that the amount of story-telling elements and the subjective content is slight when compared to the amount of production craftmanship required to make the finished work. Photography in the moving film form has within its projected image every element of art, merged into a whole by editing, direction and conception of the relations of time sequences of events portrayed, of images moving and the balance of tone, light, sound and shape. And just as other art forms, moving pictures are good sources for facts. The best as in graphic arts will be those films made for historical records, the News Reel, "The River", "Grass", etc. All films, whether fantastic, comic, unreal or stupid are useful in a library. They, bad or good, record the times in which they were popular, the moral and social standards, the level of beauty, fashions and humor. Because

of the power of the camera to unflinchingly image with precision and detail, I believe that the highest function of the photograph, both still or on film, is that of contemporary recording.

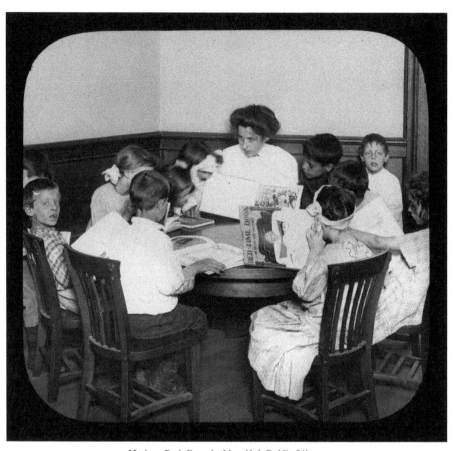

Hudson Park Branch, New York Public Library
Miss Cutler teaching children how to look at picture books. ca. 1910.
Lewis Wickes Hine.

Chapter Two

Annual Reports, 1929 – 1939[4]

Annual Report of the Picture Collection, 1929

Excerpted from: *Bulletin of the New York Public Library, Astor, Lenox and Tilden Foundations.* New York. Volume 33, pp.428-429.

T he year saw the accumulation of a plan by which it is now possible for the Picture Collection to keep abreast of the great tide of illustrative material coming to it as gifts from all sides. For years an appalling quantity of picture material has been accumulating through lack of enough associates to care for or classify it adequately. After some three summers' work, a scheme has been evolved which has made it easier to handle all incoming gifts at once and roughly classify the great store of accumulated material. Through the development of this scheme all pictures in the collection, classified or unclassified, are available for immediate use. Pictures of society in a Southern Hot Springs resort in 1870, Balzac in slippers on the streets of Paris, and ward healers' activities during a Presidential campaign were found in a few minutes' consultation of this previously inaccessible material.

The constant criticism of the Collection has been that, although there were many pictures, there were few modern ones. Because the growth of the Collection has depended primarily on gifts, some subjects have been better represented than others. To remedy these conditions the work of classification was put on a new basis. Each month a fresh subject or source was assigned for classification to each assistant. Thus, by the end of the year a greater diversity of sources had been tapped, and fresher material added to the Collection. For the first time newspapers and current magazines were regularly clipped. This policy has already made an impression on the public which can now find not only a picture of Zoroaster but also Commander

4 *Excerpted from:* New York Public Library. *Bulletin of the New York Public Library, Astor, Lenox and Tilden Foundations.* New York. Volumes 33 – 43, 1929-1939. Full texts available on Hathi Trust site at: https://catalog.hathitrust.org/Record/000055341/Home

Byrd; the Graybar Building as well as the Taj Mahal.

Each year has shown more and more that the public not only depends on the Collection for the actual use of the pictures, but also for all kinds of information pertaining to them. Where to buy prints, where to obtain free material on birds, what kind of print is best for reproduction in a newspaper article and how to locate illustrations in magazines are typical questions met with in a day's work. To make such service satisfactory and also to help the schools, libraries and business firms turning to the Collection for advice in starting similar files, a card index of information was begun. This file indicates dealers in prints, and periodicals and books which yielded picture material.

All this work was made possible by the addition to the staff of pages who now carry the burden of cleaning, mending, filing and lettering of returned pictures – work that in previous years drained the energy of the trained assistants.

The steady increase in the number of borrowers and in the number of inquiries about pictures created a serious problem; curtailed hours of opening continued to work hardship on public and staff. Instead of decreasing, the circulation has steadily increased despite the fact that the Collection is open to the public afternoons only. The pressure during these five hours has become so great that the time allowed each borrower is inadequate and does no justice to the resources of the Collection.

Branches have continued to draw upon the fine prints in the Collection to supplement exhibits of books.

In surveying the year's development, it is interesting to note that it is the art student above all others who derives the greatest amount of inspiration and help from this Collection. It was gratifying to hear at a recent banquet, one of New York's distinguished artists say, "among the many opportunities offered the student in New York, the privilege of using the Picture Collection stands first."

Annual Report of the Picture Collection, 1930

Excerpted from: *Bulletin of the New York Public Library, Astor, Lenox and Tilden Foundations.* New York. Volume 34, pp. 422-424.

At the beginning of the year, the Picture Collection was growing at such a pace as to demand complete re-organization. The increasing and more discriminating use of the Collection intensified the existing problems caused by inadequate space and equipment, and a staff too small to serve the public.

In February, Room 100 was re-arranged. The cutting board, all worktables, and shelves for returned pictures were relegated to the stacks. For the convenience of the public, the desk for charging, discharging and registration was transferred to the entrance of the room. All routine classifying, filing, mending, cutting, etc. could now be done in the stacks near the files of pictures.

With this arrangement and open-shelf collection could be achieved. Previously, it had the character of a closed-shelf library. Each borrower was personally conducted to and from the stacks where the material is kept. The assistant waited until the borrower chose the pictures he wanted. This meant that only one request could be met at one time by one assistant. As the collection was restricted to card holders, the files were available for circulation only. No reference work whatsoever was permitted; those of the public interested in looking at pictures, were referred to the Reference Department.

Now, a clerical worker is left in charge of the desk in Room 100. This frees the trained staff from desk work. The staff can now give more thought, attention, and research help to the public. The public comes directly into the stacks and consults the files. The staff is scheduled in the stacks to assist. This change has enabled the borrower to become more familiar with the scope and possibilities of the Collection. By allowing the public to consult the files freely, the staff has gained more time for reference work and classification. The Collection is now available for reference as well as for circulation use. It is to-day vastly more useful and valuable tool, not only for the general public but also for other divisions of the Library.

Formerly, each picture before being issued was mounted on heavy cardboard. The boxes were crowded to capacity. With increasing circulation and a parallel growth in the number of mounted pictures there seemed no end to the floor space

the pictures would soon need. All mounting was stopped early in the year. As an experiment, pictures were circulated unmounted. This years' experience has proved that the circulation of unmounted pictures is practicable and economical. It is imperative where floor space is limited. It has saved time, labor, and expense. It has decreased mending, cleaning, and filing work and has eliminated the awkwardness of the former method of handling.

Still further to relieve the crowded conditions the first revision of the file was started. By September, the entire file had been revised and weeded. About one third of the mounted stock, about 27,000 pictures, was dismounted. Poor copies, small prints, and material rarely in demand were withdrawn to allow more room and to raise the general standard of the clippings in the Collection.

A need was felt for a separate borrower's card for pictures only, to be issued at the Picture Collection desk. Since November such cards have been issued to firms, organizations, and individuals. The card has lent a new dignity to the privilege of borrowing pictures. Holders of branch cards are now required to register their names and addresses the first time they make use of the Collection. With this twofold registration, the charging was simplified. Pictures are now charged to name only. The new file relieves the overdue and messenger work which entailed communication with branch libraries to obtain addresses. The registration file is a guide to the commercial, professional, and educational uses to which the pictures are put.

Beginning with November the Collection was again opened all day from 9 am to 6 pm. This was necessary to relieve the pressure caused by the large increase in circulation.

The circulation (174,510) was a gain of more that 50 per cent over that of 1928. An average of three thousand new pictures was added each month, twice as many as in the previous year.

The post card collection was transferred to the stacks and made a part of the larger picture files. The bulk of the reserve material was brought together and incorporated into one file on shelves directly over the picture files. The negatives and photographs of Library buildings and Library activities were assembled in two new files, classified, labeled, arranged and stored in folders for safekeeping.

How the commercial artist uses the collection was graphically shown at the October convention of the New York Library Association at Lake Placid. With the generous cooperation of firms and individual artists an exhibit was sent of textiles, originals of book and magazine illustrations, trademarks, book jackets, posters,

models for theater sets, costume and mural decoration designs. All the display was derived from pictures borrowed from the Library. A Soviet-Russia book jacket inspired a wall fabric; a photograph of the keys of a piano gave the pattern of a bookbinding; a color print of Venetian glass developed into a backdrop for a ballet.

The requests are covering broader fields. An afternoon's requests have included such variety as: pictures of a footprint of an elephant, a lamp in a New York boarding house in 1860, a scene from the film play "Metropolis", the button-wood tree in whose shade the Stock Exchange had its beginnings, a face laughing hysterically, a Hebraic dance, and a perpetual motion machine.

Much favorable comment has been aroused by the re-organization. Artists have expressed themselves as feeling a greater responsibility in handling the pictures, as they now feel that the Collection, its growth and welfare, is a matter of personal and professional pride. It is a source for ideas and as such indispensable to their profession. In the new and freer relation, the collection and its public have developed intimacy, consideration, and a more human quality.

Annual Report of the Picture Collection, 1931

Excerpted from: *Bulletin of the New York Public Library, Astor, Lenox and Tilden Foundations.* New York. Volume 35, pp.386-388.

The Picture Collection continues to attract the public in greatly increasing numbers and for more diverse uses. The circulation of 261,611 pictures in 1930 is an increase of 49.9 per cent over that of 1929 and 125 per cent over 1928.

Such statistics overlook the amount of reference work entailed in the circulation of pictures. Continually questions arise: the date of the picture, its source, where it can be purchased, what medium was used, where reading matter can be obtained on the subject, etc., etc. The picture requests demand research, time, and ingenuity. A local museum needed the detail of a pack on a donkey in ancient times and in early America; a school required the history of the wheel in agriculture; a department store was interested in early advertisements of corsets; a magazine cover artist asked for the color of a flea's eye; a necktie manufacturer wanted internationally known

waterfall as a basis for designs to be used in silk manufactured in Switzerland; for a stage set, a designer needed the lettering of an 1930 menu; and among myriad requests for illustrative material such subjects were included as – the use of lipstick in Japan; famous people who had committed suicide; historic examples of gift presentations; an Assyrian milking scene; and, sleeping garments worn by men in 1710.

The growth in circulation has necessitated many physical changes. During the summer the entire file was shifted to merge its arrangement in one alphabetic file, reading wholly from left to right. The cases were clearly labelled, and large guides were placed at the beginning of each row. The increased burden of filing returned pictures was simplified by the addition of special sorting shelves for each letter of the alphabet. To replace the former cumbersome closed folder for unmounted pictures, a new envelope was devised which is open at two sides. Pictures can now be seen and refiled without removing the folder from the file.

The next problem was the inadequacy and clumsiness of much of the classification. The subject headings had been based on precedent of collections primarily serving school needs. Broad divisions such as "Forms of Land and Water" were general. Such classifications are obscure where a public is not a specialized group. The Picture Collection is unique in the public it serves and must make its own precedents. Each picture should be of help to schoolteacher or artist, author or manufacturer. A careful scheme was mapped out. During the summer, work was begun on a section of the alphabet. Pictures were reclassified and cross-indexed, and much additional information entered on cards.

The first year of registration of borrowers throws light on the use of the collection. About one-third of the borrowers are teaching; some training classes in the department stores, others lecturing at universities. Another third includes theaters, publishers, advertising agencies, printers, barbers and wig makers. The rest is made up of the individual artist, from mural decorator to trade-mark designer.

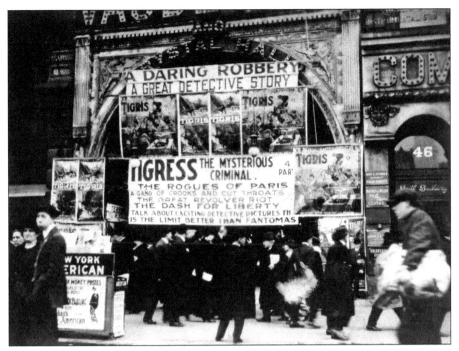

[Vaudeville Theater advertising the silent movie *Tigris* next to the Brill Building at 46 Broadway, Times Square.] c.1913. Yampolsky Collection.

Twice as many new pictures (64,207) were added during the year as were included in the previous year. The public follows with interest the growth of the Collection. More and more the gaps are being filled by gifts from the public. Often not finding the picture in our file, an artist will give a print from another source. Most welcome are the many gifts of proofs of designs based on research in the Picture Collection. Gifts during the year included 1,000 half-tones, 52 framed pictures, 39 volumes, 5 subscriptions to magazines using the Collections, 50 posters, 155 photographs, 150 prints, 287 miscellaneous items.

Among the principal donors were the New York Herald-Tribune Books, New York Times Sunday Magazine, RKP Productions, Inc., Chile Exploration Company, Famous Players-Lasky Corporation, Columbia Pictures Corporation, North German Lloyd, UFA Films, Inc., Messrs. Lambert Guenther and Ferdinand Hutzi-Horvath.

Visitors from other libraries, business organizations, and museums come for advice, interested in the methods of classification, storage, and circulation peculiar

to this collection because of its size and the varied interests it serves. Mail brings inquiries from all parts of the world. The All Union Lenin Memorial Library is starting a picture collection in Moscow. A model picture file was prepared to answer their inquiry.

The Collection is becoming widely known and it is flattering that this publicity has come solely from the borrowers. Local art schools have arranged for visits to the Collection as part of their courses. Professional guilds periodically remind their members of the opportunity this Collection offers to enrich the historic background of a design and to keep abreast of old and new technics. Despite the physical handicap of the stack space, the public does not cease to comment on the privilege it enjoys in having the picture files open for "browsing" and borrowing. The public is realizing that the Picture Collection is not an art file but a picture encyclopedia. As such it is a valuable tool for graphic presentation and for research.

Annual Report of the Picture Collection, 1932

Excerpted from: *Bulletin of the New York Public Library, Astor, Lenox and Tilden Foundations.* New York. Volume 36, pp. 339-342.

For the first time since its beginnings fifteen years ago, the Picture Collection is housed in a room devoted entirely to it. In August the entire Collection was transferred to Room 73 of the Central Building.

In order to move the Collection into quarters much smaller than its previous space in the stacks, it was necessary immediately to dismount the sixty thousand mounted pictures. With this accomplished, the pictures occupied only one-third of the floor space previously required. The entire change was made without the necessity of closing the Collection for more than one day.

The advantages of the new room include better air and light, adequate space for sorting and filing. And a workroom screened from public interruption. One of the most important assets is the table at which the users of the collection may sketch and study the material. More extensive reference use of the Collection is now possible. Facilities for exhibition of loan collections of contemporary art have been arranged. In general, the change of quarters has brought a much higher degree of

comfort and convenience to public and staff.

The shelf space reaching the ceiling on three sides of the room is filled with the reserve stock. The upper reaches contain bound, indexed magazines and books discarded from the branches, arranged by subject. The information desk at which picture requests are presented is flanked by a collection of reference books and dictionaries. Purchased at the beginning of the year, these books save much time previously lost in referring borrowers to other parts of the building, for the Picture Collection previously had no reference tools. Cupboards in other wall spaces fold a third line of reserve, that of loose material roughly sorted – such as a library of 40,000 moving picture "stills", hundreds of travel leaflets, and similar materials received through gift.

The Collection now numbers 316,877 classified pictures in its files. The additions of new material during the year (44,034 pictures) and the discarding of poor material during the moving, raised the quality of the entire file. The gifts during the year had much to do with improvement in the type of picture the Collection offers. Gifts in 1931 numbered 4,617 photographs, 1,882 prints, 40,762 moving picture stills, 124 books, and 1,166 miscellaneous items. The principal donors during the past year included: Mr. Valentine Dudensing, Miss Cecil Castegnier, the New York Central Railway, the Frank G. Shattuck Company, Kurt H. Volk, Inc., the Autogiro Company of America, the Frick Art Reference Library, Mr. Jules J. Brodeur, the Culver Service, Mr. Ludwig Roselius, and The Bureau of Navigation.

The Picture Collection continues to show an increase in circulation. In 1931, there were lent 316,633 pictures, an increase of 21 per cent over 1930. This seems remarkable when one realized the unavailability of a good part of the stock at moving time, and the general unemployment among artists. Lending of pictures for school use was somewhat curtailed because the requests far exceeded the supply.

The most fruitful innovation of the year was requiring the public to present picture requests in writing. This was started to overcome the repeated difficulty encountered in understanding the public's myriad accents, enunciations, and pronunciations. For example, a man searching for pictures of wharves and docks was repeatedly given those of wolves and ducks. From timesaver and interpreter, the written request has become a strong adjunct to the classification and purchase of new pictures. Requests in the language of the public give practical help in making cross-indexes from the subjects as called for to the subject as classified. The request is written according to the needs of the borrower and not as a cataloged sub-

ject-heading. The reader does not ask for a picture in zoology, but for the "profile view of a lamb".

Economic conditions have strongly affected the year's work; the use of the Collection by advertising agencies has been almost wiped out. Business firms have taken more interest in experimenting with new ideas and media to overcome the dullness of trade. As artists lost employment, they made more use of the Collection for technique, style and ideas to keep abreast the market. More intensive studies were made to assure the sale of design and drawing.

Fad and fashions seem to crop up and die despite economic deflations; 1931 saw Eugenie hats, models of covered wagons, Matisse, and Scotch terriers. An interesting development has been the repeated request for pictures showing textures, the texture of walnuts, tree barks, wet pavements, and sparkling beverages. The year's fads, slang, news events, scientific interests, world politics, diseases, fashions, and depressions appear in a day's questions; requests for pictures of panhandlers, men on bread lines, beauty contests, interplanetary warfare, Godey brides, racketeers, gangsters' machine guns, "gun molls', hungry man eating, frail boy, hand knitting, baseball suit of 1898, degraded human being, illustrations of bartering, body floating in water, newsboy crying out "extra", donkey braying, scurvy, baby carriage in Victorian period, flying geese showing feet in position, butcher cutting meat, theatergoers in seventeenth-century France.

Early in the year the Child Study Association asked for an exhibit of pictures suitable for hanging in a child's room. Successful experiments were made in mounting pictures in inexpensive colored papers. This improved the appearance of the prints and helped to make the display thoroughly attractive. For the Regional Arts Council an exhibit on "Theatre Through the Ages" was prepared for display in a local theater lobby and a School of the Drama. For Seward Park High School, exhibits were arranged on the story of the alphabet, facsimile pages of the Aztec writing, color plates of illuminated manuscripts, old block prints of early presses, photographs of modern newspaper plants. The success of these exhibits encouraged continuance of this work, so that more than one hundred exhibits on various subjects are now available. Each is mounted on attractive background and is suitable for exhibition purposes. These exhibits are not restricted as to use and many individuals borrow them: for example, a letter carrier borrowed some to hang in his child's room, some are broadcast each week from television station WINS to illustrate a series of lectures on art appreciation.

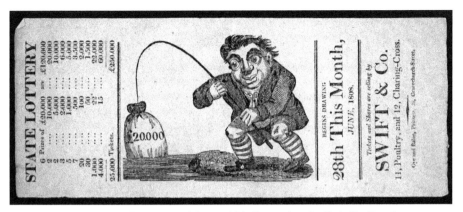

[Advertisement for a lottery.] June 1808. Engraving. Swift & Co. London.
Yampolsky Collection.

The Picture Collection is trying to represent current life in New York City in its files. With the co-operation of local firms and organizations, photographs were obtained of outstanding window displays, architecture, vehicles, fashions, vaudeville acts, the dance, etc.

The proximity of the Central Children's Room and the Central Circulation Branch emphasizes the importance of the circulating privilege. The pictures go into the workshops of the city. In the theatre district the pictures are at work in a wigmaker's shop and at the make-up mirror. On Wall Street, in a new office building, and in Radio City, walls are being painted from designs borrowed from the Library. To New Yorkers art means something caught within frames in a museum. To the Picture collection art is a live profession, hungry for ideas, inspiration, and experimentation.

Annual Report of the Picture Collection, 1933

Excerpted from: *Bulletin of the New York Public Library, Astor, Lenox and Tilden Foundations*. New York. Volume 37, pp. 400-402.

This lean year accentuated the practical attitude of the public in coming to the Picture Collection. Essentially, these pictures are put to a bread-earning use. There were 406,967 pictures lent during 1932, an increase of 28 ½ per cent over the 1931 circulation, 316,633. This indicates but meagerly the work involved, since, in general, each request requires research.

Gifts to the Collection amounted to 545 volumes, 1,727 pamphlets; 1,631 magazines; 5,580 prints; 17,074 clippings; 1,485 photographs; 1,352 cards; 128 drawings; and, 2,734 moving picture "stills". Through the generosity of Mr. A.A. Hopkins, valuable additions were made on military insignia and uniforms, nineteenth-century London, heraldry, and Dickens.

For the Picture Collection the year seemed built of alternating requests for Goethe, George Washington, and Spinoza, with lively interest in plaids and Persian frescoes, campaign bandwagons and beer-making. Mickey Mouse and the "forgotten man", Radio City art and solar eclipses, the Victorian whatnot and the leg-of-mutton sleeve, stratosphere and marionette.

The Collection has the individuality and emphasis of the public it serves. Through the recorded everyday picture needs, numberless ideas, technics, attitudes, economic influence, stage conventions interweave to an extent that shows the live, contemporary character of the collection and its influence in the community. Rugs, stage-sets, murals, metalwork, and sculpture in the Radio City project were designed with the aid of the Library's picture files (both the bad and the better depending on that help), Exhibitions lent by the Collection enlivened lectures, store windows, theater lobbies, settlement houses, schools and homes. Because of the attractive style of mounting developed in the last two years, the public began to borrow prints for home decoration.

A cross-section of a day's requests reveals the variety of needs answered pictorially: the American farmer's beard, eye of a seahorse, lips, still life of a steak, modern clock numerals, windy day, moths working on fur, interplay of searchlights, lettering for street-naming plates, lying and liars, lovelocks, umbrellas and rain, park

benches, position of a cock's legs when crowing, peas in a pod, studios in Trilby's time, Victorian baby carriages, factory roofs, ticket booths, and "whatever Arabs drink coffee from".

This year the lack of a collection for school use culminated in a problem. The Collection has not fulfilled the double demands the public has made: that the Collection include pictures classified from the particular standpoint of teaching; and that, quite simply, it should become a general subject file. Within the limitations of inadequate funds, it has been impossible to do more that keep the file general in scope. Excepting that of the Queensboro Public Library, there is no other free, general picture collection in this locality. This turns some six hundred schools to the New York Public Library for pictures required in the syllabi. To handle the quantity of the requests and to avoid crowding out the general public, a restriction was imposed on the use of the files for school requests. They were all handled by a member of the staff scheduled and prepared for this work. She made the preliminary selection, choosing only such pictures as had been mounted to withstand the rigors of classroom use. Complaints were met with the explanation that this procedure prevented monopoly by first comers, since there were often as many as sixty requests in one afternoon for the "life history of the frog", *Silas Marner*, or "Eli Whitney and the cotton gin". The direct use of the files was closed to students and teachers in grade schools. Easier handling of crowds on Saturday afternoons improved condition of pictures used in schools, and a fairer allotment of pictures to each request was gained.

The work of the year was much broadened by the aid of eight Emergency Relief Worker. Pictures in the original file (some 150,000) were stamped with an identifying possession mark, trimmed, and mended, saving much labor at the charging desk. The entire post card collection was reclassified. The collection of portraits was transferred to open type folders. Freed from the routine of filing returned and new pictures, the regular staff found time for more constructive work. The staff devoted the summer to renewed work on a list of subject headings. Constant inquiry from other collections in private and commercial libraries has brought to light the need for a printed list. The variety of professions this Collection serves makes it the logical source for such a guide list.

As a forerunner to the future printed description of the Collection and an answer to constant query and interest, an exhibit, or "ABC", of the Picture Collection was hung around the room in alphabetic sequence. This exhibit chosen from the

Collection's own files showed the scope of subject and the types of pictures making up the Collection. Beginning at "A", a nineteenth-century advertisement of suspenders was shown; next a color print of Aztec writing; nearby, a list of subject headings which included agricultural pests, anchors, attics, angels, apparitions, and auroras. From cheese, clowns, and crabs, the railroad signals, textures, umbrellas, weddings, and winter. Engravings, newspaper clippings, photographs, motion picture "stills", museum color prints, and post cards joined to make an alphabetic holiday. The exhibit showed that the Picture Collection is primarily interested in the subject matter of the pictures and is equipped to give this interest a rich and varied expression.

Annual Report of the Picture Collection, 1934

Excerpted from: *Bulletin of the New York Public Library, Astor, Lenox and Tilden Foundations.* New York. Volume 38, pp. 373-375.

There is stimulation in the increasing use of the Picture Collection, despite three years of depression. In 1933, 467,897 pictures were borrowed. This was an increase of 14.7 per cent over the circulation of 1932. For three months no pictures were circulated though the branch libraries, a curtailment of service caused by insufficiency of staff to cope with increased work.

The collection continued to grow in size. During the past year 76.318 new pictures were added to the classified stock, bringing the total to 456,588 (total stock at the end of 1930 was 280,933). In addition to this file which forms the core of the collection, there is the reserve stock now consisting of approximately 21,000 clippings roughly classified, 1,000 volumes of bound magazines, and 3,000 illustrated books.

Funds for purchasing needed pictures was limited, and the collection depended almost entirely on gifts. The high percentage of useful material in the unsolicited gifts reflects the serious intent of the borrowers in building up the collection, on which they in turn depend. Gifts for the year include 200 volumes, 844 pamphlets, 3,061 magazines, 1,956 prints, 14,819 clippings, 4,735 photographs, 1,884 cards, 209 drawings, 13,167 moving picture "stills", 67 photostat prints, and 992 posters. Principal donors were The Century of Progress Exposition, Mr. A.A. Hopkins, the Hurok Musical Bureau, Mrs. F. Luis Mora, the New York Times Sunday

Department, *Soviet Russia Today*, the Van Buren Corporation, and Miss Frederica Warner.

To fill growing demand for exhibits of subject interest, there are now available 92 sets of selected pictures ranging in subjects from the "History of Beauty Culture", "Housing", "Fairs", and "Picnics". To "Three Centuries of Tahiti" (Gauguin, Captain Cook, and the modern travel film). From individuals, shops, schools, clubs and libraries, came constant inquiries for advice on the display, mounting, and arrangement of picture material. Spectacular ocean-going use was made of the "Centuries of Costume" exhibit. In its ship's library, the Holland America Line steamer, *Statendam*, displayed 90 prints tracing the history of dress and headgear. On this "Style-Show Special" the pictures accompanied the passengers bound for the style displays by Paris dressmakers, and were on view at the European ports.

The public took pleasure in the changing exhibits displayed during the year on wall space in the Picture Collection. Outstanding, was an exhibit of moving picture "stills", selected and arranged to show cinema as an art form. This was a pioneer exhibit of its kind in this country, attracting much attention from public and press. It described the chronological development of the moving picture in Russia, Germany, and the United States and the contributions of individual directors. Typical films from Sweden, France, Holland and Japan, were included. The exhibit was enlivened by posters, naïve advertisements of western thrillers and serials, delicate Japanese versions of American melodramas, and the bold, modernist interpretations of U.S.S.R. and Germany. Through the generosity of the firms exhibiting, enough material was left to form a permanent circulating exhibition the artistic development of the film here and abroad- an important addition, as it is the first public collection made from this point of view.

As in other years, requests kept pace with newspaper headlines. In the wake of Repeal came search for pictures of early whiskey flasks and Burgundy labels, King Gambrinus and juniper berries, treading grapes and British liquor advertisements. With unemployment were linked requests for pictures of slum clearance and the deterioration of buildings through disuse. Calls for Russian ornament, costume, and customs, swept in with Litvinoff's arrival. Picture requests for pogroms, burning of books in other days, revolutions, the Century for Progress Exposition, Islamic art, NRA, and the "big bad wolf" cartoons, round out the year's interests.

Although as usual the roots of the requests were in the news item and the current fad, an analysis of the year's work with the public shows a marked shift towards

concentration on the American scene. In former years, designers asked for foreign sources and old period designs. To-day, the American artist finds his own background one of flowing richness hardly as yet tapped. Scenes of early American historical events, early views of American cities, the beginnings of the great industries, every graphic element of the natural resources. Ohio flatboats, Charleston balustrades, corncribs, cowboys, gold mining, cotton, the "Don't tread on me" flag, filling stations, samplers, *and silos- were used as a basis for fresh design.*

Numerous public projects assigned to artists the problem of representing the American scene pictorially. In the research for factual bases for the mural, illustration, or miniature model, artists discovered the glamour and robust variety of American history. The privilege of borrowing pictures and taking them where the work was being done, brought the resources of the library into direct contact with the created design. A well-known American artist now painting a P.W.A. mural commented on the Picture Collection, stated that its development and growth were of importance to him because the form of his conceptions was often fixed by the kind of material available in its files.

Annual Report of the Picture Collection, 1935

Excerpted from: *Bulletin of the New York Public Library, Astor, Lenox and Tilden Foundations.* New York. Volume 39, pp. 284-285.

I n 1934 a total of 667,967 pictures were lent. This represents a 42.7% increase over the 1933 circulation (467,897).

The many artists hired under the Public Works Art Project to produce designs for the decoration of public buildings turned to the Library for the needed factual data. These murals demanded research, often requiring the assignment of a research worker for each dozen artists. This served to introduce the possibilities in the use of the Picture Collection to a large group of artists not previously familiar with its resources.

The registration records indicate an overwhelming change in the public. There is today a greater use of the Collection by free-lance designers and the "gallery" painter and sculptor than, as formerly, by the commercial art agencies. (Artists of

the caliber of Ruth Reeves, textile designer, Albert Johnson, scenic artist, Gaston Lachaise, sculptor, and Diego Rivera, fresco painter, regularly availed themselves of these library facilities.)

In this connection it was most flattering to have the National Society of Mural Painters in April move that a vote of thanks be tendered to the New York Public Library for "such signal service to artists" as is offered them through the Picture Collection.

During the year 75,754 pictures were added to the classified stock. This brought the total to 530,509 pictures. As in previous years the generosity of the public response accounted for the large number of gifts. Included in the gifts were 157 volumes, 1,918 pamphlets, 988 copies of magazines, 6,207 prints, 25,727 clippings, 5,644 photographs, 1833 cards, 301 drawings, 10,452 moving picture "stills", 31 photostats, 148 posters, 221 labels, 314 proofs of book illustrations. An important gift was that of the Public Works Art Project. The government gave as a permanent loan to the Library 91 fine prints and 20 paintings. This made a rich addition to the exhibits available for Branch Library use. An idea of how acute is the need for decoration and color enlivening in the Branch Libraries may be elicited from the fact that most of the pictures were immediately reserved for the next two years. Among the purchases made during the year, was a set of the color collotype prints published by the British Museum. With the Public Works Art Project paintings, these made the handsome beginning of a circuit collection of framed pictures for the use of the Branch Libraries.

The outstanding exhibit of the year in Picture Collection was a display of photographs on the "Romance of Railroading". The exhibit was made possible through the cooperation of the Baltimore and Ohio Railroad; Milwaukee and St. Paul and Pacific Railway; Lackawanna Railways; New York Central Railways; Northern Pacific Railway; Pennsylvania Railroad; and Southern Pacific Railway. Many of these photographs were on public view for the first time. This display constituted a graphic story of the railroad from the raw products used in the construction of a train to the "life and death of a railroad ticket". At the close of the exhibit the entire collection was given to Picture collection to be part of the permanent file. Through the generosity of Mrs. F.X. Milholland, the widow of a former vice-president of the Baltimore and Ohio Railroad, the Library was presented with two sets of the unique collection of photographs relating to railroads prepared by Mr. Milholland, this collection to be known as the "F.X. Milholland Memorial Collection".

Aside from requests that mirror the season and current fad, there is kaleidoscopic variety in a day's inquiries: dead game being carried from the hunt, sports that might illustrate timing, saddle bags in 1812, the lighting of factories in 1900, unloading a circus, backstage in the Civil War period, straw hats in ancient times, pictures of forsythia as the basis of the color scheme of a projected New York Central streamliner car, industrial strikes, taxi dance halls, the vocal chords of a giraffe, designs for fabrics to be used for coffin linings, architecture in relation to stage design, history of bottling, drawings to show how cows convert food into milk, costume in relation to woman's posture by decades (debutante slouch 1918, straight front 1900), typical newspaper headlines indicating crime waves, African signal drums, authentic turbulent skies, class struggle with mobs and soap box speakers, photographs of an automobile lying on its side.

Two incidents of the year epitomize the relation between the public and the Collection. A French designer felt it important to inform the staff that, although having worked in several capital cities here and abroad, he found this service unique. For the last three years, this designer who resides in Paris has spent part of his time in New York in order to have the use of this Collection for much of his work as required documentation. The second instance is that, at the opening of the first school window display in the city, the director thought it essential to include as preliminary training for entry into this field, a thorough familiarity with the picture files of the Library, which she considers indispensable. The important Work Relief Projects in the Picture Collection are described on Pages 262 and 263 of this Report.

Work Relief Projects (pp.262-263)

For years, the Picture Collection staff had been unable to cope with the routine of issuing pictures for circulation and refiling them on return. The E.W.B. workers were of great value during 1932 and 1933. But it was not until C.W.S. workers, professional and clerical, came early in 1934 in sizable numbers, that real progress was made in building up the collection and in properly serving the public.

Picture material contained in a ten years' accumulation of books and magazines has been extracted and placed on file; the reserve stock of 300,000 pictures has been sorted; and the classified file of 500,000 has been rehabilitated by clerical workers.

Library-trained workers have done constructive work which has been sadly needed for years. The entire file has been reclassified; many subjects have been sub-divided; valuable information, often obtained after exhaustive research, has

been added; more thorough cross references have been made, and much foreign-language material has been translated. The 15,000 moving picture "stills" covering the history of moving pictures here and abroad, have been classified, cross-indexed, and analyzed. The files relating to paintings, etchings, engravings, and illustrations (numbering 1,900) have been reorganized, and the artists name, nationality, date of birth and death, and school of painting, added. Similar information has been added to the loan exhibits of ninety subjects, which have been assembles by the staff and contain in some cases several hundred pictures. Relief workers are making interpretive posters for these exhibits, attractively designed, lettered, and decorated. Work has begun on the catalogue of picture subject headings, needed for years and invaluable to other libraries trying to form picture collections.

Annual Report of the Picture Collection, 1936

Excerpted from: *Bulletin of the New York Public Library, Astor, Lenox and Tilden Foundations.* New York. Volume 40, pp. 244-246.

That pictures as documents are an indispensable part of public library service is easily justified by the circulation statistics of this picture collection. During the past year, for use in studios, workshops, backstage and at home, 726,028 pictures were borrowed. This was an increase of 58,061 over the previous year, despite restrictions on school use and further restrictions on all material related to the subjects in demand for mural projects, e.g., the history of postal service.

Born of the year's news, fads, fashions, wars and discoveries were such picture requests as Van Gogh, Ethiopian flora and fauna, horrors of war, Quetta, helmets of the Bengal lancers, cattle dead in a drought, abstract paintings adaptable for embroidery designs, G-men, dude ranch clothes. Typical requests crop up each year: renderings of perfume bottles, a dowager type face, a chorine, the position of a goat asleep, the first roller coaster, a Roman emperor having his heels massaged by a slave, the advertising of soap between 1900-1920, and egg being fried on a sidewalk, a horse pistol, gastronomic maps, gardenias, Antichrist. Despite the variety of subjects presented the ends to which these pictures are used remain fundamentally the same.

Ninety-seven thousand six hundred and forty-six pictures were classified and the source of each indicated. With these added to the files, the classified stock totaled

625,668. In the four years since the Collection moved to its present quarters, the classified stock has increased ninety-seven per cent without increase in floor space or filing equipment.

In addition to the rich residue salvaged from discarded and duplicate material of other divisions, 50,994 items were received as gifts from the public. These included: 2,826 prints, 24,915 clippings, 3,047 magazines, 7,638 moving picture "stills", 5,659 photographs, 191 labels, 389 samples of fabrics and papers, 116 posters, 782 proofs of book illustrations, 141 volumes. Through the generosity of Miss Susan Bliss, fifty engravings, mounted and framed, were presented for use in branch libraries. There are now available for circulation 104 framed prints.

Four exhibits were displayed in Picture Collection during the year. All of these exemplified possibilities in display emphasis on the subject matter of pictures. The first exhibit showed the development of the "Tree of Life" motif in ornament. Its significance was increased by the inclusion of ten facsimile color drawings made by artists on the Federal Art Project with detailed historical references and notes of origin and development.

The next exhibit "Announcements of Exhibits" aroused much comment in the trade journals interested in typography. More than 1,500 cards were received from which selection was made for the show. The changes in arrangement and choice of type, the more frequent modern use of color, excursions into stunt layout and sur-realism made vivid the difference in fifty years of announcement cards. The earliest card on view (1870) looked excessively shy and discreet, delicate and completely unrelated in spirit to the exhibit it was announcing. Through the courtesy of the Metropolitan Museum of Art, a selection of its announcements was displayed. It was interesting to overhear comment on how far this Museum excels commercial organizations in the use and arrangement of type. The cards, in recent years, have developed a style which instantly evokes the spirit of the exhibit advertised.

During the summer, pictures of "Peddlers and Vendors" were on view. The public found diversion in the lack of change between the eighteenth-century sausage vendor and the modern hot-dog stand, between the seventeenth-century scissors grinder of Ostade and a modern New York scene. The three exhibits herein described are now part of the collection of 115 circulating sets of exhibits, which, when not on view in the Central Building, are sent to branch libraries.

Museums and art collections maintain collections of pictures selected as ends in themselves. It is only in a public library that pictures are organized as documents,

not as good or bad art. Here the public come to make their own selection and find inspiration, stimulation, factual data, and opportunity for comparisons.

Annual Report of the Picture Collection, 1937

Excerpted from: *Bulletin of the New York Public Library, Astor, Lenox and Tilden Foundations.* New York. Volume 41, pp. 238-239.

E ven a flat row of numbers discloses, though feebly, the enormous extent of the public use of the Library's picture service. 824,443 pictures were borrowed for use as data, document or stimulation outside of the Library's walls, an increase of thirteen and one-half per cent over the previous year.

Improvement in the picture stock, both in quantity and quality is marked. The stock now numbers 718,612 classified pictures; of these 94,170 were added during 1936. The greatest change has been in the rich addition of thousands of photographs. One well defined photograph will yield more information that three of four half-tone reproductions or artist's renderings. Fewer pictures are needed for specific document because the quantity available is large enough to act as a comparative basis for selective elimination.

The gifts of the year (104,167 items) helped change the caliber of the picture stock. Especially welcome were photographs received from the Resettlement Administration and *The New York Times*. *News-Week* has cooperated to the extent of supplying us weekly with current news photographs. In addition to photographs coming to the collection by gift, some 10,000 photographs of paintings were purchased together with a hot-press machine for properly mounting them.

Picture Collection is never far from the newspaper headline and fashion fronts. The year brought picture requests for labor unions emblems, sharecroppers, cooperatives, surrealism, Mrs. Simpson, Goya's war etchings, voting booths, royal plumes and regalia, inaugurations, coronations, treatment of incurables in other ages, potter's fields, dish gardens, fatherly faces, opening oysters, brand marks on cattle, effects of hard labor on hands, front end of a parade, a rural store hot stove-league, latch strings, insect wings, frowsy violas, parlor in an old-ladies home, black widow spiders, potted palms, sides of houses, a New York street showing a variety of social classes, leopards in cartoon handling, spot treatment of polo, machine forms, rhythm as

in cogwheel, wheat, ship propeller and fern leaf, birds alighting, broken backs, and cows lowing.

There is so exhilarating a community in the usefulness of this type of library service that both the organization of the material and its development is never static. It keeps both staff and public alert and arouses a lively stream of cooperative support from the public from whom we receive an amazing percentage of constructive and understanding suggestion, always in the spirit of keeping the collection one of live preservation and availability.

More and more there is an obvious need for lending collection of framed prints. The good taste of the general public as it is disclosed in the requests, we receive would amaze the average museum staff which bemoans the lack of "art appreciation". Every picture from our limited collection of color facsimiles of unfamiliar and often decidedly not "popular" art (primarily framed for use in the branches) has evoked many urgent requests for the privilege of temporary home use.

Several governmental projects involving the handling or organization of pictures as document, turned to the experience of this collection as basis for their own guidance. The staff of the Visual Education Project of the Board of Education studied our methods of selection, classification, storage, mounting, etc., before embarking on the organization of their own visual aid service. The photographic section of the Resettlement Administration took into consideration our experience with a general public's picture needs when it attempted to set up criteria for documentary pictures. Likewise, the American Index of Design organized its files of pictorial data on precedents established within the collection.

Bi-monthly exhibits were held during the year in this room. The most interesting one devoted to graphic representations of Fabulous and Fictitious Beasts and Monsters. It included some twenty-five color facsimiles made for the exhibit by artists on the Federal Art Project. These were detailed close ups of monsters from Greek pottery and Chinese paintings in the Metropolitan Museum of Art. On view were man-made monsters, such as Frankenstein from a recent film, the harpies Ulysses may have seen, the Loch Ness sea serpent, the unicorn, and hundreds of fabulous forms man has imagined to add to the myriad beasts he found in the air, the sea and on earth – devils, gods, and angels. The original drawings of Boris Artzybasheff to illustrate *The Circus of Dr. Lao* presented monsters of modern imagination.

In May a repeat performance of the Picture Collection 1933 pioneer exhibit on the Moving Picture as an Art Form was arranged at the Hudson Park Branch. For

this new display, new material was solicited and received on the history of projection machines, on use of sound and color, and on the animated cartoon. For the latter, the United Artists Corporation contributed, as a permanent part of the exhibit, some of the original drawings in color, characters in Walt Disney's technicolor productions. Since this exhibit, we have received requests for it from many parts of the country. It was on view at the University of Chicago this winter.

Annual Report of the Picture Collection, 1938

Excerpted from: *Bulletin of the New York Public Library, Astor, Lenox and Tilden Foundations.* New York. Volume 42, pp. 245-247.

Pix, picts, photos, prints, clips, illustrations, data, document, stats, scrap, swipes- by every other name 870,398 pictures were borrowed by the public in 1937, an increase of 45,955 over 1936.

On picture requests, current fad offsets recent horror; movie romance overshadows a kingly coronation; a ventriloquist's dummy takes precedence over a mayor's election, a Moorish fabric design overlaps the war in Spain. A spotlight chancing across the picture problems of the past year stops at such as these: pictures of Charlie McCarthy, of crispy heads of lettuce, of the Big Apple, of demi-tasse cups, of people sleeping fitfully because of noise. Others searched for pictures of the ancient Greek type of hot-water bottle used in healing, clenched boxing gloves, Japanese women shaving their eyebrows, extraction of a wild animal's tooth, a party-line telephone, the safety device used in painting industrial smokestacks, a horseman picking up an object, the earliest advertisement of ready-made dresses, sausage casings, bananas in a bunch, the Marco Polo bridge in China, a skewer, a cartoonish cow, a school slate with felt edges, "silent life" for a restaurant signboard, the color of stripes in an Arab tent, nineteenth-century clothespins, a clothing store dummy, candy pulls, rats deserting a ship, soap-box derby, top hats, a human skeleton in repose, and again Charlie McCarthy.

More than 80,000 pictures were added during the year, bringing the total stock to 798,594 pictures classified for circulation and reference uses.

The first exhibit of the year was on "Soil and Land", a collection of large photographs prepared by the Resettlement Administration, through the personal

interest of Mr. Roy D. Stryker. This handsome series which graphically presented the struggle against erosion, the fight against wind and dust, was given for permanent exhibition use. The most important show was a loan for exhibition on the "Spot Use of Drawings", a pioneer display on this subject. The use of drawings is new and has developed in the trail of the magazine era. Offsetting the photographic story-page and in advertisement, these drawings, of artistic merit in themselves, supply imagination, good design, and spontaneity of observation. The original drawings on view gave the Picture Collection public an important opportunity to study the variety of techniques and viewpoints. Many artists who are regular contributors to the *The New Yorker, New Masses, Esquire, Harper's Bazaar,* and the art editors of these magazines, made possible the success of the showing.

In the spring the Federal Art Projects asked permission to exhibit in the Picture Collection the work of its Poster Division. The artists on the project had expressed themselves strongly on the importance of their work being displayed here, at the place which has become the busy cross-roads of movements in contemporary art. The exhibition of posters proved enormously popular and resulted in much renewed interest in the silk-screen process by which they were made.

Throughout the summer, representative framed pictures selected from the exhibit collection were on view. Much interest was evinced in the simple methods of framing and the success with which inexpensive prints (often merely clippings from magazines) may be mounted for fuller enjoyment as wall decoration. A concise description of methods of color reproduction was included. The addition to the framed picture collection this year stressed early American paintings and Chinese art.

In March this division took over, on an experimental basis, the preparation of interchangeable display units for the sixteen spaces provided in the bulletin cases outside the Fifth Avenue and Forty-second Street entrances to the Central Building. With little precedent to follow, the problem resolved itself into one of trial and error until reasonable permanent methods and usages of materials were established as practicable for display purposes where consideration must be given to weather, sunlight, taste, and timeliness. Experiences so far have been fruitful in establishing guidance for three-dimensional display within the narrow compass of this type of exhibit case.

A correspondent of a foreign newspaper, arriving at Picture Collection one day, apologized for suddenly covering his eyes. He said it was all too, too colossal and quite horrible to see such potential power, such organization of quantity. To him

these pictures were like disease ready to go into the population and penetrate its life. He saw these files as germs of limitless ideas.

Annual Report of the Picture Collection, 1939

Excerpted from: *Bulletin of the New York Public Library, Astor, Lenox and Tilden Foundations.* New York. Volume 43, pp. 258-260.

his Collection persists as the cross-roads of pictorial inquiry. It cannot hide its head in the sands of time. The rays of news, the light of invention, the beams of public attention and the glitter of current fashion penetrates its daily use. In 1938, picture seekers asked for jitterbugs, doves of peace, a hen sleep, a lion's paw, a Victorian hand-clasp, a Chinese baby left alive after an air raid, bowing diplomatic personages. Chamberlain, old ghettos in Prague, bored faces, interior of a manhole, Wasserman's tests, examination of a horse's teeth, sparks, grave robbers, a woodchuck's shadow, "gingerbread" facades, a raindrop, a peg-leg, a shoulder of beef, and ear trumpet, a garbage scow, old steam trains on the Sixth Avenue "El", profile of Jefferson for the new coin, a portrait of anyone with the surname of McCoy, hatpins in 1880, the color of Lord Nelson's eyes, dry-brush drawings, Swedish modernist furniture, world's fairs, labor in art, old-time spelling bees, the crutch in other ages, extravagance and squandering.

Ancient Egyptian daily life was the theme of the first exhibition of the year in the Picture Collection. The display was made up of colored engravings published in Paris in 1844 by Jean Francois Champollion and recent photographs made in Egypt and lent for this occasion by Donald Stern. The modernity of the daily activities, furniture making, the sports of wrestling and fishing, etc., the simplicity of the draughtsmanship and the beauty of texture were sources of ideas to the many artists who viewed the show.

From June through October a selection of three hundred pictures from the original drawings by William Steig, lent by *The New Yorker* magazine a candid comment on the "Greetings" of the native New Yorker in his daily "Hello" and "Goodbye". The entire exhibition was a pictorial speculation on man's history as a continuity of entrance and exit, on-going and coming. From coming to and fro, through real and imaginative dimensions of time and space, Birth and Death, were presented,

leave-taking and welcoming, hail and farewell. A print after Masaccio showed the Expulsion from the Garden of Eden, a picture by wireless showed Hitler entering Vienna. "Arrivals and Departures" was widely reviewed with interest in local magazines and newspapers and brought many appreciative responses from the public.

Entree du Duc D'Alencon's arrival, Antwerp. 1581. Engraving, printed 1914.

Recent Accessions were displayed next. These included a group of provocative new British posters issued by the London Underground Railway. The American artists found a fresh approach in these designs.

In the last year 79,100 pictures were added to the classified stock which now consists of 877,405 pictures. Gifts during the reach reached a total of 79,642 items. 1,800 Resettlement Administration photographs have been classified and cross-indexed for circulation use.

Instead of being welcome, the increases in the use of the Picture Collection are met with apprehension. Despite a rigid plan of control, the circulation of pictures for home use in 1938 was 870,028. Such use represents the limit of the capacity of the present quarters. It is far too large for the present staff to cope with unless there are added many supplementary clerical workers. To keep the circulation within

bounds, a restriction was introduced to curtail the number of pictures that may be borrowed at one time. Although this did not cripple the service, there was much protest and much ensuing inconvenience. The only gain was a little more time for attention to each individual. A further curtailment was the stoppage of messenger

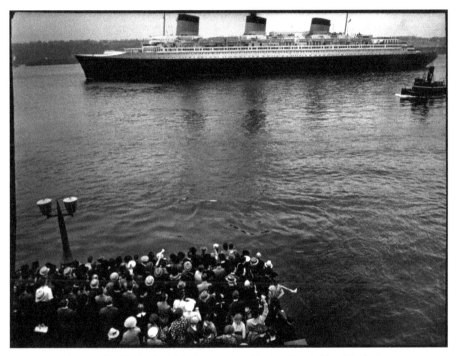

Normandie, North River, Manhattan, from Pier 88, French Line, Manhattan.
1938. Berenice Abbott.

service to the branch libraries for school requests. On the face of it, this seems to indicate a failure on the part of the Library in its function of working with schools. But it is a patently sensible attitude, for pictures as visual aids is a problem of the school system; as such it should be solved by the Board of Education libraries. For the public library to supply such pictures is like the supplying of textbooks; it would involve large quantities to fill mass requests.

Further to offset the crowdedness of the room, we diverted several sections of our picture files from their proper alphabetical position. The entire collection of portraits, although in constant use, popular and indispensable, was thus transferred

to cardboard boxes for temporary storage on shelves near the floor level. This move interferes with their usability, but it relieved somewhat the crowded condition in other sections. The space so gained was immediately absorbed by incoming material. Constant ingenuity is needed to meet such enormous public activity within such restricted space.

The use of the Picture Collection has grown excessively, out speeding the numerical growth of staff, supplies, equipment and room. Reference use is increasing; the space at the tables is being used more extensively by persons sketching directly from the pictures. They prefer the simple availability of this Collection which obviates a long search through catalogues and volumes. If such reference use were discouraged it would be most unfortunate, as there is no other large, general, comprehensive picture collection in this city.

The Picture Collection has been growing, functioning, developing since its start in 1915. By now, surely it has established itself as a necessary part of library service. Makeshift furniture, lack of proper equipment and supplies have retarded the service to the public; it has become unnecessarily awkward and time-consuming. While it is true that the Collection is serving the public, it is doing so under overpowering difficulties for both the public and the staff. Natural development of the use is becoming stunted. Here is a spontaneous opportunity for influence and direction in the fields of adult and juvenile education, and the industrial and fine arts. A constructive, coordinated plan should be entered into for the reestablishment of this Collection on the basis of the extent to which the community depends upon it. An allowance for such a plan would be a productive investment in materials which play a permanent, creative part in our lives. The Picture Collection has reached an end stage in its present setup. It cannot keep on serving the community without a fresh start based on the validity of its function in the Library.

This is the decade of the candid camera, the moving picture film, picture magazines, picture newspapers; of color photographs, animated cartoons and an impending television. One regrets that the Library cannot keep up with these newly available resources of visual education and experience. In this section of library activity one may observe that pictures arouse the desire to read for further acquaintance through words with the subjects gleaned from pictures. Intellectually, aesthetically, for fact-finding and for recording, for teaching and for propaganda, pictures have become a stimulating part of our lives. The Library can further maintain its function of enlightenment in a deep and penetrating way by offering the public a free use of all kinds of pictures,

especially pictorial records of the story of America and her peoples.

Work Relief Projects (p.233-234)

So-called "white collar" relief workers have been assigned to the Library for over five years and little new work was started in 1938. About 300 W.P.A. workers were assigned to the Circulation Department.

At the end of the year the largest group, thirty-two, was in the Picture Collection, while thirty and seventeen were at the Music Library and the 135th Street Branch respectively.

The catalogue of subject headings for classifying pictures – the major project in the Picture Collection, on which staff and relief workers have labored for seven years – is still in process, having grown to over 200,000 entries. In the various operations involved in the development of the catalogue during the year 180 new subjects were devised, 27 subdivisions made, 1,000 cross references entered, 7,000 pictures identified, captioned, and classified, and 17 subjects surveyed and analyzed, accompanied by bibliographies.

One million pictures were arranged and filed, 200,000 mended, 20,000 new ones mounted, and 15,000 old ones renovated. Among the additions which required special treatment were 274 moving picture titles, from which 6,400 "stills" were labeled and cross-indexed, involving 6,000 entries in the subject index.

The year saw the completion of the clipping of tons of reserve material which had accumulated over ten years. The size of this project is indicated by the fact that the reserve collection is composed of 600,000 pictures. Now roughly arranged under general headings, the reserve pictures are at last ready for final classification and addition to the regular file. In the mean time they contribute invaluable supplementary material.

Nine sun bonnets rendered by artists from the Federal Art Project's
Index of American Design. 1935-1942.

Chapter Three

Origins of the Index of American Design

Mr. Holger Cahill
12 East 5th Street
New York City, New York April 29, 1949

Dear Holger Cahill:

It is good to hear that you are recording the history of the development of the *Index of American Design* project as part of the National Gallery's publication of reproductions of the original. I appreciate, too, your inquiry about the extent to which the New York Public Library was involved in the beginnings of that project. Unfortunately, a good part of our correspondence in those years was destroyed for paper waste during the war, and only a few of the letters from this project to the Library were kept...

In 1925 and 1926 I visited libraries and museums in Italy, Austria, Poland, Germany, France and England. At that time, I studied the organization and the contents of documentary pictorial collections. I was especially interested in how these foreign governments perpetuated in pictures changing customs and costumes of their own peoples. Everywhere I went, I found that the records of the folk arts were exceedingly rich and well preserved and that the governments had been interesting in subsidizing this recording and documentation. In some cities there were museums devoted entirely to the history of that city. Often the contemporary scene had been recorded by contemporary draftsmen and photographers, and the original drawings and prints were preserved as documents without consideration of their aesthetic content or function.

In the National Art Library of Berlin I studied the organization of the *Lipperheidschen Kostumbibliotek*, a library devoted entirely to the history of costume. It was established by the owner of the first fashion magazine published in Europe (*Die Dame*), with funds to be used by the Library for hiring artists to make patterns and drawings of the costumes worn by

ethnic groups in Africa which were dying out. These later were published as portfolios of color plates.

When I returned to my job at the Library in 1928, I felt the inadequacy of the pictorial record on the American scene. Our staff was constantly frustrated by the lack of pictures to answer constant inquiries. We were besieged by foreign visitors and recently emigrated artists who asked over and over again for the American record – What kind of clothes the farmer wore in 1810; was there a tradition in the use of overalls in America; did we have pictures of all sides of the sun bonnet; where could they see a cigar Indian? It seemed shameful to me then that we had not developed pride enough in our own past to record the appearance of what the people wore, the details of their kitchens, their tools, their houses, their shops and toys. In comparison with the pretentious coverage of peasant costumes that the French, Portuguese and Swedish Governments had subsidized, we had nothing except State and Federal publications of beautifully printed drawings of our natural resources, illustrations of fishes in our rivers, the grapes and the apples of our States, and some surveys of the Western scene, and the Indians, but on the intimate life of the people and their homes, their tools, artifacts and the whole output of our craftsmen, there was no record except in widely scattered references and in widely scattered museums where the objects themselves had been stored.

Beginning in the 1930's we noticed in requests directed to the Library a fresh trend in the interest of the American designer, and a good part of this change came from the curiosity and enthusiasm of foreign visitors and artists coming here for the first time. This trend was away from the blind repetition of period ornament and European design. The American designer began to seek his own country, the peoples of his own land and their arts as inspiration for his design. For him pictorial research sources were completely inadequate.

By that time I had begun to realize that the only solutions would be a planned series of documents on America's crafts and that probably subsidy would have to come from either a great foundation or the State or Federal Government. As I saw it, this work would be published just as the Smithsonian Institution Reports were or, more familiar to us, like the volumes on the Wild Flowers of New York State issued by the New York State Museum. I thought of it as an index to the past of our national

culture in terms of the craftsman and in terms of what the people worked and played with; that it would be an amplification and a natural growth of the service we were then giving the public – making available, without selective basis, all of the pictorial documentation we could gather and organize that the public may draw on the past to familiarize themselves with our national heritage.

As I worked with the artist-public doing reference work daily for years, I frequently complained of the dearth of pictorial records on the American past, for we could find no pictorial coverage on the early decades of this country. It was just as hard to find a woman's apron of 1905 as it was to find a picture of a Shaker bonnet. I constantly discussed this lack and apologized for our inability to supply the public with the pictures they asked for and required in their work.

Miss Ruth Reeves has been a frequent user of our file for more than fifteen years. Along with other artists among our public I had discussed with her the great need for a national awareness of the importance of recording our past; the need of support for a project to record the daily life of the American people. I discussed this idea with her over and over again and out-lined it as a series of illustrations, fully documented by accompanying text, that could be published in quantity and made available to every library in the country. These drawings were a means toward producing a printed image so that everyone throughout the country could find in their local library part of their cultural heritage preserved in the liveliness of color and line.

I recall that Miss Reeves came to me one day and said that now some-thing could happen to the sunbonnets that I always complained about, to the pictures that I always wished to see made, that she was now with the WPA (Works Progress Administration) and that they were seeking an idea for a project which could absorb the talents of the "non-easel" artist, that there were hundreds of unemployed artists and no project had been thought of as yet to absorb them on a mass basis. It had occurred to her that my idea of a subsidized project for recording America, as I had described it to her over a period of years, could be a possibility for WPA. She asked me whether I would be willing to present my ideas in detail. I remember telling her that I was ill and unable to take on an added assignment immediately, that I would want to think it out carefully and I

would only do it if there were a good chance of its being useful, that is, of its being set up. I told her then that she should feel free to call on me to present the idea of the *Index* to her project supervisors.

Then there was a series of luncheons with Mr. (Carl) Tranum. Mr. Kaufman and Mrs. (Frances) Pollak. They could not visualize what was in my mind without a clear statement and detailed exposition. I spent a week writing a description of the *Index* and a plan of procedure as I had thought of it for many years. Then I realized it would be futile to give this to them without insisting upon a few basic conditions. First of all, knowing that this entire project would be akin to the organization of documents in a library. I told Mr. Tranum and Mr. Kaufman that I would not turn the plan over to them unless they agreed to have a librarian trained in subject index work do the preliminary organization. It seemed futile to me to turn the outline over to administrators and artists because primarily this was a documentation problem and documentation is so closely linked to and inseparable from facts that the entire purposes of the *Index* would be defeated, unless from the start it was organized to accumulate factual records and keep those records in usable order. It was because of my insistence, that Phyllis C. Scott was taken away from her job with H.H. Wilson Company and invited to be in charge of organizing the Index with emphasis on its research aspects.

A further indication of its Library origin is the fact that the New York Public Library was the first to be approached for sponsorship of the project. If you read Enclosure IV, you will notice that in Mrs. Pollak's letter to Dr. Lydenberg, the Director of the Library, to enlist his sponsorship she enclosed an exact copy of the project outline that I had presented in July 1935, the same as Enclosure II.

To clarify my position in the founding of the *Index*, all I can say is that for years I had conceived of a governmental project to take the final shape of portfolios of color plates covering American craftsmanship century by century – the signboard, the horse shoe, the sunbonnet, the toy, the store front, the tools and the utensils. The entire idea was born of the expressed need for this material by the contemporary artist, teacher and writer coming to the Library seeking and not finding a pictorial record of our everyday living.

Teapot, American 19th Century; watercolor, graphite, and colored
pencil on paper. Index of American Design.

Bandbox design (Grouse), 1937. Harold Merriam. American, 1910–2002.
Watercolor, gouache, and graphite on paper. Index of American Design.

Familiar as I was with the textual coverage in the same field – particularly of other countries – I was impatient with our lack of awareness of the importance of our accumulated heritage in folk art, and I felt strongly that something would have to be done on a Governmental level to record the past before it was lost completely.

My discussion of this with Miss Reeves as well as with many other members of our public, interested her in the problem. She was searching for a project to absorb a great many artists, considered this idea as a basis for such a program, asked me to describe my idea and make a plan for it, arranged for me to see her supervisors – and thus, the *Index* was on its way.

Sincerely,

Romana Javitz
Superintendent
Picture Collection

RJ/nr enc

April 29, 1949
Enclosures for letter to Mr. Holger Cahill

Enclosure I:

July 11, 1935, Mr. Kaufman and Mr. Tranum came to the Picture Collection and asked me to describe the project as I visualized it, particularly from the point of view of the need for such an index. After the discussion, which they had hoped would be sufficient to clarify the general concept, I received this letter dated July 11, 1935 from Mr. Kaufman.

Enclosure II:

Project writeup for an Index of American Design prepared by Romana Javitz between July 11, 1935 and July 25, 1935 and presented to Mr. Carl K. Tranum. (see below)

Enclosure III:

An acknowledgement of Enclosure II in letter from Mr. Kaufman dated July 25, 1935.

Enclosure IV:

In August 1935, Mrs. Pollak and Mrs. McMahon urged me to help them obtain library sponsorship of the project. Because of the conservative attitude of the Library about the WPA and other Governmental projects, I felt that it would be more effective to have the request come from the project than from a library staff member. You will notice that Mrs. Pollak in writing to Dr. Lydenberg enclosed my outline for the Index. Dr. Lydenberg then called a conference of division chiefs and the consensus of opinion was that the trustees would never agree to such sponsorship. Here Dr. Lydenberg replies to Mrs. Pollak.

Enclosure V:

Letter dated April 13, 1936 – signed by Mr. Charles O. Cornelius – asking me to serve on the Advisory Board. Quote from letter – "I understand that you are in a certain way the mother of the project."

Enclosure VI:

April 20, 1936 – then there was a great flurry of requests from the people on the project – particularly from Miss Phyllis C. Scott – to give them the historical precedent for Government subsidies in the field of recording folk customs. In my original writeup I had mentioned a few casually. Now – I was asked to elaborate the information and if possible, arrange for the Library to lend the publications so that they could be used as a talking point with the Government for the support of the index project.

Enclosure VII:

Much later in the Winter of that year (1936), the Art Project staff was still trying to show the extent to which foreign Governments subsidized such publications. You will note that Miss Scott mentions the fact that in the preliminary descriptions of the project "great European publications" were mentioned.

Enclosure VIII:

From the printed annual report of the New York Public Library for 1933:

"Although as usual the roots of the requests were in the news item and the current fad, an analysis of the year's work with the public shows a marked shift towards concentration on the American scene. In former years, designers asked for foreign sources and old period designs. To-day, the American artist finds his own background one of flowing richness hardly tapped as yet. Scenes of early American historical events, early views of American cities, the beginnings of the great industries, every graphic element of the natural resources, Ohio flatboats, Charleston balustrades, corncribs, cowboys, gold mining, cotton, the "Don't tread on me" flag, filling stations, samplers, and silos – were used as a basis for fresh design.

"Numerous public projects assigned to artists the problem of representing the American scene pictorially. In the research for factual basis for the mural, illustration, or miniature model, artists discovered the glamour and robust variety of American history. The privilege of borrowing pictures and taking them where work was being done, brought the resources of the Library into direct contact with the created design. A well-known American artist now painting a P.W.A. mural, commenting on the Picture Collection, stated that its development and growth were of importance to him because the form of his conceptions was often fixed by the kind of material available in its files."

Enclosure IX:

From the printed annual report of the New York Public Library for 1934:

"In 1934 were lent 667,967 pictures. This represents a 42.7 per cent increase over the 1933 circulation (467,897).

"The many artists employed under the Public Works of Art Project to produce designs for the decoration of public buildings have turned to the library for the needed factual data. These murals demanded research, often requiring the assignment of a research worker for each dozen artists. This research served to introduce the possibilities in the use of the Picture Collection to a large group of artists not previously familiar with its resources."

"The registration records indicate a very perceptible change in the public. There is today a greater use of the collection by free-lance designers and the "gallery" painter and sculptor than, as formerly, by the commercial art agencies."

Enclosure X:

From the printed annual report of the New York Public Library for 1936:

"Several governmental projects involving the handling or organization of pictures as document, turned to the experience of this collection as basis for their own guidance. The staff of the Visual Education Project of the Board of Education studied our methods of selection, classification, storage, mounting, etc., before embarking on the organization of their own visual aid service. The photographic section of the Resettlement Administration took into consideration our experience with a general public's picture needs when it attempted to set up criteria for documentary pictures. Likewise, the American Index of Design organized its files of pictorial data on precedents established within this collection."

Addendum

Proposal for an *Index of American Design* as submitted and accepted. July 1935

U.S. Works Progress Administration

Project:

To make an historical, pictorial record of the daily life of the American people.

Form:

This record to take the form of a series of volumes of illustrated plates in historical sequence and accompanied by text.

Scope:

To include all the pictorial aspects, from Colonial times to the present day, of the costumes, household arts, (ceramics, cooking utensils, textiles, toys) shops and trades, and interiors of dwellings.

Style:

Plates in color to show the costume, the object, or the interior a used. Wherever essential or helpful, patterns and scale drawings will be added to make the presentation complete and vivid. Faithful facsimile rendering of the materials used, e.g., fabrics and wallpapers.

Need:

There is today no single coordinated source for data on this important phase of American culture. This lack deprives American artists, designers, manufacturers, teachers, and scholars of the impetus to be derived from familiarity and contact with the roots of a national tradition.

Use:

This re-creation of America's past will be a source of inspiration and encouragement to the American of today. He will discover the richness of his national tradition and reshape his work aware of this heritage. A record will have been made of American culture which will be of inestimable value to teaching, sociological research, play, and film production, the fine arts and all branches of industrial designing. It will have permanent cultural, educational and industrial importance. In technical schools, these publications will become research laboratories for discovering new designs based or projected on the American tradition.

Precedent:

European countries have long realized the importance of placing at the disposal of their designers the full picture of their national or folk arts. They have published thorough well illustrated books on the costumes and customs of their nations. Foundation in their national culture has added a rich individuality and national flavor to the designs of the European artist. This quality has tempted the American manufacturer to the European markets and has resulted in the complete neglect of the American designer. American design talent has been slighted and the consumer public fed designs in the European tradition.

Sponsorship:

Governmental sponsorship of the recording of documentary facts has produced works of rare beauty, both here and abroad. Good local examples are the volumes on "Wild Flowers of New York," prepared by the University of the State of New York, and the Annual Reports of the Forest, Fish and Game Commission of the State of New York. Governmental sponsorship assures a rigorous standard of selection, based toward a complete record of fact. It avoids influence by such commercial considerations as fad, fashion or public taste.

Organization:

This project culminates in selection and editing. Expenses of equipment and supplies are far outstripped by the numbers of workers to be employed. The project will depend overwhelmingly on personnel; economic utilization of appropriations and successful projection will depend on the expertness and high caliber of the administrative personnel assigned or selected to originate the work.

Scheme of Work:

Starting with COSTUME, the earliest century will be completely recorded. When the second century is undertaken, work can start on the earliest century of the next phase: DWELLING INTERIORS. Local material will have been exhausted with the completion of each of the above described units. With this finished work as guide, the project can branch out to other cities until the sources of the entire nation have been tapped to make this record embrace both regional and historical elements. One can readily see from the extensive scope of the subject that the size of the project is conditional only by the number of workers assigned.

Work Schedule:

Work to be done: Field work, research, descriptions, reading, collating, bibliographica, indexing, cataloguing, typing, correspondence, photographing, pattern-making, drawings, drafting, coordinating, selecting, editing.

Workers needed: Editorial assistants, research workers, writers, bibliographers, cataloguers, clerks, typists, photographers, pattern-makers, architectural draftsmen, painters, art directors.

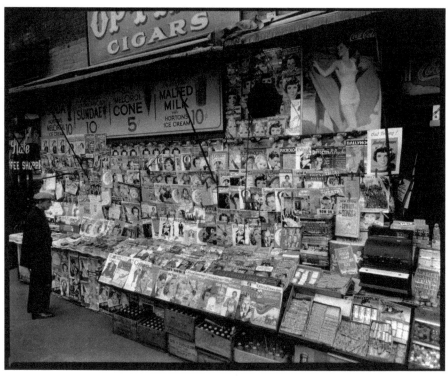

Newsstand, 32nd Street and Third Avenue, Manhattan. 1935. Berenice Abbott.

Chapter Four

The Organization of Pictures as Documents[5]

T
he organization of still pictures as documents in a library cannot prove effective and fruitful unless it is founded upon a clear understanding of some of the basic characteristics of pictorial images. There is a lack of assembled information on the subject content of pictures, its uses and function. There is no integrated presentation of this pictorial impact on our culture except in its art phases. The history of pictures as documents, the dissemination of pictures through printing, their effects, their intrinsic limitations and their potentialities, have not received comprehensive study. Detailed consideration has been given mainly to the place of pictures in art, as illustrations in books, and as part of the development of methods of printing.

There are two classes of pictorial material: one, the original drawing, sculpture, painting, engraving and photograph; and two, any printed copy or facsimile of the original rendering or production. The subject of this study is the documentary function of pictures and for the most part we are concerned solely with copies, that is, pictures in print. These are the most frequent and abundant source of pictorial documents. There are two separate categories of printed pictures. One must distinguish between original prints and pictures that are printed copies of the original artworks.

Prints are individual items of creative production, pictures in which the artist intended to realize his purpose by producing a printed impression from his original drawing on metal, wood, and stone or from his record on film and glass negatives. The original print is the proof made by the artist from the substance on which he placed his drawing or impression. This holds as true for the photographer as it does for the etcher, engraver and lithographer. As in any of the other graphic arts processes, selection, design, and careful planning are required to produce photographic fine prints. Prints are original works of art and they are made primarily to express an art experience; not to clarify and illustrate texts. In this analysis of documentary pictures we will concern ourselves with the printed copies of such prints and not

5 *The Organization of Pictures as Documents* n.d. TMS. 1941-43. 75 pp. Picture Collection records, Box 8, Folder 3. Manuscripts and Archives Division, The New York Public Library Archives.

with the artist's original.

The usual terminology to indicate this difference is prints for the originals and illustrations for all printed copies of pictures. When pictures are being considered from the point of view of their subject content it is better to employ the term printed pictures instead of illustrations.

Printed pictures include the great mass of pictures in our books, magazines and newspapers. These re-record the appearance of the original artwork, reproduce photographs taken from life, and photographs in the graphic and plastic media. The printed picture shows the superficial aspects of the original and, through the new methods of reproduction, can achieve a high degree of faithful facsimile. However, only the original has a full reality of texture and color. The third dimensional quality in the artist's handling of the original medium is lost when transposed to the flat surface of a printed page. Printed pictures are products of a highly skilled manipulation of technical processes and are not themselves within the province of the fine arts.

All types of printed pictures may act as a temporary substitute for the study of original artwork or for the original in life. When used for their subject content, they serve as documents. Any picture may be employed in one or all of these ways.

Since the introduction of the camera for fixing pictorial images and for making copies of them, the entire visual world of man, and the pictorial expression of past centuries have been recorded in print. Through the improved methods of printing, the half-tone screen, the high-speed camera and reproduction of color, this pictorial material has reached an enormously wide and relatively cheap mass distribution. While there is extensive writing on the power of the printed word, there is proportionally little on the power and scope of the appeal of the printed image. Its revolutionizing effects on taste and education receive little attention.

It is difficult to realize that, before the introduction of lithography and photography in the printing of pictures, the external aspects of the world were known to the mases of the people only through direct visual experience from life. Acquaintance with other parts and peoples depended upon travel or reading and hearing word-descriptions or seeing imaginative renderings of an artist's impression. To the common people, the appearances of their grandparents, their ancestors, their rulers and the great personalities of their day were unknown except through verbal descriptions; most people had no idea of their own appearance as children or in their earlier years. In the first days of book illustrations, likenesses drawn from life were copies on wood blocks and used indiscriminately over and over again in succeeding pub-

lications as portraits of different personalities. It was common to find a drawing after and ancient bust of Caesar printed as a portrait of Cicero or of some later man of letters or action.

Before the discovery of the camera [one hundred years ago] people were not familiar with the works of art of the past unless they had access to the originals in the homes of the aristocracy, in places of worship, or through drawings or reproductions made after crude copies of the original. With the faithful eye of the camera focused on works of art and the introduction of photo-mechanical methods of reproducing pictures, for the first time a record of the known history of art was fixed in pictures. Through these combined processes, there has been a steady infiltration of pictures through our books, magazines and the newspapers.

Previously, artists and students of art had meagre and indirect acquaintance with the art of other ages. Students and scholars in other professions and arts could communicate with the great minds of the past and derive a full measure of familiarity with their ideas and specific knowledge, by studying and reading their books and written records in the language of the original and in translation. But artists could not study the works of their forerunners through words alone. Copies were made with the stumbling and not dependable skill of copyists. It was impossible for the artist to visualize the original works of art when he read a description in words. In each generation the artist was compelled to learn methods by apprenticeship. Usually the artist was familiar only with the work of his teacher and of his contemporaries or with the local art, the decorations in churches and public buildings.

Since the camera, artists have grasped a fuller understanding of the continuity of the art impulse and the persistence of the basic principles and function of art in all societies. Instead of slavishly copying the work of his imitation masters, the artist could now study in close pictorial detail the currents of the past of art, and the influences that had contributed to the formation of the styles of the day. This was made possible through the cheap and profuse availability of printed photographic reproductions. "An interesting historical observation is that the photographic reproductions of El Greco at his best, taught Cezanne the power of expression that lay in extreme distortion." (1)

Laocoön. oil on canvas, c. 1610/1614.
El Greco. Courtesy National Gallery of Art, Washington.

The Bathers (Small Plate). colored lithograph, 1897. Paul Cézanne.
Courtesy National Gallery of Art, Washington.

Until the introduction of lithography and photography in printing, copies of art on the printed page were dependent upon the skill and accuracy of the copyist and engraver. Only the camera brought the full achievement of copy faithful in appearance to the original. It seemed at long last possible to reproduce the appearance of an artist's rendering, and the image of nature fixed by the camera, without submitting it to distortion by the freehand copyists. "Though the older methods of engraving and printing achieved masterpieces of craftsmanship in the field of reproduction they more often especially in later times travestied the originals they set out to copy; if the hand techniques are now very much alive this is due in a large measure to the photographic processes." (2)

In the light of the great profusion of illustrations in our modern press, it is with a glimpse at a loss of sense of wonder that we read in an 1839 London publication "the facsimile of the photographic drawing in our last number has produced a much greater sensation than we had anticipated." (3) Today, we take our illustrations for granted. We can hardly visualize the effect of the opening of the floodgates of photography. For the first time the image of the living stopped and fixed forever on a surface through printing was liberated to reach all of mankind throughout time. Fixed, yet from it innumerable copies could be printed. "Whatever masterpiece the photographer may achieve by skill, luck, or cunning this morning, the printers are equipped to share with millions of people this afternoon." (4)

It was almost half a century later before the critics, worried whether photography was art or craft, stopped long enough to start appraising the product of the camera on the basis of its utilitarian function. Not until the third decade of this century, was the term documentary established to designate the photograph made primarily for the purposes of factual recording. Nevertheless, photography is still plagued with unending controversy that hovers over all art production. Is the result, decoration or illustration? With the rapid succession of flash bulb, range finder, improved exposure control, miniature camera, the fast lens, and fine grain film, and other technical developments, the photograph has hit a mature purposeful stride. The skill and analysis required for the production of a clear pictorial statement of fact are now recognized. We speak of the documentary photograph with full awareness and respect for its function.

Booker T. Washington. nd. Yampolsky Collection.

Although most pictorial productions are regarded as art, not all of them were made for aesthetic ends. Paintings, drawings, sculpture and photographs have been made solely for the recording of facts, or to elucidate ideas, and to document events. Many were made to teach, preach, admonish, satirize, ridicule and influence. "Circulation of these prints (woodcuts) had both a commercial and a religious character. It met the demand of the faithful who wanted religious pictures. They served as a piece of propaganda for the Faith. They were hung on the walls of the home. Pilgrims looked on these woodcuts as talismans, sewing them up in their garments. The prints protected the traveler against accidents and sickness, and he pasted them inside his wood or iron chest." (5) A survey of all of the pictures of all times would

show that, in addition to their capacity for producing aesthetic satisfaction, they have served mankind in many other ways.

There is no realistic acceptance of the existence of the subject matter in works of art. If an artwork fails to reach some arbitrary, contemporary standard of acceptance as art, it is relegated to neglect as art, and its role as social document, or factual delineation of the appearance of man and his customs, is forgotten or left to the specialist, each in his own field. Medical men, for instance, have referred to early engravings in order to visualize the medieval hospital and the effects of disease during the Middle Ages. By studying the wall paintings of the period, it was found that the ancient Egyptians suffered from infantile paralysis. Descriptions in words may have left some doubt about the identity of the disease but the representations of crippled persons in the Egyptian paintings revealed its nature.

There is still a snobbish impatience with the practical aspects of pictures. Art critics and many artists have little tolerance for the public's interest in the subject appeal of most pictorial productions. Before the appearance and success of the tabloid picture paper and the candid camera, an English critic wrote "Pictures are more often looked at from the point of view of the subject than from any other. It is so frequently the first consideration to enter the mind of the spectator that it is idle to regard it as of little or no consequence." (6)

The production of art is quantitatively enormous. It does not seem sensible to insist that the only function of pictorial representation is to evoke an aesthetic reaction. This would be comparable with maintaining that our customs and our language are not material for the anthropologist but are subjects only for the poet and musician. In addition to the aesthetic quality of a work of art, there may be in its content, a record of an ephemeral fact of social importance, some detail of observation that may recreate the appearance of things that have passed into the forgotten history of another society.

We know that all times in man's known history, he has used pictorial symbols as a mode of communication. Such representations have often been made for no other than a utilitarian end. Without any certainty about its function, without knowing whether or not it was made as a record of factual notation or as an expression of beauty, we accept most of the original ancient works of art as art and look to them for aesthetic satisfaction. But whether made for artistic ends or not, any picture may at some time or to someone appear as art. Of ancient Mexican picture-writing, Franz Boas wrote "The importance of communicating ideas outweighs the artistic

interest." (7) To the modern painter this obscure writing is a combination of form and color, and although he cannot read the meaning of the figures, he enjoys the entire sight for its beauty and emotional expression.

Pictures have always been used to tell a story, to record man's experience, his gods, his cruelties, his playfulness, his pets, customs, inventions, superstitions, his knowledge of nature, his rulers, his amusements and his ideals. Through the pictorial records man leaves, succeeding generations can envisage the intimate aspects of living in other times. Pictures usually made use of familiar subjects and still today we speak of that which is awe-inspiring as something which defies representation in art. The belief is still current that only the known can be depicted, and if unknown that it should be represented in the guise of familiar forms. The Early Christians frequently represented Jesus but rarely God, and Jesus appears as a man. And so, in the manner of his presentation of the activities and of the beliefs of his day, the artist cannot escape the period and the culture from which his work originated. Consciously or unconsciously the work of all artists documents their times.

We all have a continuous visual experience. For most of us only a small part of that experience is bound up with pleasure and aesthetic satisfaction. We have a factual curiosity in looking at the world and in looking at pictures. There is no validity in the tremendous prejudice against the enjoyment of pictures for their subject matter. For a long time we have held to the idea that art is at its best when functioning as art; this is true and can remain a verity, but we should not maintain that this function is the only function of art. We are so afraid of losing our appreciation of Art, that we are timid and neglectful about searching pictures for their objective content. We receive no training in the use of pictures as a form of communication of ideas.

The continued arbitrary division between so-called good and bad art, has had a stultifying effect on our acceptance of all pictures as fit subjects for study and use. It has bred an impatient, narrow attitude towards all of the great body of pictures produced for utilitarian purposes. From the moment of their introduction, photographs were scorned because they were realistic, made by the aid of a mechanical eye and because they could be used as illustrations. It is still usual to disparage a work of art by speaking of it as "illustration".

In his survey of the graphic arts, Sir Philip Hamerton defended the picture made as a record of observed facts. He believed that there should be proper appreciation of this type of artwork, the drawing made to give information about "matters of fact surpassing our own knowledge". We should accept and study illustrations such

as those of architecture and of anatomy; judge them not by standards we apply to art, but on the basis of the faithfulness of the renderings, the precision and care of the execution and on their straightforward exposition of the factual aspects of the subject.

Science depends upon the illustrations in textbooks and photographic records to carry over to each succeeding wave of scholars the visible facts of proportion, of comparative relationships and cumulative observations of nature by scientists and artists in each period. The Leewoenhoek drawings of microscopic life may have no value to the print collector or the art dealer, but for the spread of knowledge in his day, for the record of the steps preceding later discoveries, these drawings are exceedingly useful and important documents.

Printed pictures include all aspects of visual experience. The scope of the word picture has been vastly enlarged by the development of the projection machine, the great ally of the camera. Today pictures include both the moving and the still photograph. They include all of the pictures of historical and modern art and all of the great and growing mass of illustrations pouring out of our printing presses to appear in our publications. We are familiar with the likeness of prehistoric percussion players from photographs of Chinese tomb figures and we have seen the details of instrumental playing by each member in a modern symphony orchestra by watching slow motion pictures of its performance.

Pictures in print embrace the full gamut of the visual experience of man, from the gesture in chalk on a pre-historic cave to the stroboscopic analysis of a drumbeat. None of these is necessarily an expression of an aesthetic experience. "The mere attempt to represent something perhaps to communicate an idea graphically cannot be claimed to be an art". (8)

The accuracy of the camera and the ease which the amateur could produce a semblance of reality helped break down some of the prejudices against the representational character of pictures. It seemed a simple process now to obtain "realism" and anyone with a camera and a free Sunday afternoon and some sunlight could perpetuate the image of his offspring or of his dog. Immediately magazines broke out into an epidemic of articles assuring everyone and the artists that the product of the camera could not be art since it was achieved mechanically and mirrored nature too automatically.

That much of the world's art production has been made for the same purpose as the photographs were made, was overlooked. Our museums are lined with paintings

and sculpture, some of which are no less fact-recording and utilitarian in purpose than the common run of news photographs. Although we feel we are committing a desecration, many of us have realized along with the lay visitor to the museums and art galleries that most of the art on the exhibition walls has a higher value as a pictorial record of the artist's time than as art. Most art productions inescapably render the costumes and social usages of their time and remain sources for information on the culture of the period. Of course, caution should be exercised in the use of any artwork as document, since all such productions presuppose selection, elimination and distortion according to the point of view of the artist.

Walking in the Snow. late 1820s.
Lithograph by Ducôté, A. (fl. 1829-1832). Illustration by Hervieu, Auguste.

The drawings and paintings of other centuries should not be accepted as completely faithful records of the subject presented. But they are interpretations conditioned by the beliefs, customs and visual experience of the day. They are not to be compared for historical verity with the camera record made on the spot. They are invariably useful as an index to a period, its costumes and customs, but there must be reasonable care in using them since, often they are reconstructed from many experiences of the artist including his familiarity with representations of other periods, with fantasy and his own exaggerations. But once the researcher has learned how to bring out of earlier artworks the facts of the period which produced them, he will find them a graphic and enlightening window into the past. (9)

Changes in taste are unpredictable and that which is rated as art in one decade is hailed as craft in the following years. Artists now find inspiration and stimulation of an aesthetic kind in the illustrations and cartoons of the 19th century. Unequivocally these may be called utilitarian and commercial works of art. Daumier, as a cartoonist and an illustrator, led other artists as an influence on the painters of the third decade of the 20th century. El Greco, a god of the modern artist, is barely mentioned in general histories of art until after the World War I; he was considered a minor artist and the style of his paintings was not accepted as art until taste changed. The work of El Greco had a religious and decorative use for centuries, today it is Art.

We must start with a clear comprehension of the role of art and the role of documentary representation. The casual visitor to our museum of art has been exposed most frequently to the black and the white halftone on the news page. Trained by the tabloid's editing of those pictures, he looks at all pictures as technical efforts to represent the world he sees and reads about. The atmosphere of the museum warns him that within its walls pictures are not displayed to entertain or to shock him; the attractions of the exhibitions are blunted and rounded off in keeping with the hush of the institution.

If the gallery-visitor has seen a photograph of a work of art reproduced on the page of his newspaper, he is better prepared to cut through the fog of museum attitude and may reach the original with a sincere intention of studying it. He will feel free to discount the subject interest because he has full opportunity to see that aspect of it in his newspaper. This is one of the ways in which the printed copy of a work of art may serve as an introduction to the study and appreciation of the original for its aesthetic qualities.

Through the medium of printing we have a profusion of copies of both artworks

and pictorial documents. The cheapness and commonness of these copies make it possible for us to have many duplicates. Without paying any attention to the relation of any of these to the art function of the artist's rendering, we can look upon all printed pictures as useful illustrations. The ends to which these copies may be put will not affect the original nor its appraisal as a work of art. When copies of pictures were first made available for quantity publication, through lithography, it was commonly believed that no one would value a print "which has been disseminated through all the cafes of France in the pages of *L'Illustration*" (10) Today we look with more respect at a work of art if we have seen it widely reproduced on the printed page.

By these copies, painting, sculpture, print and photograph in addition to their powers as works of art, become a forceful medium for the communication of ideas, thoughts and knowledge. We can learn to use them in the study of science, art, ethnology and history. In addition to its aesthetic possibilities we must learn to make practical use of this great reservoir of information. Just as we accept both the journalistic and the literary function of words, we should learn to accept journalism, research and art as functions of pictures.

Through photography and printing, pictures of the accumulated cultural heritage of man were brought to the masses. More than any previous generation, the people could gain a clearer visualization of the world of past and present, and a broader view of the relation of man to nature throughout history. For the first time, all the people could see with their own eyes, people of other times and far places. The printed picture has impressed the life of all of us, changed our tastes, affected our ideals, and enriched our memories; it has invested the whole population with an awareness of color and form.

Whereas the speech and language of many peoples are frequently unintelligible to us, their pictures communicate to us visual experiences similar to our own. A prehistoric drawing of a resting bison thousands of years later gives us a sense of swiftness and heavy flesh; time is no barrier here to the communication of the prehistoric artist's impression of this animal. Language separates the people of different regions today, and each generation from those succeeding. Meanings in the same language change and ideas appear differently expressed in the words of another century. While the culture may be vastly different, and the picture may have entirely different meanings to each generation, pictures remain intelligible to the illiterate, to the young and to the mature. A drawing of a hippopotamus is as fully enjoyed by a New York City child as it was in ancient Egypt, although for the

modern the original story and religious aspects may be entirely lost.

Philip Hofer writing on the place of illustrations in the 17th century travel books reveals this usefulness of pictures in crossing gaps of time and space: "Here one could not explain to the reader in words, things and sights which he had never seen. Pictures were necessary, and once again demonstrated their fundamental value in transmitting information accurately." (11) This description should be compared with an editorial in a 1941 issue of the Saturday Review of Literature which commented upon the paucity of descriptive passages in our contemporary literature, and the dependence of the modern writer on the vividness of his readers' picture experience. "Far better than any words of the writer could, the screen has made familiar and vivid foreign scenes and distant persons and communities." (12)

The camera has brought to us an experience that is almost real, with the appearance of other parts of the world, and the writer today finds photographs serve instead of descriptive passages; by editing these, he can make the reader look at them from his point of view. In earlier books, familiarity was achieved by word pictures, and the illustrations helped to give concrete form to the author's words. Today the public can see outward likenesses through photographs, but amplification is needed on those phases of a subject which are beyond visibility.

When we have studied the past as it unrolls for us intimately in pictures, we may approach our own times with keener perception. Acquaintance with the past, through its recorded aspects, conditions and broadens our experience of the present. Such acquaintance with the past gives us a sense of our relation to universal elements, taking us beyond the currency of events.

There is an interrelationship between the use of a picture as art and as document. The term documentary does not outlaw the aesthetic qualities or artistic performance of a picture. When a painting by Brueghel is being searched for representations of the type of hobby horse used in 16th century Europe, the painting is serving as a documentary source. Such use does not detract from the value of the painting as a work of art. There is no scientific frontier that can set the boundary between the beginning of art and the ending of documentation. When we use the term documentary, we describe either the purpose of the artist or the end for which the picture is used.

All pictures may serve a variety of functions and still maintain their artistic integrity. Good pictures have illustrated books to make the text take on a clearer meaning, to stimulate the imagination, and reconstruct the experiences and visions

of the author into visible forms. No one attempts to depreciate the artistic quality of Blake's engravings because of their service as illustrations to his poetry. They are art and they are illustrations of his verbal imagery. The painstaking and stolid drawings of Bosse and the sly humor of Grandeville serve as documents of the social structure of the day as works of aesthetic caliber. In 1500 B.C., the Cretan artist who painted a mural in which a blue monkey stops to pick a flower, achieved a record of beauty on the wall. He drew that flower with such faithfulness and naturalism that the modern researcher can identify it as the saffron crocus, whose pharmaceutical uses may have been known in those ancient times.

We have a suggestion of this dual function of art in the emphasis on subject analysis in the succeeding catalogues of prints and drawings in the British Museum. In 1911, A.M. Hind, Curator of Prints at the British Museum, commented on the interest in the subject matter of art "But considering the variety of ends, besides purely artistic to which a great collection such as the British Museum is put, nothing could of course be more desirable than a completely comprehensive subject index." (13)

Both types of approach to pictures are needed, that of the art lover and that of the social historian and scientist. The drawings of Daumier inspire aesthetic satisfaction and too, they have potency as political commentary; as human documents they are direct and simple in their message and can arouse masses of people. They are masterpieces of art, but we cannot remain unmoved by their subject content, which graphically depicts with bitterness and touching (humanity of) the little people of that time, in all of the patterns of their middle-class daily round.

The news photographer does his skilled work in the immediacy of a matter of fact news-gathering assignment, without an eye for posterity or for the artistic quality of his result. There have been many draftsman, painters and sculptors who worked for a similar fact-recording end. There are many photographs made in the line of news-gathering duty that may evoke an art experience in the onlooker. The purpose for which a picture was made does not control nor limit the number of uses to which the picture may be put. This applies to a moving picture, a news photograph or a drawing from life. Any one of these may serve to excite pleasure, entertain, influence, decorate and document. Stills from a film or photographs of paintings may serve as pictorial records. All pictures are potentially useful as minute records of natural truth and observations of life.

"Boston Police Break Up Radical Rally. Mary Donovan, recording secretary of the Sacco-Vanzetti Committee, showing signs which caused police of Boston, Mass., to break up a monster Sacco-Vanzetti rally on the Boston Common. Several of the Communist leaders were placed under arrest." n.d. (ca. 1927) ACME news photograph. Yampolsky Collection

Often a magazine cover showing a pretty girl, or a clipping of a runner from a rotogravure section of a newspaper are tacked on a wall. The occupants of the room enjoy these pictures and experience them as art. A more sophisticated person may come in and inquire what the clippings represent, asking if the photograph is a picture of Jesse Owens running. Only the facts in the picture interest this onlooker and for him the picture is merely a record of a sport's hero.

The term "documentary" when applied to a printed picture indicates that the picture is being used as a source from which we may ascertain facts. When pictures are being looked at as art, or for stimulation, or entertainment, the content of fact or their social implications are of secondary consideration. Films made for documentary ends may function as an art form and as a factual source. Although fantastic, unreal or distorted in locale, period and story, a film may function as documentary material. It may be used for the study of changing standards in attitudes towards

social, political and economic matters, and of changing tastes in entertainment, lovemaking, social usages and culture patterns.

Commercial drawings made for purposes of advertising are also material for use as documents. All types of pictures influence our lives; the drawing that illustrates a joke in a magazine of humor and a drawing that sells corsets, both document the customs of the day. The civilization of the ancients can be visualized through a study of pictures of their clothes and of their gods.

Commercial art is isolated from the stream of art production. Since it is made for ephemeral purposes, it is usually a good indication of the swift changes in taste and fashion. These drawings as a rule are dependent upon the copy in the advertisement. The media of illustrations in advertising are always selected to fit the requirements of the printing process by which the final reproduction is to be done. In a similar way all illustrations on pages of our contemporary magazines are limited by the method of reproduction that will be used, by the contents of the story to be illustrated, and by the audience to which the magazine is addressed.

Despite the insistence on the commercial aspects of their use these pictures maintain a high standard of representational rendering. When their immediate usefulness in advertising and illustration is over, they are important records of our daily life and should be considered as documents of our times.

None of us fully comprehends the extent to which our ideas and attitudes have been nourished by our experience with pictures. The gargantuan output of our presses working in conjunction with the camera impinges on all of our activities with its influence. The flash news photograph speeds across the wires and reaches us in our morning newspaper; we recognize the same photograph edited, analyzed and re-issues in the brown tints of the Sunday rotogravure; the newsreel filled with concentrated, staccato sound of commentary shows the same picture expanded into continuity; the designs in our wall decorations, our fashions and in the recruiting posters may all center around the use of the same photograph.

Above all factors, it is through attendance at moving picture projections that our observation has become experienced and alert. The close-up, the photographic emphasis on texture and form, the sight of the world from points of view far removed from the ordinary human experience, the detail of physical characteristics, the appearance of places strange to life and strange to fiction, the intimacy of entering into the homes, the lives and the emotions of other people – all these have become the visual experience common to all the people. The impact of seeing the lives of

others dramatized and pictorialized reaches the aged and the young, the literate and the illiterate.

We now accept without any wonder, familiarity with the appearance of people and places in distant parts of the world; with a matter of fact attitude, our feelings are responsive to the gamut of human emotions spread out before us in more than human size images. We have learned to watch and enjoy the sight of dramatized gesture and movement. Undoubtedly, by now, our imaginations are keyed up to react to an increasing intake of the coordinated continuity that the filmed image requires.

The face of a dictator, of an actress and of an animated mouse is as familiar to us, as the faces of those nearest kin were to our forefathers. In the cold definition of a newsreel close-up we discern the teeth, the skin, the ears, and gesticulations of a gangster and a mayor. The peculiarities of the gait of Goering and of Garbo have become part of our graphic memories. Gestures and movements, such as the artists throughout history tried to preserve on a surface with paint and line, are now captured images through photography, are within the reach of everyone through printing and through projection of time sequences.

The flight of birds that our eyes have never beheld in life, is now thoroughly familiar to us through photographs taken in all parts of the world. The shapes of distant things and places that we have looked at in films and on a newspaper page, are often clearer in our memories than objects and places we pass each day. Unless we are creative, our powers of observation are not as developed and keen as those of the photographer and artist. Their productions are the result of preliminary analysis, interpretation, selection. Simplification and coordination. Such pictures provide us with a synthesis by which we see forms and forces in nature in their relation to man.

We realize that there is less reading, that the radio, the moving picture, and the still photographic picture in magazine and newspaper have cut down dependence on words alone as a medium for the communication of ideas. The reiteration of words through the radio and the oral descriptions of life foreign to our experiences, have created in the public a restlessness for visualization. If the people have not seen the subject, reading will not help them to actualize the form of that which they have heard described over the radio. They want to see a concrete representation. We all know how hard it is to discern the actual shape of something or person unless we are looking at them.

The moving picture can show many aspects of a subject and present it in a semblance of living action; as yet this is done without a three-dimensional life likeness

and without the color of life. The film and the still photograph can show all of the external aspects of life with as much faithfulness as a two-dimensional surface allows. With all of its power to carry us back in time, and its imaginative freedom and scope, the moving picture does not supply satisfaction through graphic means only. It is difficult to give close attention to pictorial detail except when it is relative to the story and plot, because the film has a continuity in action and one image follows another in such swift time sequence. Comparative relationships between one image and the next cannot be grasped while a film is being projected.

Only a series of still photographs of several views of a subject can be observed for a time sufficiently long to allow for careful study of the separate images and the full subject matter of the pictures. While the film shows the outer aspects of movement in action and with clarity of analysis in slow motion projection, still photographs are better records from which to study the progressive steps in the performance of a movement. Still pictures made on the stroboscopic principle are particularly valuable because in them the progressions in high speed analysis are broken down to the component parts in the articulation of a movement; as individual items, these can be spread out onto one surface from which one may study the entire series simultaneously and leisurely. While watching a film, we are listening to sound and commentary and following the continuity of the unfolding sequences. All these elements contribute to our experience of the film as a whole, but they do divert from a close attention to the pictorial aspects of the film.

Since only one image may be seen at a time while watching a film's projection, the moving picture is not practical and adaptable for prolonged study, comparison of relationships, and thorough observation of detail. The still picture is better for documentary use, except that quantity is essential, and that many sides of the same subject must be included. For the full apprehension of the appearance of a subject it is important to have many views and many aspects for simultaneous observation and comparative study. This necessity for the consideration of more than one aspect at the same time is indicated in the running commentary of a speaker during the showing of a film who describes other phases of the subject while the audience sees only one. It is difficult for us to retain in our memory the form of the image we have just looked at, while we are looking at the next image. We may describe with words those forms that we have just seen delineated, but not with any pictorial accuracy.

The experience of following a moving picture is far from being merely a visual experience. The attention we give to the images moving before our eyes is

conditioned by our absorbed interest in the synchronization of plot, action, and soundtrack. We are too sophisticated to follow the movement of the images and enjoy them for gesture alone.

The influence of the radio has encouraged interest in pictures. With less and less dependence on descriptive words in print, the listener turns to pictures for the many facts he gathered previously from printed texts. Wherever the appearance and the external likeness is needed, only pictures present the reality of shape, color and texture, the visualization of social conditions and historical events. "Editors have come to see news photographs, not merely as a means of supplementing stories with illustrative ornament but, further, for what they are: the most precise, economical, and effective reporting of human events that there is." (14)

Before we are ready to plan the organization of documentary pictures, we must understand the interrelationship between pictures and words. There is no knowledge inherent in pictures. Pictures in themselves have little explanation of the facts they image. The information we need in order to understand the subject of a picture when it is functioning outside of art, may be found in a caption, in an accompanying text or in our past knowledge and experience. The habit like performance of most visitors to museums and art galleries, is familiar to us. They squint vaguely at the art works on display, hardly seeing them; then they rush over to read the title of the painting and the name of the artist. They look for some preliminary enlightenment from the name on the label. People rarely look at a painting on a wall or a snapshot on an executive's desk without at once asking what the picture represents. Long training of taste with maturity in art appreciation are needed before the onlooker comes to pictures without seeing the subject matter first.

The range of the effect of a picture on the onlooker is directly enlarged or limited by the contents of its accompanying labels of descriptive texts. The power and scope of any picture is limitless when words are considered in conjunction with it; this holds true for words for they, too, become infinitely more effective when accompanied by illustrations. All pictorial material, except when functioning as art, needs captions and the content of the captions determines and conditions the possible uses of the pictures and the range of their potentiality. For documentary record or for statement of facts, a picture that has no identification is worthless and useless.

When a picture is studied for its content of fact, the external aspect is not enough, its subject must be identified by a specific title. John Dewey discusses the title's relation to the work of art, and asserts that a title is unimportant in the consideration of

works of art. In doing so, he states clearly the type of treatment that helps a work of art function as a document. Titles "identify objects for easy reference... in such treatment the picture in so far ceases to be a picture and becomes an inventory or document as if it were a color photograph taken for historical or geographic purposes or to serve the business of the detective." (15)

As soon as there is a description of the subject matter of the picture, not a critical appraisal but a simple statement of fact, and to it is added the name of the producer, the date of the production, the name of the place where it was made, a picture is sufficiently documented to begin to function as a record. Without an accompanying text or words, it is a record of his knowledge and his living. The power of words and their swift penetration, when amplifying pictures, are experienced by all of us when we see propaganda during a period of mass hysteria. We accept their contents, without looking at the pictures carefully; we respond to the emotional appeal in the glowing, inciting prejudicial legend below. These words are so pungent that it is difficult and hardly possible to disassociate the idea communicated by the caption from the subject matter of the picture. Our visual experience is, in this case, conditioned by the words alone.

Such newspapers as the New York Daily News should be studied by all workers with pictures in order to appraise the use and influence of the printed picture when edited for mass distribution and immediate effect. Picture newspapers from their inception, realized that the meaning of their illustrations would be carried over to the reader by a special technique in the wording of captions. The captions hold the power of directing the reader's reaction and response. To some extent the caption controls the meaning the editor intends to have the reader derive from the picture.

In observing people reading tabloid picture papers, we find that they do not gain full satisfaction of their curiosity by merely looking at the illustrations. The News reader looks at a picture, gives it a cursory glance, then he reads the caption. Then his eyes rush over the page, hardly noticing how powerful the image is, how sordid or scandalous its subject. He continues down the page to find that small box reading "story on page 6". Then returns to the story, reads it and, in the light of the reporter's point of view, the reader turns back to look at the picture, searching for details to fill out the story. This is all done somewhat automatically, it is a habitual procedure. Sometimes one can see a whole row of subway travelers reading the newspaper in this manner.

The screaming headline, the scare word in super bold type, that impel one to

buy a paper, have more power of attraction than the featured photograph which, without words explaining its content, would be a disappointingly concrete, static representation of the dark, limitless idea of horror that was expressed in the vague hint of the headline language. The image will take on more of the meaning of the title, after the details of the story are read and understood and the eyes have returned to observe it fully for their implications of the story it illustrated.

In a library where the public looks at printed pictures of all sorts, such as moving picture stills, tin can labels, color prints after old masters and newspaper clippings, there is good opportunity for observing the reactions of people to pictorial representations that are divorced from any art interest. People look at pictures tirelessly, sometimes wandering from item to item for hours. When the captions below have some continuity of idea or are strongly edited to point out the relation of the pictures to subjects of current interest and of contemporary controversy, the public studies the words with meticulous completeness and then looks at the pictorial material with greater attention; it is as if they challenged the pictures to visualize the idea expressed in the accompanying words. They enjoy the relationship of the verbal information with what they discern in the pictures.

The same series of pictures may be edited from all sorts of different points of view; in each approach, the captions would be different, the illustrations the same. The display may be captioned "Man's Short Stay on Earth", "Arrivals and Departures", or for a practical purpose "These pictures laid end to end spell the name of a popular brand of cigarette: prize: $1000." Each of the captions would have a different effect of the appearance of the pictures for the onlooker. The contents of these pictures would have a different function with each change of the title that may be used in conjunction with their display.

This interdependence between pictures and words is especially clear when we look at pictures intended to amuse us. The subject matter in a pictorial representation rarely causes laughter. Usually the laughter is provoked by the story below the illustration, or by the words in the balloon issuing from the lips of a comic strip character. A frequent cause of amusement is a title completely incongruous or ridiculous when it is read in combination with looking at the picture. Sometimes the reader is amused because he knows that the image is concrete and the idea in the legend is completely abstract.

Looking into the pages of most magazines of humor, we find the same drawings week after week, with changing legends below them. The public responds to

the idea that the lines of type carry the humor into the situation. Amusement is derived when the reader looking at a picture knows that the appearance or the performance of the subject is impossible or incongruous in life. Animals dressed or behaving as human beings, and situations in which human beings are engaged in fantastic activities are both capable of amusing, because of the element of the reader's superior knowledge, not through the picture itself. Magazine covers such as those of *Collier's* and *The New Yorker* are examples of the paucity of visual ideas that can amuse without the addition of a legend or words. In checking through a year of any of these magazines, we may note how many of the humorous situations require the addition of a sign or other device, such as the date (St. Valentine's Day) in order to register as humor for the public.

During the comedy film, the continuity of action substitutes for the story attached to a still comic picture. Stills from film comedies are disappointing in their ability to arouse laughter. The suspense over the impending action, the inevitable embarrassment of the enduring gesture, keeps the audience in the pace of the film's continuity; with close attention, they are ahead of each image, supplying in their minds the probable development; this all contributes to the effect of humor. Since the printed pictures are static and humor depends so much on knowing what preceded and what followed in a story, and gesture, the comic strip with its continuity of images is a more effective producer of laughter.

All pictorial records, sculpture, painting, moving pictures, and photographs are at the mercy of labels. The power of the label is so strong that it may negate the appearance of a picture. In magazines before World War I, reproductions of French paintings were printed to illustrate articles attacking the Impressionists and other forerunners of the modernist movement. These pictures were labeled with such strongly biased captions that it took intense concentration on the part of the reader to form an opinion of the picture without being completely prejudiced by its caption. Manet's Olympia was reproduced in an art journal of that period with the caption below it reading "degraded, lewd, pornographic daub". Such criticisms appearing within the visual field of the picture tinctured the reader's appraisal of the picture, made it appear to be indecent, and created a prejudice against new forms in paintings that is still actively injuring the efforts of those contemporary artists who are at all experimental or unacademic.

The "Wanted for Murder" placards are common enough for all to recall the type of illustration used to identify the criminal. Because a face is on a police plac-

ard, we immediately see into its likeness our ideas of criminal attributes. If you try changing the words from "Wanted for Murder" to "The People's Choice" the face below, which previously has leered brazenly, now smiles and looks unctuous. If a picture appears in an art journal, then in the New York Times, in a Left-Wing publication and in a school child's notebook, it contains different implications in each appearance merely on the basis of where it is used, and in each instance it will have different captions, interpretations and emphasis.

A picture becomes a useful tool not only because of the elements within the confines of the representation, but on the all-important addition of information in its framework of words; and its source of origin may affect its value. These words divert the onlooker from the facts in the picture; also, they may analyze, censure, extenuate, or explain the content. This hold as true for the moving as for the still picture. During the showing of a newsreel it is the commentator's emphasis that diverts the onlooker so that he seeks out within the picture only the elements that uphold the point of view of the commentator. Unless a printed caption of the picture is read before a scene appears, or unless you hear the words on the sound track, it is impossible to know with certainty whether the scene depicted is an event of yesterday or of last week, whether of truth or fiction, whether the persons shown are criminals, actors, or public officials.

There is nothing inherent in the pictorial image that can give knowledge about the subject except that it gives us the facts of external appearances. We need previous knowledge, familiarity, or a synchronized explanation in order to comprehend in words what we look at. If we are watching pictures of an event, we want to know how, where, and when it happened. Obviously, the usefulness and life of a picture for informational purposes is determined by the amount and accuracy of factual record accompanying it, and the authenticity of its source. This is an essential characteristic of pictures and must be kept in mind when approaching their classification as documents.

For example, if a picture of the interior of a house is identified as a painting by Vermeer in 1665, then every detail of that picture is potentially a source for information, on the usages, standards, and point of view in that decade and place. The knowledge of the source and date of a drawing is helpful in scientific fields also. In a recent study, illustration of early books were analyzed in order to discover whether it was accident or knowledge that led artists to show the activities of mice in their renderings of plagues. To that researcher-author, a study of works of art

and illustrated Bible stories of plagues brought to light an interesting link in the story of the influence of disease carrying animals in times of epidemics. In this article, in a quotation from an earlier writer we read that on the basis of illustrations, "among people two hundred years ago the dominant idea about the plague of the Philistines was the same as that nowadays propagated by such eminent scientists … The plague-smitten rat belongs to the domain of public interest in epidemiology. Works of art add to our historic knowledge in this line." (16)

Lack of recognition on the part of the onlooker may be bridged by the addition of captions. We see the common use of this in propaganda when the facts in a picture are distorted by the addition of titles. The propagandist takes little interest in the facts of a picture since all that he needs for his purposes are the obvious perceptible elements. He adds a completely false caption which is usually so vivid that we are deceived and accept the contents of the lie and neglect to see the contradictory evidence within the picture. The propagandist knows he uses words freely and so controls the effect or reaction he intends to engender. In a recent incident, a photograph of tenement dwellers rescued at a fire was reprinted as "Victims of air raid". The faces of the women showed all the terror of destruction raining down on them into their faces. In fact, these people were seeking their possessions destroyed and had just experienced an escape. That same picture was used to shame a city's administration into improving the local housing conditions.

In 1941, during an air raid alarm, many lives were lost in a Chinese shelter. A dramatic photograph appeared here showing the bodies of men, women and many infants strewn across the exit stairs along which panic, and suffocation had snuffed out their lives. We all recall the familiar heat of the summer pictures of crowded beaches on which city people sprawl in the sun. Unless the reader looks closely at this Chinese tragedy and reads the caption, he will receive the same sensation of relaxation, heaps of bodies, care forgotten that were so frequently see in pictures of Coney Island. The picture of the beach captioned "Death after panic" would horrify us. By the way, the Chinese scene is moving in its content of beauty, the limbs, the arms, the position of the bodies in this arrested movement of flight have a pictorial power which dispels the horror of the facts. Many artists clipped this picture for further study; many of them did not realize or stop to read that the picture recorded Death, they were conscious only of its calm statement of form.

Some experience irrelevant to the subject of an image may condition its appearance. During war times the art productions of an enemy nation arouse a blind

hatred which forbids looking at the pictures and dismisses them entirely on the basis of their racial source. Hamerton tells a personal experience that is an example of the unforeseen effects a picture may have because of some extrinsic factor. While swimming with him in a country pool, a young companion of his drowned. Ever afterwards in art exhibitions or in print, whenever he saw representations of a typical English countryside which included clumps of bushes and a small pond, his mind became blind with a sense of experienced tragedy. No matter what the title of the picture or what the purpose of the artist, Hamerton's mind added the words "my friend is dead in this water."

This unknown element, what is in the public's mind, background and past experience, makes it impossible to control the immediate impact of any picture on all people. A picture probably never has the same meaning for any two onlookers. To a greater degree than with books, in order to understand the subject content of a pictorial likeness, one needs an accompaniment of information, and past experience or familiarity with the subject. Through words we may gain information about a subject, of which we have no knowledge. But an image without words gives us no information, unless we have some previous knowledge of the subject depicted.

The early educational films, so-called, were glorified representations of nature with no more story element than that of a sunset lithograph on a calendar. These were the forerunners of the consciously produced documentary film. All documentary pictures have their fullest influence when information is simultaneously supplied or, as in the case of the cinema, sound and music are composed specifically to carry out the continuity which holds the meaning of the film.

Unless the idea is carried out in combination with sound and sight, or the words of a lecturer during the projection, a film would not reach the audience. It is the script, the underlying continuity of thought and image that carries the audience into the experience the director planned to arouse.

In any of the great documentary films, it is the complete coordination, the entirety of the sequence of image and time, the purposeful script and the conception of the whole that make the film function at all. Without this combination of fused elements, without this synchronization the film would be gesture and movement and little more. Understanding a moving picture depends upon more than the visual elements in the film. As with still pictures, the intent of the producer is emphasized, discovered or distorted by the addition of those elements that carry out the meaning, the idea and the information that the film is planned to give.

When art productions are looked at for stimulation or for aesthetic experience, at those times, they are functioning as art; neither text nor label is needed. Those who go to a work of art for stimulation, find it lucid. If at first they cannot experience the aesthetic satisfaction they came for, they do not expect to find it in extraneous words of information; they come back and study the picture itself until such time as the representation becomes clear to them on its intrinsic values. Of course, reading about the man who made the picture and about the period in which it was made, may take the onlooker a step further towards reaching sensitivity to its art content and the meaning of the artist.

Essentially, the final appreciation of the artwork is based on the elements contained in the image, not on external additions of information and elucidation. A work of art functions as art without the aids of word and sound. Art uses an emotional undertone within the concept of the painter, rather than in the subject matter of the production. This use is the opposite to the use of a picture made for purposes of documentation, where the emotional impact is not part of the picture but is induced by an additional theme of words and sounds.

The work of art does not become better as an art production nor has it a greater aesthetic potentiality if a description is added to it. Admittedly, it is useful for the onlooker to have such information, but the aesthetic function is dependent on those elements produced by the artist within the work of art. If we look at a rendering with the idea of checking it as a description of some particular locality, or for the naturalness of the subject, to find out the date of the things represented, or for the techniques of the planning of the colors on the canvas, then for us at the time the picture is acting as a document; it is a representation of a subject that we are seeking information about; it is a record of the use of certain substances to produce a picture; it is being judged as a catalogue of its objective contents.

Knowledge of the method by which a painting was made, of the artist's life and of the subject of a painting is not kept in mind while looking at it as an art experience. Analysis of its factual content and the information on the source and date of a picture is kept in mind during the use of it as a document. From this we can deduce, that the documentary record increases in potentiality as the information about it increases in quantity and authority. As far as its documentary function is concerned, a picture with full identification, although technically mediocre is of more use than a good picture without identification. Unidentified pictorial records have a short and limited life of usefulness except in some instances as art.

Full satisfaction in a search for pictorial information cannot be derived from the study of photographs alone. During the 1939 Spanish war, photographs of extraordinary beauty and sensitivity were taken by Robert Capa. These photographs stimulated interest in records of parallel scenes in Spain, a hundred and thirty years earlier, the aquatints of Goya. His "Disasters of War" were made after experiences of the artist in circumstances similar to those under which Capa produced his photographs. Both interpretations are bloody, both factual and imaginative, both records of actual happenings, both produced for similar ends. The ruthlessness of war is better understood after we have seen both these interpretations; compelling emotional reaction is inescapable.

It is interesting here to record that although these photographs and aquatints were used for their interest as documents of history, in looking at them it was easy to forget their historical implications; aesthetic fullness from their moving, beautiful synthesis was experienced by all those who saw them.

The work of draughtsmen is needed to offset the limitations of the camera. All points of view in all types of media should be available for the pictorial study of a subject. It is not enough to have photographs and the photograph does not displace the artist's rendering. When Max Brodel, father of medical illustration in this country, teacher at John Hopkins, retired in 1940, he surveyed the place of illustration in Medicine. From his writing the following excerpt discloses how closely linked and interdependent the camera and the draughtsman are.

Photography "shows form, structure, colour and texture, all with complete realism but it does not analyze, interpret or teach. It makes a dramatic picture, not a scientific one.

… Nearly every photograph in the medical literature can be made more valuable by the addition of an explanatory sketch or diagram, a synthetic picture, so to speak, created in the mind of the artist.

… A photograph rarely shows more than what the photographer has understood." (17)

We must not be satisfied with the camera view; we also need the skill and vision of the draughtsman. We should not underestimate the power of works of art even when reproduced in black and white print. The characterization of a coal miner in one of our contemporary dramas, was inspired by the study of a newspaper clipping of a half-tone copy of a sculpture by Meunier.

The fullest and most productive use of pictures as documents depends upon

the availability of a comprehensive quantity of pictures, whereas in the study of art, examples of the greatest works of art are sufficient. It is important to gather a quantitatively large collection to assure the documentary value of each item included. Since there are so many aspects to each visual subject, the greater the number of pictures that are available to the researcher and student, the stronger becomes the factual basis. The interpretation of the artist should be studied along with the photographer's record of the subject. This is of particular importance because the artist can make comparisons on one surface, can bring the past and present together and present many sides of a subject simultaneously.

We must realize that a still picture can show feebly that which happened before the fixed moment depicted in the picture, and it cannot show the resulting action unless a series of pictures is incorporated into the boundary of one larger image; this is frequently met with in photo-montage, in mural paintings and in the comic strip.

The subject matter of pictures is clarified and sometimes further identified by comparison with other pictures. In studying works of art as art, we make use of comparisons as further judgement upon the value of a work of art as a work of art; in a collection of art, quantity is not a factor in enhancing the use of the pictures; it is important to have each item selected and accepted on the basis of being a fine example. Selection, elimination and standardization control the excellence of a collection of art. In a documentary collection each picture gains by the company of many other pictures. As more pictorial documents are gathered together, the more valuable becomes each item.

In the sixth volume of the Catalogue of Political and Personal Satires of the British Museum, it is interesting to note that "… the value of the satirical print as an historical document increases progressively in proportion to the completeness of the collection…" (18)

The comprehensiveness of a collection gives each picture larger scope. For example, if an addition to photographs of Charlie Chaplin from life we look at caricatures of him, stills from films he has appeared in, and paintings interpreting his appearance if he were to play Hamlet, then the study would be based on more aspects than a camera or the painter can produce separately. We achieve a truer appraisal of his appearance. Through comparisons among pictures we can establish the differences not obvious nor suspected if only one view or point of view is available. Information from each representation of any subject forms a body of observation and knowledge which increases the information in each item in the collection.

Pictorial record is enriched when it is available in quantity and when its organization is encouraged to grow on a comprehensive rather than a selective scale. Limitations on the type of picture to be included should be kept at a minimum; all restrictions should be towards efficiency in availability, not on the grounds of taste or artistic merit. Selection should be left to those who will use a documentary collection not to those who gather and organize it.

Because of the flexibility of interpretation inherent on the pictorial image, pictures have a characteristic peculiar to them – their timelessness. The 17th century picture which portrayed the effects of old age on the face of a man, is as intelligible and as moving today as when it was painted. A word picture of ageing in the language of that same century and place, would have had to be translated into the idiom of today, and translated for succeeding generations in order to convey the author's intention; the picture of the same subject remains a clear understandable image, completely recognizable as a picture of ageing to both the literate and the illiterate. After the description of a news event is stale, and the novel based on it is just remembered as a statistical success, a picture of the moment of the event is still fresh, interesting and enhanced in value because the moment was recorded; it may be of more usefulness ever afterwards than it was when it first appeared.

Pictures do not go out of date; they remain as expressions of the period which produced them. Often, they are the only records of the appearance of a people and life for later generations. Work and science and the gaiety and somberness of the people in each tide of living leave in pictures the concrete imprint of the basic sameness of man's activities century after century.

Since visual aspects remain unchanged, a picture continues to have interest and serviceableness. Because pictures are perceived differently by each onlooker, they will appear different in each later period and will have all sorts of unsuspecting influence.

In their practical and comprehensive book, "Pictorial Journalism", the authors give emphasis to the importance of saving pictures against the need for them in some later day. "One of the comfortable things about good news photos is the fact that their death rate is not as high as that of words." (19) This holds true for all pictorial records. The perennial potentiality of pictures is due in the main to the lack of a definitive limitation to the scope of content of a pictured image. The variety of possible viewpoints of a pictorial representation is limited only by the amount of data accompanying it, that is, its identification. Once the facts of date and source and authenticity are known, a pictorial record has permanent usefulness, serving

all sorts of purposes in each period and in all fields of human activity. It may start as a zoological record and later father an idea in genetics, and in another century be looked at as art of a high order.

Most people think of the printed illustration as an ephemeral thing – of interest one day, forgotten the next. The life of a picture is not ended with its first appearance in the news. While the original of its subject may change, age and disappear, the picture remains as a record of the appearance of the original at the time the delineation was produced.

Interested in the momentary necessity of feeding the news hunger of the public, many newspapers put aside those photographs which are of no immediate interest; these are not discarded but are stored and made available for the time when they will be needed to show the background of some new development, or as a flash-back to the past years of someone's life. The pictures of all periods have immortality of interest because they transfix a moment that has passed; through the pictorial record, this moment of time is carried into the future and will communicate the spirit of the age in which they were made to all succeeding generations and peoples.

As we need the book and the dictionary of words to translate into familiar terms the words and subjects that puzzle our understanding, we need the concrete representation of a picture to explain away our doubts and to actualize forms unknown to us. The printed picture just as the printed word should be assembled and arranged to act as a source of information and clarification. Pictures in print as part of the pages of periodicals and newspapers are as a rule part of a biased text or strongly edited caption; we hesitate to accept the application of the text to be illustrations as completely true. There is genuine necessity for the establishment of a precedent in factual captions for pictures so that they may serve as documents and may elucidate a subject instead of perverting its true meaning.

There is no limit to the capacity of serviceableness of any picture provided it can be reproduced and distributed widely. The photograph from life or a photograph after a rendering is thus the best for documentary purposes. From it clear copies can be produced. A documentary record must be properly identified before it is of any use. The information on it must include the date when it was made, of whom, his age, his title, the circumstances, and the source of the original likeness. By knowing the source, we can judge whether or not it is a prejudiced document, whether or not some biased point of view was demanded from the maker of the picture and whether or not the purpose for which it was made conflicted with the facts in the

matter and to what extent that affected the photographer or artist in eliminating or adding details. A representation that is thoroughly identified will be endlessly useful; but if it is without words, without facts it is not a document. The identified clear picture can serve all those who come to it for information, the scientist, the sociologist, the engineer, the painter, the housewife and the child.

An example in recent years will indicate the extent of the influence that the same pictures can reach. During the past few years photographs were made by the Farm Security Administration to record the plight of the farmers, their struggle against soil erosion and against the results of unscientific farming of worn land. These photographs have become tools for use in fields far removed from the purposes for which the pictures were originally made. Long after they cease to be propaganda to attract legislators to remedy the abuse of the nation's natural resources, these same pictures will serve the public in many other capacities. Their permanent contribution will be that they give a graphic insight into a section of life in the United States during the fourth decade of the Twentieth Century. From these pictures the future can glean an indictment of wastefulness and heedlessness with human and natural resources; but also, from them. People will receive a sight of daily life of ordinary people, their ways of eating and cookery, their fun and their religion their makeshift churches and their license plates shacks, the faces of the laborer, the sharecropper, the small-town drugstore clerk and the village teacher.

These pictures are for the legislators and, also, they are for the sculptor, the novelist, the dramatist, the musician and the poet. These pictures preach to the administrator of housing and to the administrator of justice; they are a text for the sociologist, a weapon for the politician and inspiration for the writer. In the "Land of the Free", (20) Archibald MacLeish added the continuity of the sound of poetry to these pictures and produced an eloquent welding of abstract rhythm and idea with the human image of man against the earth.

There are limitless possibilities for the use of pictures, when they are available without having been selected and sorted into categories of art and on an aesthetic basis alone. Fine prints and illustrations in books have received recognition and attention in libraries and museums. Collections of fine prints were established in all these institutions to supplement the plastic arts collections and books on the subject. Print collections looked upon the fine print as art and the illustrations in books as art. Many of the greatest artists, since the invention of printing, prepared drawings and paintings as illustrations to the Bible and other books. The painting of easel

pictures sprang from the illuminated page of the book; it is impossible to separate painting from its earlier form. Some of the most distinguished of the 19th century painters turned out their best drawings for the commercial purposes of newspaper and book illustration.

In their zeal to give recognition to photographs, many institutions forgot that the great power of the photograph lies in printing and its appearance in print. In order to study the photograph for its subject content and to spread its influence, good printed copies suffice. If after a study of the printed copy, the original is needed for purposes of display or further reproduction, then the negative or a positive proof may be handled. In that way handling the original can be limited. Just as with the handling of fine prints, printed reproductions can serve as substitutes for the handling of the original.

Print collections were centered about the tools and methods employed in producing fine prints, and the history of illustrations in books. In them were collected, selected and displayed the finest examples of printmaking and the best examples of the greatest draughtsmen. They have as their function the education of the general public and of the student of the history of the graphic arts. Through print collections, the public becomes familiar with the full extent of this type of art production and gradually develops an appreciation of it, acquires taste, and the power of discrimination and selection. In bringing the past and the contemporary history of drawing and printmaking to the public, the print collections serve the modern artist. By encouraging good taste and familiarity with the best in the field, the print collection instills a desire for possession of an original work of art. There can be no market for the living artist unless the general public has the opportunity to see, learn and appreciate the production of past times.

In spite of their major interest in the quality of the execution, the composition and expression in a master print, most print collections in libraries and museums have bowed long ago to the fact that people are attracted by the subject of pictures first, and that their dislikes and likes are usually derived from their reaction to the subject matter of the picture. Print collections spread awareness of the beauty of black and white and line, kept alive and nurtured respect and appreciation for the printmaker and his work. Such collections bring to the student, the artist, and the scholar, a fuller grasp of the techniques and purposes of the graphic arts and the pleasure to be derived from acquaintance with them.

Staffs of print departments admit that the public comes in most frequently

searching for some specific subject in prints. Quite properly, the curator minimizes the importance of this type of inquiry in relation to the purposes of a collection of fine prints. He maintains that the original prints should not be used for these purposes; they should be reserved for the use of artists and students and for display as art. Nevertheless, it is difficult for the public to dissociate an interest in the subject of a print from the pleasure of seeing the beauty of its execution and conception.

In most print departments, at frequent intervals, selection is made of prints for display from the viewpoint of the subject interest. Attracting the public by playing up its interest in themes, the curator takes the public along the way to experiencing the prints as art. Photo-mechanical processes of reproduction have helped the fine arts field by familiarizing the public with the history of art through press and books. The staffs of print departments realize that they have a large and specialized task solely in the handling of fine prints without taking on the organization and handling of the subject content of prints and printed pictures. For the study of the original fine print, the reproduced printed picture may serve as a substitute. These printed copies obviate the necessity for handling of the original or rare print.

By quoting here from two separate sources, one the curator of a famous print collection in a library and the other, a great printmaker of our times, we can comprehend the place of the print and the printed picture. Frank Weitenkampf wrote "… there has been excellent work in halftone. It has proved invaluable for the production of pictorial documents, reproductions of paintings and other works of art, portraits, views of anything that can be photographed and turned into a printed picture for information." (21) Rudolph Ruzicka wrote "But even the humbler kind of reproduction has virtue besides being useful; it's very commonness eliminates the element of the precious, obliging one to exercise imagination to concentrate on the significance of the thing represented; a reproduction can be freely used up without too poignant a sense of loss." (22)

The printed reproduction and the photograph were welcomed by libraries, museums and schools. These pictures were needed as associates of books and the original artworks. In all types of institutions files of pictures were organized. The printed picture and the photographic copy reached and still maintain an indispensable role as a simple practical tool for the study of art history and art techniques; indispensable and inexpensive, it is easily replaceable.

For purposes of reference on the history of art, museums and art school libraries maintain files of photographs and slides on works of art. These have as a rule, been

limited to the best in each type of art reproduction. Each institution has a different yardstick of selection and is limited in scope according to its specialization. For example, museums of art are still uncertain about the art of so-called primitive people, which is still found in ethnological collections. Until this art is hailed as great, we cannot find photographs of it in art museum collections. So, the modernist museums are a bit at sea too, since they must keep their files limited to that which is accepted as new and startling.

This ends in some confusion since the art of primitive peoples is suddenly discovered to hold the seeds of all of Cubism and then the doors are opened, and we can find in the files of a modern museum, pictures of the art of the African Negro. The public is forced to apply to the collections of a museum of natural history, an archaeological museum and an art museum to obtain a comprehensive pictorial survey of art history. The ethnology collection of one generation becomes the fine art collection of the next.

Art museums and art libraries retained this important but specialized attitude towards pictorial copies, the public libraries were free to approach pictures with a less restricted point of view and with more awareness of the informational potentiality of all types of pictorial matter. From the time of the introduction of photo-mechanical processes for the reproduction of illustrations, the libraries realized that the pictures in books and magazines were valuable sources of information.

In an article published in 1900, (23) Anne Carroll Moore with pioneering vision, expressed her observations on the close relationship of pictures and books in library work. Through her influence and encouragement, recognition of the role of illustrations in influencing the reading of books, has been established and pictures are considered today as necessary companions to the books in children's libraries. When children of pre-school ages come to a library, they are shown books of pictures; with imaginative delight and inspired patience, the librarian shows the children how to see pictures. She explains to them that the pictures have content and the children soon learn that there are richer pleasures in store in the pictures than the fun of just turning the pages swiftly and blindly. This early influence of the library is far reaching in effect and helps instill a sensitivity to the contents of pictorial images, their story-telling qualities and their power to clarify an idea and evoke an emotional response. These in turn foster the desire to read more about a subject than what meets the eye.

Libraries realized for years that the public frequently could find in pictures much

of the information it sought. Time and again books were searched for illustrations to solve the problems of color, shape, comparative size and proportion. While museums and art reference libraries were forming collections of fine prints and photographic records on the history of art, the public libraries throughout the country were gathering all sorts of printed pictures and organizing them into "Picture Collections". These were from the first of a general nature in subject content and were primarily the types of pictures appearing in magazines and books.

Of the first picture collections, that of the Newark Public Library became the leading example. Under the guidance of John Cotton Dana, this collection became the most influential force in the organization of similar picture files in other public libraries. Under his editorship, the publication of a guide to Picture Collection work became the basis for the classification of most of the general picture files throughout the country. In the introduction to the third edition we read that "Information has perhaps been more often asked for by librarians and others on our picture collection than on any other subject…" (24) Although the Newark Picture Collection became part of the Art Division of that Library, it was not set up to function as an art reference file; it was organized and classified for its usability in teaching and as an information and idea file for artists. The best feature was that it was a circulating collection; with that privilege added to pictures they started upon a new and tremendously important role that was to take them into action in the workshops and studios, the schools and law courts of the country.

All sorts of collections of pictures were established in these photographic decades. Each newspaper with the output of its own photographers and the photo material purchased through national and international agencies had libraries of photographic negatives and prints. These were indexed by the date of appearance and by the name of the personality or by the event. Special libraries all had need for pictures on their special subjects, and we find, for example that the Library of the New York Academy of Medicine has a comprehensive index to its portraits (25) and considers them an important adjunct to their bibliographical material in books.

Picture files were organized to visualize the history of one subject. The Frick Art Reference Library is devoted entirely to the history of painting and sculpture as it can be ascertained by the study of photographic copies in conjunction with books. The Liepperheide Costume Library of Berlin turned all pictorial material to the purposes of costume record. Even original drawings and paintings were considered as costume illustrations. An artist on the staff was sent on field trips to record native

costumes that were fast disappearing. The specialized interest of this library saw in all of art history the record of human raiment; all interests were subservient to this purpose of the collection.

Every special section in the larger public libraries, in municipal and federal agencies all have their special picture files. Pictures of some local aspect of a subject can be found in a department of parks, of hospitals or in its full achievement in the National Archives.

The libraries look upon the printed reproduction of all the works of art in history entirely from the point of view of their subject content. In library picture files all sorts of printed pictures are considered as printed records. The use of our heritage in print has become broadened and disseminated through the library organization of picture files. In such collections, by the magic of printing presses, the sculpture of the Greeks teaches the history of the dance, of the theatre, of costume and the transportation of the ancients. In a museum the photographs of works of art function as documents of the history of art; in a library general picture collection, they function also as documents of life and science, as sources of ideas and facts. In a museum they serve as tools for critical appraisal and for the education of taste.

In collections of pictures or photographs devoted to the specialized field of art history, methods and systems for their classifications were soon fairly well established. Usually, progressive accession numbers were assigned to the photographic negatives; the names of the artists or the chronological arrangement of schools of painting, or the nationality formed the scheme of arrangement of the photographs. Decimal schemes of classification were also used. Indexing from titles and subjects was necessary because of the numerous requests received. In most art reference files the subject indexing is not done consistently. This is so probably because of the staggering cost of constant and proper indexing.

The problems involved in the organization of a special file such as one devoted only to the history of art, are much simpler than those of a general collection. In special collections the scope of materials to be included is established; this limitation and restriction of specialization in a benign way conditions the organizational problems. The subjects to be included have been logically classified and indexed for the book stock and the same basis can be adapted to the handling of the pictures.

Most art libraries admit the liveliness of the public's interest in the subjects of pictures, but such interest is believed to be best served by picture libraries devoted entirely to printed reproductions of pictures classified for their subject content with-

out consideration of the artistic merit of the material included. No one questions the sensibleness of this attitude. Not all pictorial representations are art in result or purpose, and it is too late now to continue to neglect the utilitarian role of pictures.

Willingly or not, all libraries report the increasing interest of the public in pictures. This is true not only of art collections but in all sections of library work, in technology and in music divisions. Pictures are needed and called for information, for ideas, for stimulation, for study and for background. The business library, the professional library and the museum library, all find themselves hunting through books and magazines to find graphic views of something in the world today or of the world yesterday; and invariably the search is fact-finding in purpose and includes little of aesthetic consideration.

A library with its printed words and picture serves as a disinterested but conscientious organizer of all phases of documentary record. Pictorial material in libraries is organized for availability to the public, to stimulate the individual towards a study of the records, to evaluate for himself, to come to his own conclusions without a stipulation by the library concerning the ends for which the material is to be used. Pictures in a library collection function as fact-finding data for either propaganda or creative channels.

In a public library printed pictures should be organized quite objectively for their subject content. They should include printed copies of all the accepted and proven art works along with every type and kind of two-dimensional pictorial view that is or may be of human interest or is potentially provocative of ideas. Comprehensiveness is the important feature in the selection of the materials to be included.

Almost every library has some type of general picture file. The pictures are usually such as can be salvaged from the discarded periodical or book. They are considered as separate individual items dissociated from the bound source publication. When there is an art department in a general library, the picture file is customarily part of this department and is used to supplement illustrations in books. In most children's libraries there are picture files usually available for school room requirements. In a few of the larger public libraries and commonly through Britain, picture collections are separate sections of the library. The picture collection of the New York Public Library is a completely separate division of the circulation service of the Library.

In each of the Federal agencies, there are collections of negatives and positives of photographs made on field expeditions, during construction work, or for uses

of propaganda, and for the illustration of departmental monographs. When these files become inactive, they are turned over to the National Archives. These National Archives photographic files form a national pictorial archive file. (26) The negatives are cared for and preserved; the positive prints are in orderly organization following meticulous care the scheme of classification peculiar to the special agencies in which the pictures originated. There is as yet no union subject index to these rich documents and their final usefulness to the population as a whole will depend upon the skill with which the subject content of the pictures will be brought out and analyzed in a card index combined with miniature, or identification copies of each picture. Microfilm copies will not make it possible to study many sides of a subject simultaneously for comparisons. The pictorial material at the National Archives is overwhelmingly photographic. As one studies these files so exclusively born of the camera, the lack of the artist's point of view becomes disturbing; one misses the life, action and interpretation to be found in drawings and paintings.

Other than these there is no comprehensive national file of the pictorial data of our history. Illustrations in books, in mail-order catalogues, from newspapers, from the Hollywood film productions, from the photographs by amateurs, records of the thousands of artworks produced annually, all these are not gathered in one place for study and preservation, for availability that we may use them for teaching and learning, and as permanent record of our life and times. The tremendous paucity of pictorial records on the history of our folk arts and of the homely objects of domestic use seems astounding until we realize that there are no national records in pictures of our costumes and daily customs, our toys, our tools of trades and domesticity.

Until the creation of a Works Progress Administration program * for the graphic recording of those objects and costumes still existing in private possession and in museums, we had little realization of the richness of American design. The persistent interest and inquiry of the public at the New York Public Library for pictorial illustrations of the American tradition in costume design, in fabrics and in the objects of daily use, brought to light how very little had been recorded and gave stimulus to thousands of artists and researchers to reconstruct through pictorial documents a record of American Design. Most European nations had long ago taken pride in recording in pictures the changing costumes of the peasant and the workman, and the folk dances, the shop fronts, the cradles, the whistles, the kitchens and sleighs, the folk arts of its peoples. * The Index of American Design

The great stream of pictures issuing from the camera focused on the life of the

individual and on the life of the masses, leveled at the chorus legs in a burlesque show, leveled at the body strewn scene of a murder, leveled at the faces of people driven from home by fire, driven from country by men, impinges upon the eyes and mind, the thinking and the memory of all the people. The power of cheap and inexpensive printing in monstrous quality of duplication makes each pictured image influence millions of people with each printing; this includes the illiterate and the children. The people now have a rooted pictorial experience with the far and near aspects of the world. In the study of many varied subjects, in the reading of all sorts of publications, after listening to the radio, after watching the projection of a film, people have a desire to see in a leisurely manner a visualization of the things they have read or heard about.

Descriptions in words suggest but do not give concrete form to an idea. Libraries must accept the responsibility for supplying the general public and the artists and teachers with information that only pictures can give. Pictures as sources of information and stimulation must be accorded proper recognition. Since copies today can be and are cheaply and freely available through reproduction by photo-mechanical processes, every library should maintain pictorial files for the use of its public.

By that we do not mean pretty or decorative pictures, but pictures from a mature point of view, arising from respect for their established place as an influence of great potentiality in our thinking, activity and culture. Pictorial visualization should no longer be handled as illustrations for children only, they must be considered now as important, indispensable adjuncts to books. It is time that we recognize the full status of their inherent value as reference tools. They are important for every member of our community.

It is not enough for a library to boast of the illustrations in its book stock. And indexes to pictures in its catalogues. Separate pictures must be included to give the users of the library full pictorial experience. It is impossible to evoke the appearance of any picture by reading a catalogue card; at its best a descriptive card gives nothing but a vague list of specific items in a picture without giving the form of what is depicted. The only pictorial index that would function successfully, although meagerly, as a substitute for the original illustration would be one in which a copy of the indexed picture appeared on the index card.

Although a book becomes out of date, or its text outlives its usefulness, the illustrations often remain valid indefinitely. It is important to keep this in mind and learn to use illustration that have appeared in ephemeral or outdated texts. In all times since

the beginning of printing, the production and distribution of copies of illustrations, the pictures in book and broadside, in the pages of fashion, in caricature and in scientific literature, have wielded a deep penetrating power over all kinds of people.

We can hardly comprehend the immenseness of the tool that pictures form. We recognize the propaganda power of pictures during war times for purposes of arousing a people, for spreading patriotism and for kindling hatreds; but the continuous infiltration of pictorial experience through the press and the moving picture is harder to apprehend. Pictures are an active force in the education of the people and should be harnessed to stimulate and interest both the literate and the illiterate, and both in the present and succeeding generations. Pictures are essential in a library, where they should be gathered, identified and organized to serve as documents of man's own aspect and the aspect of the changing times he has lived in. We join with Philip Hofer to say: "I only believe that as illustration has been in the past, so it is, potentially in the future, a far greater means of conveying ideas, and so a greater force than the world at present conceives." (27)

References for Pictures as Documents

1. *Foundations of Modern Art*, Amedee Ozenfant (New York: Brewer, Warren & Putnam, 1931) p.30.

2. *On Reproductions and the Colotype Process*, Rudolph Ruzicka in *Print; a quarterly journal of the graphic arts* (New Haven: Rudge) v.1, no.4 (March-May 1941) pp.47-50.

3. *A Treatise on Photogenic Drawing*, unsigned, p.243-244 (Apr. 20, 1839); *The New Art-Photography*, unsigned, pp.262-263 (Apr. 27, 1839), in *The Mirror of literature, amusement, and instruction* (London: J. Limbard) v.33 (April 1839) p.262.

4. *The Modern Keyhole*, editorial, unsigned (Bernard DeVoto) in *The Saturday Review of Literature* (New York) v.15, no.25 (April 17, 1937) p.8.

5. *The Origins of Printing and Engraving*, Andre Blum; translated by Harry Miller Lydenberg (New York: Scribner's, 1940) p.54.

6. *How to Look at Pictures, Sir Robert Clermont Witt (London: G. Bell, 1929) p.47.*

7. *Primitive Art*, Franz Boas (Oslo & Cambridge, Mass.: H. Armstrong Aschehoug, Harvard Univ. Press, 1927) p.68.

8. ibid p.64.

9. *Theatrical Prints as Historical Evidence*, W.J. Laurence on Connoisseur (London) v.13 (September 1905) pp.29-33.

10. *The Graphic Arts*, Sir Philip G. Hamerton (New York: Macmillan & Co., 1882) p.304

11. *The Illustration of Books*, Philip Hofer, being Chapter 13 of *A History of the Printed Word*, edited by L.C. Wroth (New York: Limited editions Club, 1838) pp.389-446.

12. *Knowledge and the Image*, editorial, signed A.L. (Amy Loveman) in *The Saturday Review of Literature* (New York) v.23 no.16 (Feb. 8, 1941) p.8.

13. *The Arrangement of Print Collections*, A.M. Hind, in the *Burlington Magazine* (London) v.9, no.100 (July 1911) pp.204-206.

14. *Pictorial Journalism*, Mrs. Laura Vitray (New York: McGraw-Hill, c.1939) p.3.

15. *Art as Experience*, John Dewey (New York: Minton, Balch, c.1934) p.112

16. *Mice in Plague Pictures*, Otto Neustatter, in *Walters Art Gallery Journal* (Baltimore, Maryland) v.4 (1941) pp.105-113.

17. *Medical Illustration*, Max Brodel in the *Journal of the American Medical Association* (Chicago) v.117, no.9 (Aug. 30, 1941) pp.668-672.

18. *Political and Personal Satires*, preface, A.M. Hind in *Catalogue of Prints and Drawings in the British Museum* (London: Printed by order of the trustees, 1870-1938) v.6 (1784-1792) p. vii.

19. Vitray, Laura, op. cit. p.402.

20. *Land of the Free*, Archibald MacLeish (New York: Harcourt, Brace, c.1938).

21. *The Illustrated Book*, Frank Weitenkampf (Cambridge Univ. Press, c.1938) p.200.

22. Ruzicka, Rudolph, op. cit.

23. *The Place of Pictures in Library Work with Children*, Anne Carroll Moore in the Library Journal (New York) v.24, no.4 (April 1900) pp.159-162.

24. *The Picture Collection*, John Cotton Dana (4th edition, revised by Marcelle Frebault) (New York: H.W. Wilson, 1929) p.v.

25. *The Portrait Catalog, Richard G. Wagner in the Library Journal (New York) v.66, no.6 (March 15, 1941) pp.250-251.*

26. *Guide to the Materials in the National Archives*, United States National Archives. (Washington D.C.: Government Printing Office, 1940. In verso of t.p.: Publication No. 14).

27. Hofer, Philip. Op. cit. p.389.

Reading war news aboard streetcar. San Francisco, California. 1941. John Collier.

Chapter Five

Words on Pictures

A speech to the convention of the Massachusetts Library Association, Boston, Massachusetts, January 28, 1943.[6]

The mounting flood of pictures is permeating all of our lives, and its impact leaves deep impression on our minds. This unexploited pool of power can be tapped to produce ideas, stimulate processes of thinking and provoke action.

Libraries seem to worship the printed word as the sole conveyor of knowledge; they leave the pictorial aspects of the world to the museums. Satisfied with the power of words, they have slighted the great infiltration of pictures and left their use to commercial channels of sensationalism and advertising. Librarians should not depend on printed words alone but should utilize the printed picture as an adjunct to books. The physicist Clerk Maxwell said, "there is no more powerful method for introducing knowledge into the mind than that of presenting it in as many ways as we can". Instead of scorning pictures, libraries should take full advantage of their power in the communication of ideas.

These pictures are not art, they are not pictures on exhibition, they are pictures at work. They are documents, momentarily cut off from their aesthetic functions to be employed for their subject content. Any picture is a document when it is being used as a source of information instead of being searched for its content of beauty.

We have inherited a tremendous mass of pictorial representations from past centuries. The camera has brought us the image of the world today and fixed a record of it for the future. Through photo-mechanical methods all of the art works of the past have been reproduced in print in countless copies. We now have a full-bodied pictorial history of man, the outer aspects of his living – the face of human events. From prehistoric times, we have the hunted, exhausted bison, copied from a cave drawing; percussion instruments of Ancient China photographed from tomb figurines; the martyrdom of saints pictured in medieval prints which once were sewn

6 Originally published in the Massachusetts Library Association Bulletin, 1943. pp. 19-23. Re-printed by permission of EBSCO Information Services.

into garments of pilgrims to stave off evils; we have "stills" from newsreels showing a sailor crouched against the deck expanse of an aircraft carrier, darkened by the shadow of a Zero's flight overhead. At the moment the consideration of whether these are good art or not is secondary, the subject alone is important. These are the pictures that keep for us the appearance of the past, the visages of people and their rulers, the contour of their lands, the shape of their bread and their tools, the mechanism of war machines and the features of gods.

Pictures are an added light with which we can beam through the indistinct shape of the past; they give specific definition, bring into recognizable form, almost actualize human life in other times. They bring us the intimate detail of daily pursuits among people far away in space and distant in time.

Most pictorial representation in the past and most photographs today, were made without aesthetic purpose, they were made as illustrations. The mere attempt to communicate an idea graphically should not be claimed to be art. Most pictures have as their purpose the recording of a visual experience, the rendering of the appearance of things.

While some pictures have been made solely as records, the pictures that were made for aesthetic ends may also serve a utilitarian purpose, may function at times as sources of information. All works of art mirror the world in which they were conceived, the life and the community from which the artist sprung. The artist rarely escapes reflecting his own times.

The original work of art and its printed copy are functioning as art when they bring aesthetic satisfaction. When pictures are looked at for the subject depicted, and the surface is searched for facts of appearance, then their content of beauty and design is deliberately ignored. If a painting is studied to discover the type of hair-shirt saints wore, this is an end-use wholly outside of the painting's existence as art.

At all times there have been draughtsman employed in the production of records of the outward appearances – the shape, the color, the proportions of man and nature. They illustrated scientific writings, copied what they saw around them, and made factual drawings of newly learned facts. For example, when Leeuwenhoek made his microscope, he wrote a book describing what he saw through its lenses. To give reality to his words and convince his contemporaries, he used drawings throughout the text. These depicted for the first time a world previously unseen by human eyes. Leeuwenhoek drawings do not belong in a museum of art, logically they belong in a library as part of its organization of knowledge.

When an artist, Leonardo Da Vinci, studied the flight of birds, he made clear-eyed, scientifically sound drawings of the bone structure, the arrangement of muscle and tendon in their wings. These document the history of that machine which is now bearing men and materials through the air. Seeing these drawings on the wall of an art museum, the onlooker forgets to be aware of their scientific, documentary significance, he stands in full enjoyment of their delicacy and beauty of line.

A picture may be a pictorial document and may also function as art, and its appraisal as art neither enhances nor detracts from its potentiality as a source of factual data.

The story of pictures in libraries is the story of printed pictures and that is the story of the camera. Until our times it was costly and sometimes impossible to make accurate copies of artwork since the printing depended upon hand methods of preliminary reproduction. With the introduction of photo-mechanical processes, pictorial publication was released, and we have not yet experienced its full force. This unbridled multiplication of pictures continues ceaselessly at a gargantuan rate in newspapers, magazines, in the comic strips and through projection machines in continuity across the screen. This expanding stream carries the fixed moments of time to all of the people, the literate and the illiterate, the young and the aged.

Before the use of the camera and its simplification of the reproduction of pictures, works of art were seen only by the rich and the pious, in the homes of the nobility and on the walls of places of worship. Through the photographic copies, all of the art of the world, the entire record of man's visual expression has become common knowledge. Everyone sees copies of El Greco's work and Cretan frescos, African sculpture and Mayan glyphs, faithful photographs of precious, rare originals, in their daily newspapers.

With the widespread dissemination of printed books and the growth of illustrations in books of travel, technology and science, in studies of other civilizations and peoples, visual familiarity with the world of the past and the present became part of our cultural background. Previously people were unacquainted with the appearances of places and persons unless they had seen them with their own eyes. Some information about foreign countries trickled through written and oral descriptions and crude representations. Our grandparents had no true picture of their grandparents or of themselves in their younger years. This of course was true for those of modest means and the poor, all of whom could not afford to have their portraits painted.

It is difficult to imagine ourselves without our common lifelong exposure to

pictorial experiences, without the family snapshot, the Sunday rotogravure, the newsreel, the history of art illustrated with photographs; to relive a time when the appearance of individuals in the public fields of government and social reform, the famous author and the notorious criminal, was unfamiliar to all those who had never seen them face to face. When the image of the world could be fixed by light, trapped forever on a surface and then reproduced mechanically in mass duplication, we were presented with a great educational force and a rich, unlimited source of social influence.

The radio describes with sounds and spoken words. Many persons visualize as they listen, seeing mental images formed either from past direct experience with the subject in life, or from pictures seen in books or on the screen. Hearing and reading about people and events are not enough for those who have grown up in a camera era. The need for the reality of pictorialization becomes insistent and they want to see what they have read and heard about.

Since a picture by its nature, can depict only a fixed moment of time, it has no continuity of action. Only one scene, one aspect is visible at a time and what preceded a recorded moment cannot be discerned. Pictures without labels and identification are useless as a source of information. This holds true for documentary pictures but for a work of art no addition of words is necessary in order to have the onlooker inspired and moved.

The written and spoken words amplify the meaning of pictures. Since there are no facts within the pictorial image in itself, information must be furnished the onlooker in order to have the picture serve the onlooker possesses. The interpretation and the meaning of pictures is dependent on the user and on the captions.

Listening to a broadcast, we hear a description of an air raid on China, with many dead. Then we read about it in the press and it seems far away. We think "that is not related to us… That is not going to happen here … these are Chinese… always dying in great numbers… far away". Several weeks later we notice an unusual photograph (one of the finest pictorial documents of this war). It is a scene of many bodies strewn across a broad stairway; they are strangely still in some arrested move-ment of escape. These are people, about a hundred of them, women and babies and youths. We cannot tell whether they are asleep, whether they are dead or whether they are stricken rigid in a theatrical pantomime. What is happening? Who are they? The picture itself cannot give you the answers, cannot tell you their color, their race nor the cause of this massing of numbers. Then we go back to our memory of the

news, the words in the headline and we realize and recognize this is Death, these people Chinese; the words evoked a s superficial, momentarily disturbing response and a hazy image but the visual experience added to the verbal information, brings back the stark impact of life: these were human beings like ourselves.

Words used with pictures can distort facts effectively and make the pictures instruments of propaganda. The same photograph would appear in an Axis publication labeled: *Democracy and the colored races, extinction not protection.* Our government would use it in counter propaganda by the addition of other words: *Fascism − women and children first − for death.* In each instance the readers reaction would be conditioned by the combination of words and picture.

The use of illustrations in periodicals is more than a century old. Some of them, from the start, were as profusely pictorial as our present picture papers. The success of those first picture magazines was phenomenal in their day but not comparable with the fantastic circulation of *Life* and *Look*.

It was many decades before the publishers learned to edit pictures in order to form them into malleable tools of influence. The earlier papers used illustrations as individual items, as an end in themselves, as decorations and to illustrate something mentioned in the text. Typical of these was the *mid-week pictorial* which at least superficially was the *Life* of the last war. This weekly hardly reached a circulation of 25,000. With similar illustrations today pictorial news periodicals are read by millions weekly.

Wherein lies the difference? It is not in the subject matter of the pictures; the subjects of the pictures in the first illustrated journals were the same as those of our contemporary ones. Pictures illustrating the Civil War − the Brady photographs and the wood engravings − were the same in their general subject content as those used to illustrate this modern global war. One hundred years ago, the list of illustrations in one copy of a magazine included a picture of a hat of the latest fashion, a scene of crime, the weapons of the criminal, a naval victory and portraits to accompany obituaries. Human happenings remain within the same round of repetition.

The fundamental difference is in the editing of the picture. Publishers learned that it is necessary to add story and words, to use a script, layout and typography in order to produce continuity for the subject of a picture. It was long before they realized that pictures are not only looked at but read, that the subject of a picture must be pointed up into a recognizable idea through accompanying words and more pictures. They learned that factual pictures in themselves, bare of words, cannot

attract and hold attention and fail to communicate ideas.

Readers of tabloid picture papers depend upon the words in a copy to carry them from picture to picture. They invariably glance at the illustrations and then down to that small box which reads "story on page six", turn to the story, read it thoroughly and then return to study the picture. Now they have read about and see what the editor planned to emphasize in the picture. Now they search for the tell-tale details they have read about and see what the editor planned to emphasize in the picture.

When picture magazines first appeared a decade ago the book publishers shook their heads and decided to combat this apparent threat to reading, by publishing more and more picture-books. This was a false alarm since pictures do not challenge, they add strength to the power of printed words and actually stimulate interest in reading. Text, words, many words are necessary to fill out the rest of a picture, to add action, and all that lies beyond external appearances. Words added to pictures, likewise pictures added to words, merge into a graphic, strong medium for the transmission of ideas.

While the language of foreign people and vanished civilizations may be indecipherable and unintelligible, the contents of their pictorial records if still whole, are easily comprehensible. While a word takes on new connotations from generation to generation, and its meaning is soon lost, a picture remains constantly a recognizable image. This makes the pictorial language timeless in its understandability, truly without epoch it continues as a leaven in the enlightenment of the people.

The early relationship of printed pictures with libraries is bound up with the collections of illustrated books. The establishment of print rooms in larger libraries gave the first recognition to pictures as items outside the confines of a book. These collections were assembled to constitute a history of printmaking and the art of illustration. There, prints functioned as examples of the highest skill and as archives on the history of related techniques in the graphic arts. The prints in a library print room do not differ in purpose from those in an art museum. They are reserved for the print lover, the scholar and the artist. For information ends, such as their subject interest, it would suffice to study copies of these prints made photo-mechanically.

Since the beginning of this country, there have been general files of printed pictures in most public libraries. Some of these grew rapidly into circulating collections of hundreds of thousands of pictorial items, notably those of the Newark and the New York public libraries. To John Cotton Dana is credited the vision which first recognized the importance of maintaining a picture service in a public library.

After the publication of his guide to the classification and organization of picture collections, many libraries followed his pioneer leadership and started collections of their own.

The finest documentary picture files are not those in public libraries, but in specialized fields such as the Frick Art Reference Library in New York City and the photograph morgue of the Chicago Tribune. In one library, the *Lipperheidesche Kostumbibliothek*, Berlin, funds were provided for the parallel acquisition of pictorial as well as verbal documents on the history of dress.

Because of the overwhelming cost of administration and labor, most library picture collections have not received encouragement and have grown up entirely because of genuine necessity and public requests. They have had no funds, no specialized equipment, no reference tools and generally were ignored when the building was planned. As a whole the picture services of public libraries everywhere are still immature and far behind the needs of the public. This is due in part to the newness of techniques in the handling of pictorial information; to the fact that the photographic news magazine, the candid camera and the micro-film, the documentary film and the documentary still pictures were all introduced and established successfully within the last fifteen years.

Undoubtedly, the use of the camera in the present war will hasten the recognition of documentary pictures as indispensable to every library and will accelerate the founding of a national pictorial library with picture services in every community.

The use of the camera in pictorial recording and as an educational medium is still in its beginning stage; it is as revolutionary in effect as the invention of movable type in printing. We are only at the rim of a far-reaching extension of our visual knowledge, and it is impossible to envisage what this will do to books and libraries. Future pictorial libraries will probably include miniature positive prints of pictures as subject indices, documentary moving pictures such as instruction films and newsreels. Stroboscopic photographs and films in slow motion will be available for the public who will probably be able to study them in book-size individual projection devices. All kinds of pictures will be organized for research use, and for their fullest potentiality they will circulate, entering laboratories, homes, schools and studios.

Pictures organized as sources of information are as necessary to a library as dictionaries and encyclopedias. They enhance and amplify the content of the book stock, they serve the library as exhibit material with which to attract the public and stimulate interest in subjects of communal and universal importance. They help

dispel the dimness of the past and animate the words of history. With pictorial data, the playwright recreates a period, an orthopedist traces the shape of hand supports on crutches; an anthropologist disproves false concepts of racial physical characteristics; a camouflage worker learns the appearance of factories from the sky; obscure scientific and technical writings are clarified for the general public.

The documentary picture collection in a library should be organized on a basis of comprehensiveness, with emphasis on the clear definition and visibility of a picture rather than its artistic content. Since these are documents, the selection by the librarian should be kept at minimum. In a library, the public selects and chooses; in a museum the staff sets up standards since it is the function of a museum to guide the public and set up what the public may see to improve their taste. The library has a different role. With the vigor of impartiality, it marshals documentary pictures and through classification and editing, offers the public an impartial pictorial record of man's cultural heritage, his life and history which they may use as they see fit.

Nothing is more amazing and gratifying in work with pictures than the limitless ends to which pictures are put to use by their users. One experience at the New York Public Library picture collection furnishes a good case history of the many roles of a pictorial document, showing the multiplicity of interpretations and applications a single picture can undergo. One of the Farm Security Administration photographs is that of a sharecropper's wife standing at a shack door. She rests her youngest baby on her hip as two other children cling to her skirt; they are undernourished and unkempt and stare directly at the camera. Obviously, the mother is soon to have another child. This photograph has beauty and the feeling of the cameraman comes through to the onlooker. It was made as a routine pictorial report on the conditions which follow in the wake of drought and dust.

The Library's first use of this picture was as part of a display on People and the Soil. A mural painter borrowed it to incorporate the types in a fresco he was painting for a hospital ward. A birth control society needed it as a good illustration on the importance of limiting families; a Catholic charity organization reprinted it on a leaflet soliciting funds for the needy; a Fascist journalist wanted to have it as an illustration in his Milan paper in order to ridicule Democracy and show "documentary proof that such a way of life breeds only poverty among riches"; a lecturer displayed this photograph to his Negro audience to bring to their attention that there are white people who live in shacks and starve and that poverty has more

than racial implications.

A picture that is a straightforward, simple statement of observation is an effective medium for the dissemination of ideas. It can be a dangerous and a benign influence; it can be the source of facts and of lies; it is an insidious source of propaganda. It is always useful for conveying messages to all of the people because it is the most specific, easily understood and cheaply available record of human living.

We can hardly comprehend the immenseness of this medium of words and pictures. The full effect of the constant infiltration of edited visual printed images is too frequently slighted by those who work with words. Pictures are an active force in education and should be harnessed to the highest purposes, to stimulate the present and succeeding generations. Pictures are essential to libraries where they should join books and serve as documents of man's own aspect and that of the changing times he has lived in.

We join with Philip Hofer* to say, "I only believe that as illustration has been in the past, so it is, potentially in the future, a far greater means of conveying ideas, and so a far greater force than the world at present conceives."

Visual records of our times seem more precious than ever before. So much of the world and its people is changing at a rapid pace, the land, the customs, and the rounds of domestic life. We look to the pictured image; it is only through this, whether by draughtsman or photographer, that the world of the future will see us, see the appearances of everything around us. Words alone are not enough, pictures visualize the form and shape of things destroyed, irrevocably altered – Wren's towers and the streets of Madrid.

*L.C. Wroth, editor, History of the printed word. New York: Limited editions club, 1938. Pp. 389-446.

Fitted coat. Designed by Pearl Levy Alexander. Pencil, gouache on board. 1939.

Chapter Six

Annual Reports, 1940 - 1953[7]

Annual Report of the Picture Collection, 1940

Excerpted from: *Bulletin of the New York Public Library, Astor, Lenox and Tilden Foundations.* New York. Volume 44, pp. 265-267.

A chronology of requests for pictures strikes the same note as a chronology of events. In 1939, pictures were wanted of the deathbeds of popes, curtsies to kings and queens, Albanian farm buildings, Polish convents, the Russian bear, spy investigations, the Four Horsemen, jalopy used by California migrants, the burnoose, the evolution of the sailor hat for women, passementerie, airplane carriers, submarine rescues, the crew dead on the *Monte Carlo*, colored fireworks, water festivals, insufficient playgrounds, mutual betting, Pinocchio and Picasso, Stalin, Hitler, and Chamberlain.

The juxtaposition of picture requests arouse curiosity about the use for which such varied subjects are needed. Often, the use amazes one as much as the request. The public asked for pictures of the cells of a frog's skin, turkey tracks, a plucked goose for use in a political cartoon, a watermelon sliced to ascertain a color described by cable from abroad, doughnut dunking, angles of kissing, reticules, a chuck wagon, a truck transporting automobiles on a highway, ice sculpture, catchpole such as bailiffs used to catch debtors, a straw ride, a hair-growing machine, underwater torches, blinders on a horse, luminous organ of a firefly, farmer in a course of work which may result in an injury, microscope for observing blood, French key used in eviction cases – broken off and left in lock, sawed-off shotgun, and the interior of the Hippodrome.

During the year an experimental analysis of recorded requests indicated that

7 *Excerpted from:* New York Public Library. *Bulletin of the New York Public Library, Astor, Lenox and Tilden Foundations.* New York. Volumes 44 – 50, 1940-1944. Full texts available for years 1940-1944 on Hathi Trust site at: https://catalog.hathitrust. org/Record/000055341/Home Picture Collection annual reports for 1945–1953 were not published in the *Bulletin* and were only reported internally. See New York Public Library Archives, Picture Collection records, Box 7 f. 4-11 Annual Reports 1928-1999.

the most frequent inquiries are for pictures of techniques in the graphic and plastic arts, next, for all kinds of animal and plant life, and third, for portraits. Then, in less demand, come requests for costumes, foreign countries and peoples, interiors and furniture, New York City views, industrial scenes, sports, and the theatre.

In judging the needs of this type of picture collection it is essential to be aware of its function as a *general* collection. In planning for its maintenance, the general scope of its subject inclusion must be assured if it is to meet the calls made on it. Since its beginning this Collection has depended upon chance gifts, with a subsequent deplorable lack of pictures on many staple subjects. This past year, a more than normal purchasing fund helped effectuate planned buying to fill in those gaps. Gifts during 1939 numbered 54,088 items, including 11,224 photographs, 23,830 clippings, and 1,620 proofs. The entire file of classified stock is now 937,816 pictures, of which 62,176 pictures were added during the year.

Beginning with the decade of the thirties, the candid camera and picture magazines such as *Life and Look* came into being with a trail of encouragement in the use of pictures throughout all phases of living. There was an extension of the fields in which picture information was necessary. Federal art and theatre projects brought an increased familiarity with our cultural heritage to a general public, followed by interest in pictorial documents on arts, history, and science. In this decade a preponderance of painters, sculptors and muralists learned to use these files. The use of the Picture Collection by advertising agencies was almost wiped out in the first depression years but is now restored to greater activity.

In these ten years, Picture Collection changed to an open-shelf type of library, issued its own borrowers' card, developed an unmounted type of picture for circulation, decided a new scheme of classification for pictures, made a record of its subject headings, started an exhibition and display service with pictures, and organized a subject index to moving picture stills. Before 1929 no reference was permitted. Today this part of the service is established as indispensable to the general public. The stock has been improved by the addition of actual photographs, by the addition of framed pictures and hot-pressed color prints, all available for circulation. The greatest improvement is the building up of the reserve stock of solicited material and gifts, which is classified and available in specially designed storage boxes.

In 1929, the picture stock was 222,828, at the end of 1939 it reached 937,816. In 1929, the circulation was 174,510, in 1939 the circulation was 854,551 despite curtailment of circulation due to insufficiency of staff.

In the fall of the year the trained and experienced W.P.A. staff was dismissed because of general cuts in appropriation. This brought a standstill to all work on the list of subject headings, brought a stoppage of all exhibition work with branch libraries and a general curtailment of all work with the public.

Identification marks on wings of Army pigeon.
U.S. Signal Corps. photograph, n.d.

Annual Report of the Picture Collection, 1941

Excerpted from: *Bulletin of the New York Public Library, Astor, Lenox and Tilden
Foundations.* New York. Volume 45, Jan.-Jun. 1941. pp. 282-284.

Pictures are wanted even though it may take thousands of words to distinguish or clarify their meanings. Listening may divert from reading, but the desire and need for visual experience remains. The classified pictures in a library file have far-reaching power in the unlimited ends to which their contents are used. The multifarious uses of pictures continue to astonish those who work with them.

Drawings of beggars by Jerome Bosch served an orthopedist who was tracing the introduction of hand-grip crutches; a bag worn by the beggars served a fashion designer as a basis for a new type of purse; the same print helped a lecturer on public health to illustrate medieval community's neglect of the chronically disabled. A photograph made for the Farm Security Administration showing a mother in a sharecropper's family with three young children tugging at her skirt and an infant in her arms, was used by a religious organization to solicit funds for the poor; the same photograph was used by a birth control society for propaganda; a visiting European used it to comment disparagingly on life in a democracy, and a mental hygienist used a detail of the mother's face to demonstrate the link between insecurity and mental diseases. Pictures of eagles served the War Department for recruiting posters, gave embroiderers motifs for handkerchiefs, supplied a drug firm with a pattern for packaging its products, and yielded a device for a political campaign button. A staff artist of a museum used the same pictures to study inexpensive lithograph processes used in printing illustrations of birds.

An analysis of requests for pictures revives events and personalities. Even a list of the animals most frequently called for during 1940 gives a glimpse of the events of that year: Trojan horses with Fifth Columns, donkeys and elephants with elections, mules with conscription, doves of peace with invasion. Fashions and screen favorites appear as frequently as offensives and retreats. Helmets on the shore at Dunkerque were asked for in the same breath as the feather headdress of the Fijis. There were the usual requests solely of new origin- Lord Byron fighting for Greece, "horses and 40 men", soldiers using toothbrushes, Roman tax collectors, delousing machinery, bottlenecks, teeth extractions, hay wagons, and war tanks. There is

always the perennial type of picture for cracker barrels and stuffed squirrels, for noodle cutting machines, ink renderings of lamé, of satin and of lizard grain, for Barrymore's; attest profile, fishes with their heads out of water, skiers with feet sticking out of snow drifts, cancer of the lip, handlebar mustaches, little girl hair styles, exhibits in a murder trial, electric chairs, a chaise lounge, famous people who look like animals, asphalt aprons, Chesterfield coats, early ironing boards, broken arm slings, collection baskets, statues of small-town benefactors, a dirt road in the rain, sink faucets, grapefruit blossoms, floral horseshoes, historical and biblical running sores, and for the weave of a gabardine.

The centering of fashion design in this city brought a greater dependence on these files for costume history and ideas. The background and history of the Americas, and the pictorial aspect of their peoples and places, were studied anew for adoption, especially by the many artists and craftsmen transplanted from European workshops. The competitions for the decoration of Federal Buildings again brought many muralists and sculptors to use the Library's picture service.

Public dependence on this picture collection grew rapidly, suddenly, and over-whelmingly in the past few years. The service was seriously overtaxed, with no compensating increase in funds for supplies and additional appointments to the staff. Proper care of the picture stock lagged far behind the wear and tear of daily use. By the beginning of 1940 an emergency existed. The only proper solution would have been adequate financial support based on a recognition of the importance of these picture files. In order to avoid a complete breakdown of service, partial curtailment in the hours of opening was necessary. Beginning on the first of March 1940, this department was closed to the public indefinitely for two days of the week, Wednesdays and Fridays. Such curtailment in hours of opening did not greatly diminish the use of the files nor did it lessen the amount of work involved, since it resulted in great crowding on the four days the department was open. But the staff gained uninterrupted time in which to do routine work which had fallen far behind; thousands of pictures were remounted, reclassified and made available. The entire section on costume was reorganized and rehabilitated. Through the generosity of an anonymous donor, a special binding machine and tape and a display typewriter were purchased. These new tools eliminated the necessity for hand-lettering and effected durable folders. On the closed days W.P.A. workers completed the first check list on cards of all the subject headings in use for the classification of these picture files.

In addition to the curtailment in hours of opening, two whole sections of the

Collection were closed to the public: the file of indexed motion picture stills and the file of reproduction of paintings. The unavailability of the stills has hindered research workers and illustrators who have had no other source from which they could borrow photographs which reconstruct the customs of other times and places. Both of the closed files were very popular, especially with art students, and had become worn, ragged and in need of repair. The stills have always been housed temporarily in crowded, heavy wooden drawers which the public found awkward to handle and often dangerous. Many of the stills are irreplaceable and unless properly mounted cannot be used again for circulation.

It is evident that the public comes to the Picture Collection because it needs the Picture Collection, since the inconvenience of curtailed hours has not discouraged its use. Despite this curtailment of one-third in hours of opening and one-eighth of the picture stock, 704,298 pictures were borrowed in 1940 for home use. This, a decrease, is approximately one-sixth less than the circulation for 1939 and is the lowest circulation since 1934.

It is quite obvious to the public and the staff that this curtailment has seriously impaired the service. Pictorial documentation, necessary and indispensable to many private and public fields of activity, suffered days of postponement with subsequent loss of work and working time. Picture stock deteriorates in storage and fails to serve contemporary needs. Drawings for air raid precautions, for camouflage, and for recruiting posters, are typical public requests which were delayed.

The public is disturbed by the situation and has voiced its surprise that a service which has proved its popularity and usefulness cannot find adequate financial aid. Friends of the Picture Collection established a committee which made sincere and active efforts to secure means for reopening the department full time.

At the end of the year there were 982,819 classified pictures in the collection. During the year 45,584 were added, the smallest number of additions since 1931. Gifts of 191,130 items came from a grateful public. Included were 11,705 photographs, 7,035 motion pictures stills, 10,821 cards, 89 posters, 266 books, 1,290 proofs and illustrations.

This collection should continue to function fully and should be allowed to develop in response to the need of the largest community of artists in the world, where it plays an essential role in the work of the teacher, student, apprentice, and artist. "These documentary pictures are as essential to the creative artist as his color and clay," wrote a group of our leading painters and sculptors in a letter to the Mayor.

Work Relief Projects (p.253)

The types of work done by W.P.A. workers in the branch libraries continued as reported in previous years. At the end of the year, 320 men and women were assigned to the branches to do various kinds of clerical work, which enabled the professional staff to devote more time to professional phases of library service. The largest group of workers was assigned to the Picture Collection, where there were thirty workers.

Annual Report of the Picture Collection, 1942

Excerpted from: *Bulletin of the New York Public Library, Astor, Lenox and Tilden Foundations.* New York. Volume 46, Jan.-Jun. 1942. pp. 304-306.

Visual records of our times seem more precious than ever before. So much of the world and its people is changing at a rapid pace, customs, costumes, buildings, and the rounds of family, social, and domestic life. We hold on to the pictured image; it is only through a pictorial record, whether by draughtsman or photographer, that the world of the future can recall the appearance of things now taken for granted. Pictures are searched to refresh memory of what people wore, their manners of eating, their dancing, and the form of their dwellings. Words are not enough; the pictorial records are necessary to visualize the form and shape of things destroyed or irrevocably altered – the appearance of Wren's towers or the streets of Madrid.

The requests for pictures during 1941 reveal how deeply the public delves into the intimate detail of homely or ephemeral objects from soup tureens to pen flourishes and automobiles wrapped in cellophane. Many of the requests spring directly from the immediacy of events; pictures of arctic uniforms, jeeps, Vitamin B crystals, boom-town dwellings.

The popular pictures of one year may continue so perennially. The call for pictures is basically similar year after year; changes, however, are noted in the purposes for which these same pictures are used. The view of a forest that has for years served mural decorators and school teachers is suddenly important for the design of camouflage construction. The Hawaiian hibiscus, serving for travel poster and sheet music cover, is used to make a war slogan poignant. The eagle of a National

Seal takes action on recruiting poster and Defense Stamp.

In 1941, 598,624 pictures were circulated. This is approximately 106,000 less than during 1940. The curtailment of hours opening, begun in 1940 when the Collection closed all day Wednesdays and Fridays, is still enforced. In addition to this curtailment, several sections of the files were closed off, and new restrictions instituted. The concentration of interest on military subjects and on the panorama of regional American design, American folk arts, and the events of the American past overwhelmed the supply of picture material, and many pictures in these classes were restricted to reference only.

The cut in circulation, and the time achieved by curtailing hours of opening, provided time for detail work sorely needed. Worn folders throughout the files were rehabilitated; the files of paintings were checked and revised; the classified pictures from A through S were stamped with an identification or possession mark; 155,000 pictures have been mended, 80,000 mounted; of the latter, 7,000 were photographs mounted by hot-press.

The motion picture stills file has been closed to the public for two years. The pictures were in need of mounting, and the equipment in which they were filed was hazardously dilapidated. In the fall of the year, a project was set up to mount the stills; W.P.A. workers were trained and assigned for this task; equipment and material were set up in newly provided stack space. In three months, 10,000 stills were mounted by hot-press.

The W.P.A. provided steel equipment, which was assigned to the Picture Collection, in order that these stills might be made available to the public. Also, steel equipment was received to house the materials used in the processes of mounting, mending, matting, and binding the picture stock.

With the increase in equipment and work processes, space in the room was rearranged. Exhibit files, now closed for three years, were removed to temporary quarters outside of the Division.

During the year, 40,202 pictures were added to the classified stock, bringing the total to 1,019,721 classified pictures. Gifts were received in generous quantity; of 81,088 items, 15,255 were photographs, 7,326 moving picture stills, 27,677 clippings, 2,534 copies of magazines. The most interesting accession was a file of photographs entered in an amateur contest between 1895 and 1905; these were productive of detailed views of interiors of blacksmith shops, middle class homes, and life on small farms throughout the United States. The Portland Cement Association and

the United States Army Information Service made large gifts of photographs. From several anonymous donors, money was received for use in the purchase of supplies. Money was given to the Library by the Friends of the Picture Collection for use in rehabilitating the motion picture stills file.

The friends of the Picture Collection, under the leadership of Mrs. Nicholas Riley and Mr. J. Vincent Keogh, carried on an intensive budgetary campaign in the interests of this department. The committee published a leaflet, of which 4,500 were distributed; 1,565 persons were enrolled as members. The *Herald Tribune* commented editorially, PM ran several articles, the magazines A-D published a long story with several pages of illustrations.

Pictorial facts derived from the files of the Collection helps in the preparation of visual air raid precaution directions, in the planning and construction of camouflage devices, in the design and rendering of recruiting posters, in the visualization of American ideas, and in the propaganda of nutrition, civilian defense, housing, and public health. Graphic representation can be understood by all of the population and is of heightened importance in a period in which there is less reading. Pictured facts must be kept available as tools of education, stimulation and propaganda.

Annual Report of the Picture Collection, 1943

Excerpted from: *Bulletin of the New York Public Library, Astor, Lenox and Tilden Foundations.* New York. Volume 47, pp. 210-212.

The enemy loomed large as the most popular subject in picture requests during the year. Since a soldier is taught to bayonet the enemy and not some undefined abstraction, he must learn to recognize that enemy; a bombardier must be able to visualize the appearance of the factory which is to be his target; a designer of camouflage must have the specific knowledge of the shape of forests in the battle area as seen from the air.

War leaders require pictorial surveys preceding decisions of strategy and action. Direct information for the use of the Army, Navy and Marine Corps was supplied by this picture collection through photographs of territories along the routes of the planned action. Just before the attack on Pearl Harbor, the travel bureau of an Axis country donated its photographic collection to this department. In January, these

photographs were turned over to the Army Air Corps headquarters for filming and enlargement; they were "of immense value in the prosecution of the war"

Long in advance of the invasion along the Mediterranean, leaflets, clippings, photographs and post cards from the Picture Collection were consulted by the information services of the War Department for pictorial facts about North Africa – air views of railroad terminals, shapes of leaves of poisonous plants, the sheep dogs used by natives, native dwellings and the natives themselves.

To prevent the inadvertent disclosure of strategic military moves, the entire geographic collection, about ten per cent of the entire file, was withdrawn from public use and reserved for government agencies. Otherwise the calls for scenes of Sicily, the valley of the Ruhr, factories at Essen and Turin would have left obvious gaps.

Pictures borrowed from this collection helped impart the visual facts and experience which are necessary equipment for warfare of global extent. The pictorial needs of the government were not fully met by the existing picture sources in Washington, and the lending privilege of this collection enhances its usefulness by freeing the pictures for direct participation at conference table, camp and laboratory. These pictures are used by the government to illustrate manuals and films; to yield information of military interest in the assembly of facts about the enemy; to strengthen the power of printed propaganda by addition of visual interpretation; to simplify and dramatize messages to the people; to foster morale, loyalty and unity through the graphic media of cartoons, photographs, posters and moving pictures.

Artists employed by the Graphics Division of the Office of War Information asked for selected sets of copies of past works of art which portrayed ideas of freedom and the dignity of man. There were frequent calls for earlier representations of the results of tyranny, the horrors of war, the exodus of peoples, lawlessness, uprisings, the masses, courage and the steam of battle. Prints after Goya, Kollwitz and Daumier took on fresh popularity and helped inspire the contemporary artist, including men in service, to produce a full-blooded art with which to stimulate the nation and inspire the worker and the soldier. In the editing of government propaganda. In the formulation of ideas and the selection of illustrations, the staff of this department, because of their specialized background and their knowledge of picture techniques, was consulted by government picture editors, designers and researchers.

Possibly the most lasting war service of this department was aid in government propaganda and information addressed to the people of the United States. This is aimed to create a full awareness of the role of the civilian in wartime, to teach

the implications of a total war, and to reaffirm the promises of democracy. There was a mounting interest in the history of racial, religious and national minorities. Picture editors from Washington spent days here analyzing and selecting the pictorial record of the life and cultural contributions of the Negro in America. Pictures from the collection helped new citizens and foreign-born groups in the indoctrination of American ideas. A typical activity was the preparation of a pictorial display for local trade unions whose membership is largely Italian. This exhibition of Library pictures served to recall that Italy has a tradition of liberty and that Fascism is a temporary growth.

The pictures in this department were on active war duty, not idle and unemployed. In 1942, 399,234 pictures were borrowed – testimony to the persistence of the need for pictorial data. While the circulation of pictures dropped thirty-three per cent below that of the previous year, there was a large increase in reference work of which no statistical record was kept. This is attributed directly to inquiries from government agencies and individuals in the armed forces, particularly the Office of War Information, the Coordinator of Inter-American Affairs and the War Department Film Production laboratories.

With the addition of 44,022 pictures during the year, the total of classified pictures is now 1,058,611. Through the continued interest and generosity of users of this collection 105,556 items came as gifts; these included 17,413 photographs, 15,608 stills, 8,207 printed pictures. Unusual material was received from Mrs. E.H. Dawson, Mrs. Edith Denton, Ruth Freund, Marie Malmquist, Mrs. Charles Mergentine, Mrs. Eric W. North, Mrs. Francis M. Pinkney, Mrs. R.O. Smith, S.A. Bloch, Joseph Cornell, Stephan Lorent, Oliver M. Sayler, the Columbia Broadcasting Company, Hanzl-Hanzl Art Service and the S.T. Seidman Company.

The withdrawal of all W.P.A. workers from this project in May was a loss of two-thirds of the staff and resulted in further curtailment of the service to the public. The entire collection was changed to an "open shelf" basis and the public was allowed direct, uncontrolled access to the picture files. This has brought alphabetic disorder and breakdown of the overtaxed equipment, but there was no alternative other than complete shutdown.

Decorating a soldier's grave in one of the Negro sections on Memorial Day. Arlington cemetery, Arlington, Va. 1943. Office of War Information. Esther Bubley.

Annual Report of the Picture Collection, 1944

Excerpted from: *Bulletin of the New York Public Library, Astor, Lenox and Tilden Foundations.* New York. Volume 48, pp. 329-331.
(not listed on Hathi Trust web site)

With gargantuan strides, the use of pictures has advanced since the start of the war. With desperate need for speed in the communication of ideas and information, and for precision in visual recognition, pictures were used in all types of training for the armed forces, and in propaganda and information for civilians. The combat use of the penetrating eye of the camera

has increased dependence on pictorial information. Today pictorial reference work accompanies most training programs.

New concepts of distance required a fresh orientation for which pictures were indispensable aids. Navy, Army and Coast Guard personnel training courses called on the library's picture service in their production of visual instruction devices.

The first year of the war brought overwhelming inquiries for geographic information. The second year showed a swerve from requests for the geography of invasion to requests for the geography of the future. From intense terrain study and orientation in the life of peoples abroad, the trend turned to the task of enlightenment, toward new methods of speeding the education of all peoples in order to achieve awareness of our basic ideals. Ideas for planning and designing for after-the-war living took notable presence over all other pictorial inquiries. Calls for more realistic and less sugar-coated illustrations of the war increased as the year progressed.

Pictures from these files actively participated in propaganda, orientation, analysis, and the dissemination of information. They are participating in the designs of the future, helping the public visualize things that are and that might be.

In a sense, the library breaks out of its confining walls, and through the circulation of its stock becomes a participant at the educational and propaganda front wherever that may be. It is gratifying to report that in 1943, pictures from this collection were on display in Cairo, Egypt, and that simultaneously some pictures of Lincoln lent by mail were functioning in London, that pictures of the Gay Nineties were busy at camp shows giving ideas for entertainment and staging; that a painting of the battle of Stalingrad at the Soviet Embassy and the camouflage work of an army engineer and maneuvers in Tennessee – both stemmed from research done here; that on life rafts in the Pacific the sketches of edible fish in guide books had been drawn from the library's pictures and that in an Army medical museum, students visualizing ancient Roman methods of protection against flame throwers used our pictures; that scenes of Valley Forge, borrowed from the Library, appeared in a Chinese newspaper to spread familiarity with the American tradition of fighting for liberty.

The general use of pictures to illustrate ideas expressed in words brought new and stimulating excursions of effort for the staff this year, particularly in calls for help to combat ideas of race superiorities. Pictures were selected, gathered and made part of circulating exhibitions to give potent, visible testimony against false ideas about racial differences. These displays helped prod or introduce a desire to

read about the subject.

Exhibitions were prepared for use in camp training courses, such as the Northwest Passage exhibition for Fort Monmouth, and for use in giving young officers training at Yale University familiarity with foreign places of assignment. An exhibition "Words at War", using pictures, poetry and booklist was prepared in twelve units, and has been on continuous view through circuits since August. The fan mail it provoked gave full evidence that the library was active in communicating ideas directly to the people. A composition of a cantata for soldiers was inspired by the idea of this exhibition. A news dealer wrote it gave her personal comfort and new faith. A painter asked permission to express the idea in terms of an easel painting. A precision instrument factory owner asked to borrow the display as a morale builder for the workers there.

Not the pin-up girl but the typhus louse, the hari-kari knife, the war paint on an African's face – these were the popular picture requests. Purposes of war were served by pictures of the patron saint of tailoring, by the propeller of a seahorse, by pictures of electric light fixtures in a European peasant's house; not the texture of the skin you love to touch, but the texture of bread; starlit skies not illustration for a romance, but for weather charting.

Since March 1941 this collection was closed to the public two days a week due to the full stoppage of WPA aid. This closing worked a real hardship on the public. Since then, representatives of local and national art organizations, including the Scene Designers Union and Artists for Victory and many individual artists have formed a committee of "Friends of the Picture Collection" organized to further the interests of this picture service. Under the leadership of Mrs. Nicholas Riley, they motivated publicity, circulated leaflets and made personal calls on members of the City government. Full proof of the effectiveness of the work of this group came in the gain won in the 1943-1944 City Budget, when funds were allotted for four additional members to this staff. On the basis of this increase, the collection resumed full time service on October 15, 1943. The picture files are now open to the public every weekday from 9-6, closed Sundays and holidays.

Through funds donated by the Friends of the Picture Collection, the mounting of a file of 40,000 moving picture stills was completed. This minutely indexed file, although greatly in demand, was closed down for years because of lack of funds for its re-conditioning.

The use of the collection by individual borrowers dropped off considerably.

Nevertheless, the work of the department continued to expand, especially in reference and consultation with groups, schools and governmental agencies.

During 1943, 47,462 items were classified enlarging the total of the classified stock to 1,099,982 pictures. The work of keeping up with incoming material became an alarming problem because of space limitations and lack of equipment. In 1943, 165,094 gifts were made to this department. Of these, 100,274 were photographs. Since this collection is the only free source from which photographs may be borrowed by the general public, it seems important that material in demand should be added. But no growth is possible unless space, staff and equipment are provided for the work of accessioning and handling. Ten years ago, this collection contained practically no photographs except moving picture stills. For the last decade, an average of 25,000 photographs was added each year. All through the past year, the use of the files was greatly hampered and often completely inefficient, since more than 25% of the picture stock was inaccessible.

From a foxhole came a letter from a soldier who in civilian life had made good use of the picture collection. He wrote to report that he had been pleased to read in the papers that photographs from these files helped the Air Force identify Japanese terrain. He asked that we reserve some space now for post war exhibition of his work since between combats he was recording the strange sights along the Army's path.

Annual Report of the Picture Collection, 1945

Excerpted from: *Bulletin of the New York Public Library, Astor, Lenox and Tilden Foundations.* New York. Volume 49, pp. 227-231.
(not listed on Hathi Trust web site)

The first American artist to enter Paris with the American Army of liberation dropped into the Picture Collection on his return to see if it was still functioning. His first comment delivered with a sigh was a wish that he could have had the whole file of these pictures with him on his jeep as he went into Luxembourg. Now returned to record what he had seen, he was anxious to borrow pictures from those German magazines he had mailed to the library from Germany. His memory needed refreshing before he made his drawings.

As in peace, so deep in wartime, the daily calls on this picture service emphasizes

the Library's role as a great tool for democracy. The collection continued to record life in remote places and life today as it is preserved in images on the printed page and in camera prints. All facets of each subject were freely included and available for everyone's use. The preciousness of this democratic privilege impinged itself frequently on the staff this year because of the many visitors from central and South America who expressed their admiration for the simplicity of the organization of these pictures, the scope of our intentions and the breadth of the American concepts of library service.

Again, in this war year, this picture collection was most useful when comprehensive picture coverage was called for, since only here could be found swiftly both the factual camera-eye records and the interpretations of graphic artists. In a few minutes consultation, government workers found isometric drawings of machinery, Dali drawings of melted clocks, Leonardo sketches of bird-flight and moving picture stills of Balinese gestures.

Soldiers from a proving ground (artists in civilian life) obtained permission and were assigned to come up regularly to do picture research work at this collection. They were able to find and borrow several <u>hundred</u> specific subjects from this file; otherwise these would have had to be located and solicited from as many agencies as there were subjects.

Most of the soldiers and Navy men who were assigned to picture research work for their outfits were previously in the graphic arts field, but as a general rule, few of them had ever been to New York before. At first overwhelmed and shy at the size of the collection, they soon learned to get about and then discovered that the files included many pictures of the work of artists in many mediums. This excited them into wanting to learn how they could obtain the use of such pictures after they returned to their hometowns; would their local libraries help? One soldier duty bound to borrow colored pictures of fleas and mites ended by taking along some reproductions of Chinese paintings – he said that he never before had had the chance to see copies of Chinese art. On his first furlough from camp, he came back to New York and spent two mornings studying the material here, copying out sources for the purchase of such prints after the war.

So too, British government employee from Dover, on leave from work at Trinidad passed by and came in astonished at the idea that pictures may be borrowed. She returned later to discuss ways and means for establishing such picture services. She planned to set up a collection on the history of art to educate her neighbors and so

create a soil for the encouragement and support of local artists.

A congressman's hairdo or an event on a battle sea – and the library picture files were searched for parallels from the past. A hint of post-war living – and pictures of Utopias were asked for; the bravery of Negro troops in Italy rekindles in the storming of San Juan Hill by a Negro regiment in the Spanish-American War. When Governor Dewey's mustache came into the limelight, the faces of past presidential candidates were studied for examples of other tonsorial styles. Bloomer girl's debut was greeted by the press with pictures of famous women who had worn trousers.

The most striking change in the use of the collection this year was the increased number of high school and younger children coming in search for illustrations to help their school studies or hobby interests. It was obvious that they should not be turned away as there is no other free source from which pictures on general subjects may be borrowed. The students came from all parts of the city and from technical trade and art schools, both private and public. They were seriously aware of the importance of pictures, were visual minded and alert in their selections.

1944 saw too an increase, quite generally, in the use of drawings and paintings as illustrations instead of the previous preponderance for photographs. The Modern Library series of illustrated classics, now language manuals ably illustrated with line drawings, the many picture histories and new editions of picture encyclopedias all contributed to increase use of the library's picture resources. Then too, the advertising agencies veered away from exclusively using photographic illustrations and employed artists, using those high in the field of contemporary art. The enormous program of advertising to maintain public familiarity with brands to assure future markets, also increased commercial art output and contributed to greater demands on this picture service.

Substitute for scarce consumer goods challenged the American designer and led him to restudy older forms of design and motifs from the folk art of the United Nations. The influx of jewelry and accessories in women's wear made in ceramics derived a good measure of inspiration from reference work with pictures. So too the display field, in which New York City certainly leads the world, leans heavily on library sources since these windows keep abreast of news trends. These were often media for government drives for home front participation and the background of these patriotic displays usually required historical pictorial backgrounds.

Not for years, not since the days of the Federal Theatre, was there so much activity in stage designs for costume and sets and the picture collection served bal-

let, opera, Shakespeare revival and a Mae West production of *Catherine was Great.*

No, these were not pictures in an exhibition – they were pictures actively part of the business of the home front in school, at the theatre, in the plant, at a copywriter's desk; actively part of the war and the aftermath of war. Used in the rehabilitation of the wounded, used to bring to postwar planners pictures of the slums they could prevent, used to show the results of intolerance as lessons in democracy.

A nun, illuminating a manuscript in a nearby convent, borrowed a picture to recapture the character of an historic style; a fashion designer from a library picture, reinterpreted a Spanish peasant costume for a movie; a manufacturer with an order to produce cotton goods for lend-lease purpose, found a design to print on the fabric which would be familiar and in colors popular among the native peoples of a certain African colony. Paris was liberated, and at once the many French publications here borrowed all prints of cocks crowing. A veteran in a Bronx hospital, found in pictures from the Library the information he needed to busy himself with the construction of model coaches; and in the same hospital some convalescents were happy looking at thin, lightweight reproduction of modern paintings – too weak to hold books, too fed up with comic strips and cartoons, they asked to borrow pictures from the library. Some children in a delinquency-breeding neighborhood were talked into painting a mural for their clubroom wall. They were shown how to use the picture files as a springboard for the design. These children spent many hours on the reference work involved and were greatly stimulated by the freedom of selection.

1944, the year of invasion for liberation, was also a year of a Presidential election. True to tradition the people took sides. At such tie of strong differences of opinion, the library stood high as a great force and symbol in the dream of democratic processes. All through the campaign, both Democratic and Republican party campaigners used the Picture Collection, sitting side by side at the tables, often selecting the same picture – apple-sellers, Pearl Harbor, dictators, Lincoln, Hoover, Roosevelt, Hillman, Dewey – the same pictures used for both sides, but of course widely divergent captions followed. Each side came to the library, knowing full well, and, confidently expecting to find, and found the full, non-censored record of fact for each side to interpret as it would.

This year saw many reports published on the success of visual methods in the training and education of men in the armed forces, done with incredible speed. The Picture Collection worked frequently with the visual aids program of the War

Department helping in the picture research work for visual kits, animated cartoons and training films. Three years use of these methods proved the value and soundness of films and still pictures as adjuncts to books.

In the display and exhibit use of pictures there lies perhaps the greatest potentiality for giving directives in reading. All during the year, calls for library displays came to the Picture Collection and except on one or two instances the requests remained unfilled because of the lack of staff. In cooperation with the Central Circulation Branch it was possible to keep display boards timed to news events and so somewhat dissipate the general concept that a library must be stodgy and behind the times. These displays were shown in conjunction with books pertinent to the subject. Often the selected books circulated so fast that the shelves were empty, and the display had to be removed. Before Registration day, the emphasis was on the importance of the vote; on the day of the Normandy invasion, a display of past invasions was ready and on view before noon, exciting pleased comment from the public.

In November, a feature story describing the picture collection appeared in *This Week*, which has a circulation of several million readers throughout the country. The response in letters and telephone calls gave ample testimony that the need for library picture services is a universal one. Minister, housewife, soldier, member of a government-in-exile, farmer, hunter, nationally known political cartoonist and a city planner in San Francisco all wrote in to find out where and how they could locate some pictorial fact, some picture needed. The deluge of inquiries continued into the new year.

Work with the public was expedited this year by the opening of the catalog of subject headings, now sufficiently well along to function. Until the past year, there was no public index to the picture files. This catalog was started and worked on by the WPA staff of librarians assigned here ten years ago. In addition, the subject to pictures, including a personalities index and an index to stills from World War II moving pictures, was opened to the public.

The number of pictures borrowed in 1944, 436,398, was an increase of more than 44% over the circulation in 1943, although the collection was closed during the entire last week of the year. This increase does in no measure indicate the increase in reference use of which no record can be kept in these times. Also, many of these pictures were borrowed in the first three months of the year for constant use all during the year at Pawling, where they served in rehabilitation programs. Also, many murals were painted at airfields and camps and several hundred pictures were lent to

serve as temporary field picture reference collections while the mural was designed and drawn in by the soldier artists. Such sets of pictures were borrowed for three to six-month periods and this protracted circulation does not appear in the statistics.

The collection, as in the past, continued to depend on gifts for its acquisitions. In 1944, 90,899 pictorial items were received. Of these 33.498 were clippings, 9,782 photographs and 16,890 printed pictures. The stack of pictures has grown enormously, but since there has been no addition of storage and filing equipment in thirteen years, new pictures can no longer be added to the public files. They are now in reserve files under broad categories of classification. Nevertheless, in 1944, 61,358 pictures were classified and added to the picture stock which at the end of the year had a total of 1,145,564 specifically classified pictures. Also, during the year the entire reserve of portraits (approx. 30,000 pictures) was alphabetized and made available for circulation.

Through a grant from the Carnegie Corporation in 1942-1943, the Superintendent of the Picture Collection was given leave of absence to formulate principles underlying the organization of pictures as documents. During all of 1943 work was continued on this project, with an assistant carrying out the application of the theory to the practical selection of subject headings and the establishment of schemes for subdivisions. Although the text was not completed, throughout 1944, the staff found that the results of the work proved of good service in the classification problems arising daily. Many agencies, firms and institutions called on this staff for guidance in methods of approach to the organization of picture files. The help given would have been impossible if it were not for the preliminary thinking, formulation, and practical schemes evolved in the preparation of the manual. This unfinished manual is sorely needed for the work here as well as for the establishment of pictorial collections elsewhere, including those in the Library of Congress.

Annual Report of the Picture Collection, 1946

Excerpted from: *Bulletin of the New York Public Library, Astor, Lenox and Tilden Foundations.* New York. Volume 50, pp. 329-331.
(not listed on Hathi Trust web site)

T he eagle flew down from first place to the dove of peace as the most frequent request in 1945. On the announcement of the atom bomb, past pictorial fantasy was sought, visualizations of the world's end and pictures illustrating each step in the harnessing of nature by Man. Labor and the Press foreseeing the quick end of the war asked for pictures which documented the 1930's – the breadlines, the Hoover towns, the bonus marchers – unemployment and the visual evidences of its corroding power on human resources. Fashion looked back seeking in the styles of the 1920's the trend to follow in another postwar decade. The inflationary rush of buying was reflected in the number of pictures used for designing high-price luxuries, such as precious gems in jewelry. Calls for pictures of mourning wreaths and the bitter caricatures against the New Deal followed the death of F.D.R. The morning after the President's death, a young coastguardsman came to the picture files. With a gesture of speechlessness, he pointed to the portrait section and then sat for hours studying picture after picture of Roosevelt.

A greater dependence upon visual mediums to re-state the principles of Democracy brought many inquiries for materials to be used to propagandize the rights of minorities and to spread enlightenment so that the very freedom for which the armies fought elsewhere be preserved and flourish here. The supply of photographs did not begin to fill the demand for pictures of the face of the United States, the land and the people.

As during the first war years, again pictures were borrowed by educational, rehabilitation and hospital centers. Pictures of hometown main streets were lent to an Army post in Germany; pictures illustrating the world of Washington Irving served to arouse an interest in reading at an Army camp in the Southwest; pictures mailed to Paris were incorporated in a governmental educational broadside and filmstrip.

And the young men started to return. "Heard about this place in the Pacific, got to see it – I'm going to be an artist" "Just got back please tell me, have I lost my privilege – I've stayed away so long – four years!" Dashing from one assistant

to another, one veteran shouted "It's wonderful I am out – three days in civvies. It's wonderful and isn't this wonderful, this place here. Funny, I missed the library. Don't need pictures yet but had to come in and just look." Such incidents gave a bit of gratification to the staff, whose faith in the importance of maintaining the service throughout the war, kept them from leaving to accept positions outside the library where the same work receives far higher pay.

These veterans were given information about art training and refresher courses, about new trends in the field and books to read. In addition, the staff phoned and made appointments for the younger men with well-known artists and in many instances the returning artist found opportunities for apprenticeship and straight-forward professional advice. Refresher material such as good reproductions of con-temporary artwork and new prints of the work of the masters were purchased for the use of these men, so that very quickly the veteran would sense that the Library was geared to help him reconvert to peacetime pursuits in his chosen field.

Many of the returning artists brought sketchbooks full of drawings made while in service, all of which showed good promise and talent. Seeing these impressed the staff with the function of the Library to disseminate familiarity with the best of our heritage from the past and the work of the present, and to encourage the cultural aspects of life and respect for the arts so that all of this creative power may find channels of expression and a public to support its existence.

In 1945, 499,544 pictures were circulated, an increase of 14% over 1944. Checking through the subjects of these pictures, the pulse of contemporary life can be felt: bobby-soxers; seven-league boots; discharge button; wolf (not human); registering at a hotel; Quonset huts; riots against the invention of a machine; cloud chamber apparatus; polio victims; ancient Greek amplifier; Negro and White fac-tory workers on the same job; sirloin steaks; cyclotrons and bubble pipes; Sinatra, Eisenhower and LaGuardia; families suffering from the lack of medical care and celebrations of peace.

During 1945, 29,438 pictures were catalogued, bringing the total of specifically classified pictures to 1,165,136. This addition is about 60% less than the minimum required to keep the files superficially abreast of the news. This drop-in classification was directly due to the lack of skilled professional members on the staff.

From the public the collection received and processed 105,212 gifts including 25,357 photographs, 439 posters, 13,810 printed pictures, 4,127 prints and 20,239 cards.

The word picture is synonymous with quantity; on film it streams out in thou-

sands of feet and on the printed page it is reproduced in millions of copies. The nature of the camera image is a duplication potential; hence a representative collection of printed pictures should be a huge collection and should emphasize quantity, or it cannot function as a documentary tool. Since this collection was first housed in its present quarters in 1931, 1,109,885 gifts have been received; these included bound books, leaflets, magazines, and 293,918 photographs. The bulk of this materials has been roughly sorted and placed in active storage available to the public. In the same period, the classified collection has grown from 300,000 to over a million catalogued and indexed pictures.

In all these years there has been one slight increase in the allotment of storage and workroom space. There is no equipment for the photograph collections which are "temporarily" in paper boxes. The mere handling of incoming gifts is overwhelming, the work with the public is physically hard on staff and public alike. To make some immediate move to alleviate conditions, a major change in the arrangement of the room was affected this year. A partition which obstructed the corridor (it served to screen a narrow workroom) was removed and thus cleared the approach to the first door in the corridor so that this door could serve as the entrance to the collection. A partition within Room 73 likewise was taken away to make about one third more room for the files of pictures. Space was gained for shelving pictorial reference books, indexes to pictures and the catalog, all of which have been available to the staff only. To offset the loss in workroom space, the Staff library, Room 74, was assigned to the Picture Collection. This was organized to serve as a sorting and filing room for pictures returned from circulation. Approximately 30,000m pictures are processes here daily.

The walls and ceilings in Room 73 were painted, helping to brighten the room considerably. In order to realize the expansion every bit of stock and furniture had to be shifted and relabeled. This task took more than a year for completion.

The files are desperately crowed; nothing more can be done until a room is found more suitable for a pictorial service, until equipment and furniture is designed and made expressly for picture storage and handling. The pictures are still housed in pitifully inadequate and makeshift bins. The most important items, many of them unique and ephemeral, are without storage facilities at all. Although this picture service is more than twenty-five years old, with proven leadership in the field where it has served as pacemaker and pioneer, its physical condition is shockingly primitive. Professional methods developed by this staff are installed successfully elsewhere, while

no funds are found to realize them here. The salary scale is far too low to attract for long a staff sufficiently trained and oriented in picture work.

In cooperation with the Central Circulation branch, a program of display in relation to reading was carried out all year. Books not much in demand were placed in the limelight by dramatizing their subject content. Two display units were employed using good literary excerpts in montage with pictures. Books moved quickly; the response of the public so lively that often the display was taken down because the book stock on the subject was exhausted. Captions were devised which could easily apply to several subjects, e.g. They were there when it happened. These displays could easily be duplicated in quantity for the use of other branches of the library. It is most regrettable that funds are not made available to support a program for the duplication of these professionally designed and executed display units. With each change of display, inquiries and comments from the public testified to the impact power of the visual medium. Requests for the loan and purchase of the displays came frequently from schools, community centers and unions, but of course could not be met. During the year the use of words combined with pictures for educational and documentary display (as developed by the staff of the Picture Collection) was demonstrated and explained to many outside agencies.

A German-born artist remarked that what amazed him most about the United States was the unexpected richness of traditional American design. He was familiar with the tremendous natural resources of America, but he said nothing anywhere equaled the amount of artistic creativeness, the untapped talent of the American artist. This distinguished designer had held a high governmental post in Germany, which, he quit voluntarily to start a new life in America. He became a citizen in March 1945 and then wrote a letter to the Library enclosing a check as a "token of my gratitude to the great United States" where he found a symbol of democracy in this picture collection "the world's most outstanding source for Artists' research".

Annual Report of the Picture Collection, 1946

Transcribed from: Picture Collection Records, Manuscripts and Archives
Division, New York Public Library Archives. Box 7, folder 4-11,
Annual Reports, 1928-1999.

T he most graphic change as reflected in inquiries here is the great desire for
more people for orientation in the ARTS, while they reach for the material
necessities of life.

The use of the picture collection increased alarmingly and over-taxed its facilities;
pictures could not be processed rapidly enough to meet the routine daily requests.
Graphic artists were busier due to the many new illustrated editions published last
year; industry sponsored the work of more fine artists more artwork was incorpo-
rated in national advertising and manufacturers supplied more channels for the
output of American designers.

The sale and promotion of art, and the actual work of design is centered in New
York, now the world's largest community of persons engaged in art production and
art studies. Nowhere else is there such a concentration of art schools. Toys, shoes,
packages, window displays, advertisements, book illustration and design, animated
cartoons, stage-sets, furniture and jewelry – most of the multitudinous objects which
reappeared in the post-war marketplace – were designed within the periphery of
New York and depended either for ideas or for factual background on the Library's
picture resources, which to the artist are "as important as his paints and brushes".

Since there is no other source from which pictures may be borrowed free by the
general public, hundreds of art students, most of them veterans, used this service
and made a clean sweep of the reproductions of art. This often resulted in empty
files on basic subjects – subjects not found illustrated elsewhere except through
extensive search in many sources. To assure fair distribution, beginning August 1st,
the number of pictures which may be borrowed at one time was restricted to five on
a subject. This inconvenienced the public and diminished the value of the service.

Public request and expectation as well as its dependence on pictorial archives
is deep-rooted by now. The very growth of its usefulness seems to have brought
to this picture collection ever more curtailment instead of broadening of activity.

The circulation of pictures had been restricted before this, since undergraduates

may not borrow pictures, nor are pictures issued for classroom use, and pictures are not lent to the public through the interbranch loan service.

Despite these restrictions, from this giant picture dictionary, the public borrowed more than half a million pictures (507,276) in 1946.

Wartime uses fade away; pictures of foreign lands, formerly scanned for facts of terrain, now inspired alluring travel posters; air views of airports appeared as intricate traceries on dress fabrics and the blossom of the fever tree, no longer illustrating s cure of malaria, took form as a jeweled clip. Sand so, typically, pictures of calligraphic birds advertised perfume, the Nation's capital served for the shape of a wedding cake, knuckles gnarled by rheumatism were used by a physician for a scientific display; pictures of Senator Bilbo and a black Madonna were borrowed for an inter-racial magazine.

The reference use of this picture service has taken great strides in the last year, noticeably because of out-of-town researchers sent here for work entailed in the preparation of new types of pictorial books, periodicals, and encyclopedias. The requests by mail and telephone were more frequent. While these requests usually concerned the sources of pictures, many required consultation with members of the staff for individual direction on the handling of pictures, techniques of the display of pictures with words and on the selection of subject headings for the organization of picture archives. We were able to instruct several veterans entering the advertising field where picture files are an essential office tool. Such consultations were given on an average of 45 a month. These inquiries touched all facets of work with pictorial records. Publication of a description of the techniques developed here is long overdue.

The analysis of the organization of commercial picture agencies was continued and the work so far was most helpful in guiding the establishment of picture files elsewhere. It is gratifying to report that the theory that developed out of some of this work served as a basis for indexing sound effects in the film archives of a government collection abroad. In the Spring, a staff member was lent for five weeks as consultant in the preliminary planning of a photograph archives at the United Nation.

The branch library holdings of books in the Fine Arts were reappraised by two members of the staff of the Picture Collection. From this study a basic list was prepared to guide the purchase of books on art in branches serving the general public. The list is kept current and publications in the art fields are carefully reviewed from this specialized viewpoint.

Since many of the staff are artists, they are called on both by public and the staff of the Library for information and reading guidance in the techniques and mediums of the graphic and plastic arts. Their technical appraisal of books, their first-hand knowledge of professional problems of the practicing artist and the beginner, their creative familiarity with museum collections, all enhance immeasurably the use of the Library's resources by the art world.

To a large extent, the contents of this collection have depended upon the chance accident of gift and hence there are many gaps in the balance of subject coverage. The extraordinary interest of the public is attested to by the great stream of pictures, a total of one and a quarter million items in 15 years, donated to form this collection. In 1946, 134,684 gifts were received, of which 29,860 were photographs. During the year 51,999 pictures were classified and added to the classified stock which now contains 1,192,228 specifically classified pictures.

Cultural progress depends upon the encouragement of the creative artist. The Library's collections serving this important segment of the people should be rich in quality, broad in inclusiveness and must certainly keep pace with the highest standards and capacities of this group.

We have the public at our door, we see the need, we know how to meet it, we have the specialized knowledge and the trained staff but support in the form of equipment, proper housing, and funds for the establishment of reference archives are still lacking.

Pictorial records are an essential component of any study of man and ideas. Pictures are of universal interest and everyone enjoys viewing them. Looking at pictures stimulates interest in ideas and can ripen ideas into a full understanding.

Annual Report of the Picture Collection, January 1947 thru June 30, 1948

Transcribed from: Picture Collection Records, Manuscripts and Archives Division, New York Public Library Archives. Box 7, folder 4-11, Annual Reports, 1928-1999.

Although the Picture Collection has been in existence and functioning since 1915, its growth and development have been largely accidental and unplanned for. It began as part of another department and because of

the pressure of public request for a picture service the collection grew until, in the early 1930's, it was set up as a separate service within the Circulation Department. Then and today, 18 years later, the stock of pictures and the facilities are far from adequate for the public need.

The past 18 months, more than any earlier period, have demonstrated the obstacles that perpetuate the recurring curtailments in this service and the continued waste of personnel cost especially in the professional categories.

The Picture Collection no longer fills its purposes efficiently, it has actually broken down in its work with the public. Since its inception, the momentum of public need has spurred the gathering and organization of picture materials and the development of staff of librarians skilled in picture techniques. Direct public requests helped establish the system of picture classification and selection, as well as criteria for picture collections as part of public library service everywhere.

Since its beginning the Picture Collection has had no equipment of a semi-permanent nature – that is, equipment planned specifically for work with pictures. The result is that material classified and ready for public use is bogged down because of lack of filing and storage equipment. Pictures cannot be filed rapidly enough to feed the flow of requests. The investment of labor (we have had a large staff for the last seven years) is quite out balanced by the lack of the furniture and the tools the work requires. No matter how many pictures are added, no matter how increased the use of the files, the outmoded, makeshift furniture defeats our every effort. The equipment in use at present causes each process to be repeated many times before the pictures are ready for filing. The files of pictures are so empty that coverage of many subjects is scant and frequently presents a distortion of fact. For example, at times, the Negroes folders were empty of all but caricatures. This would not be distressing if the pictures were out in circulation, but all during the past year these pictures were waiting to be filed – useless for as long as three months after the date of their return from circulation.

At the peak of the Winter, the handling of returned pictures gave way. The increased use of the collection swamped the meager filing bins. Work was stopped until a careful study could be made, and comparison carried though with latest methods employed elsewhere. Nowhere else do comparable quantities involve the size range this picture stock presents. After a six weeks test, which proved successful, a new arrangement of alphabetic sorting was adopted to stagger the filing within the handicaps of the present makeshift equipment.

This breakdown was long expected, since it has been obvious to both staff and public that the housing of the pictures and equipment for their use had not kept pace with the tempo of the growth of public dependence on this service. It was obvious that the staff's time was diverted from direct service to the public to devise expedients against the collapse of the furniture, to extensive physical combat with storage equipment instead of work with pictures. We waste and misuse the professional training we urge new recruits to acquire.

The conditions in Room 73 became progressively worse during the year. Because of the paper shortage, folders in which pictures are filed were not replaced and pictures not mended. With increase in the number of persons using the files, control of the room became futile. Twice, extensive stealing occurred; some of it was encouraged by inadequate identification on the pictures. To protect the public and at the same time make foolproof the work of identifying library property, we installed a checking process which involved a nine-hour desk coverage to revise all pictures leaving the room; started in May 1947, it is still maintained.

The collection as a whole is irreplaceable and is one of the most comprehensive of its kind, and in many respects unique. Since its primary function is for factual information, it should be used under the supervision of a professional staff. It should be housed in stacks and used through written requests presented at a call desk. Until the year that the W.P.A. help stopped, the collection was so controlled. We then foresaw the present situation, but there was no way of maintaining a call service without a great increase in staff. It would require 15 additional clerks to handle a stack service under present conditions, and there is no room for the public to sit or stand while waiting. It was a question of complete shutdown or complete self-service, and the latter, at best a temporary expedient, is now failing.

The constant gratification the staff derives from the enthusiasm of the public and the dependence of the public on this Collection is now tempered by discouragement. The handling of disgruntled public has added to the other elements which are injuring our good record of public service. They comment and wonder why proper facilities are being denied such a popular section of the Library. As soon as subjects are in demand, restrictions are set up, because popularity taxes the storage equipment. This was the fate of the moving picture stills, now in storage due to the collapse of the wooden wall cabinets in which they were stored. They splintered so badly that we moved the entire collection into the stacks, because despite its popularity and despite the fact that it is the only indexed collection in the city, there

were no filing cabinets available to house them.

During the summer of 1947, one third of the reserve stock held during the war years to fill many calls from government agencies, was cleared and weeded to form the present compact second line of geographic stock. The entire Portraits file, which is considered the backbone of the collection, was checked through item by item and revised. With the aid of a special assistant, our important Post Card Collection was sorted, identified and dated. This makes available a rich source of pictorial Americana – our main streets and our towns State by State. From this, Fortune Magazine ran reproductions in color in the May 1948 issue. These postcards are housed in thin, paper, "shoe" boxes.

This year training of the staff in picture techniques became necessary as the part-time and restless temporary workers were replaced by serious young career women. In the Fall a weekly series of staff meetings was started with instruction in the theory and practice of subject heading work with pictures. Since similar classes are not given at library schools, the need for this training is obvious. These lectures proved a fruitful beginning and helped lead five members of this staff to enroll in professional Library Schools.

A Style manual for the cataloging of books used in picture work and books used as sources of pictures was finally completed. This includes styles for entry for subject indexing and the indication of sources. This Style manual was based on ten years development – on trial and error; and we can report that as it stands, this manual is a tool which will greatly simplify the training of new assistants. Until this year only two members of the staff could do this type of picture work, at present seven are in training.

An index on cards to sources of information about pictures in print and particularly picture publishers and dealers was brought up to date. This is an active tool in answering mail and telephone requests. It is a file limited to three catalog drawers. Gleaned from notes kept for years, it was set up and completed this past year.

The constant call on our staff to advise about sources of pictures and especially the organization of picture files cannot be discouraged, since the NYPL has proven leadership in the field. Throughout the year every Thursday sees a librarian either from a business firm, museum, or a foreign country, seeking guidance on the organization of picture files. The same day that the British Information Service asked for subject headings for their photo files, a committee of mothers from Parkchester came to learn how to start a picture file and where to obtain pictures so that they could

volunteer to organize a picture collection for their children at the local public school.

Each new year shows a widening of the variety of the use of this collection. Borrowers included playing card manufacturers, medical historians, show designers, television stations, banks, law firms, perfume bottle designers and dress cutters.

By July 1948, 1059 firms and organizations had been issued cards on which office staff borrows pictures for commercial, publishing and institutional uses. Registration of picture borrowers rose 30% in the first six months of 1948 with a 100% increase in the number of firms registered. While this is a large increase, the number of persons who did not wish to borrow pictures but preferred to stay and sketch from the pictures increased enormously. There is no room here for prolonged consultation of pictures and discouraging this use of the files became a time-consuming daily routine.

The past year saw a great extension of use by students who through the GI Bill of Rights flocked to the local art schools. The instructors, well known artists who have depended on this collection, made special arrangements so that small groups could come and be introduced to these resources for their future professional work. This has been a rich investment of our time and has given the staff an active role in promoting the quality of future artwork. It is good at this point to reiterate that this is still the only free source from which pictures may be borrowed in New York.

The requests for pictures during the year not only mirrored the passing scene but telescoped time and space. The public asked for pictures of: Tyche Brahe's gold-tipped nose; pies and popovers; cartoons on the Taft-Hartley bill; a woman surgeon in operating garb in the 1890's; Palomino horses; leapfrog; early history of the tin industry; LaGuardia; tattooing in color; camel after hair is shed; marble bas relief of Arnold's wounded leg; spinach leaf; Amish bonnets; edges of lakes; long necks; such as giraffe and swan; hen asleep; Gold rush period; blood hounds on the scent of criminals; feather duster; flag-drapes casket; buckskin shirts; miners' caps and stovepipe hats; blizzards. A director asked for actual photographs of lynching to help his cast develop a deeper understanding of the play in rehearsal; the Danish embassy borrowed pictures to be used abroad during a broadcast from the United States; an orthopedist needed a detail of Primavera's foot in Botticelli's painting to show that the glamour girl of that day had bunions; a man complained that he could not find a picture of an electric chair, although he had looked all through "Electrical Appliances".

Annual Report of the Picture Collection, July 1948 thru June 30, 1949

Transcribed from: Picture Collection Records, Manuscripts and Archives Division, New York Public Library Archives. Box 7, folder 4-11, Annual Reports, 1928-1999.

The gamut of subjects asked for last year at the Picture Collection is astounding, particularly as neither idle curiosity, nor hobby spurred the requests. Pictures on widely separate subjects were necessary for a Television broadcast to materialize, for men's ties to be manufactured, for an architect to landscape a cemetery, for a surgeon to give a paper on stumps.

Of things and peoples, short and tall, here and there, then and now, pictures were sought; of fact and fancy, of black and blue, of Bali and Coney Island, of helicopters and team calliopes, of Air Lift and bicycle built for two, of penny arcades and isotopes, of uncooked scallops and straw hats for horses – all in pictorial terms, all part of the picture needs of the world's largest community of persons engaged in the graphic and plastic arts.

For the first time since 1930s, pictures were asked for as data for travel advertisements. This was the first wide use of this material since the War Department illustrated guides and broadsides for top-secret invasion points. Scenes of the American countryside – maple sugaring, ice-cutting – served as designs for English pottery to be manufactured for export to the United States. The Presidential election brought all sides for the cartoon history of the major parties; elephants, donkeys, and ballot boxes from these files ended as buttons, banners and posters. The National Health Insurance debates made Fildes painting of a doctor at a bedside the most popular painting of the year, the same painting served opposing points of view in propaganda.

Television with its requirements for rapidly organized productions began to use this collection heavily. Several hundred changes of costume are prepared weekly, research must be done quickly and since there is no other source from which pictures on the whole history of fashion may be borrowed, these files became indispensable.

Decline in employment opportunities in commercial art fields, especially in book publishing, and the drop-in sales at art galleries, tightened competition and created

a greater demand for information on the newest design trends, more search into past art periods for refreshment, and more study of the output of successful illustrators and cartoonists. The challenge to the Library lay in making available the up-to-date record as well as the past, to offer the picture record of current work from newspaper to direct-mail advertising, from gallery art to fashion. New designs were still influenced by the foreign artists who had settled here and found themselves fascinated by the whole American saga, especially by the Far West. Every detail of cowboy life, from holster to branding iron was in demand for use in jewelry, bead embroidery, ceramics, clothes accessories and toys.

Each year, the pictorial document takes deeper root as a new part of the Library's traditional services. Nowhere is there a comparable body of information about pictures as the Picture Collection files and indexes represent. Last year, 1214 firms and organizations made use of this picture service, borrowed pictures, inquired about sources of pictures, and how to organize a picture file. Within a few minutes an atomic energy laboratory was guided to locate pictures of the heart of the guinea pig; an agricultural school was helped to identify seedlings; and a publisher found pictures of Roman underwear. A radio network, with only seconds to spare, found advertisements showing women enjoying the aroma of pipe-smoking. These pictures taken to a hesitant sponsor sold the idea of broadcasting cigarette advertising in the daytime. The reputation of this staff as experts in the field of picture documents was well attested to by the number of illustrated publications which acknowledged their help.

Most of the present professional members of the staff helped in the organization of this collection and were part of its early development. This past year it had become clear that in-service training was needed by the newer assistants. Although five new members of the staff had added library school training to their background of art training, still they had received no instruction in picture techniques. Two classes were started in March, two hours each day for two weeks. Now for the first time, every staff member was oriented in the history of the printed picture, and the implications of picture documentation. From these meetings came two more recruits to the profession and new loyalty to the work and impetus for specialization in this field. It is planned to continue this training to include picture-printing methods, the acquisition of pictures and finally instruction in the classification of pictures. Until this course, assistants were trained individually during work routines; this training class was an economical use of top professional skill. It relieved the schedule by preparing more staff members for work at the information desk.

The artist-librarians on the staff continued to review publications on art. In addition to serving as guides to book ordering by branch libraries, the reviewing proved useful in work with the Picture Collection public. Artists turned to this staff for suggestions for reading and for purchases and were especially grateful for straight-forward, expert judgement of expensive over-advertised technical publications. A thorough re-appraisal of art books in print was made this winter and a new basic list completed to serve as a guide for purchases to round out branch library collections on this subject. 418 books were reviewed last year and informally subject indexed for use with the public and for branch inquiries.

About 150 brief talks, many of them illustrated, and one broadcast over Television (which was filmed for re-broadcasting), were given by the staff last year. Most of these were to groups visiting the collection, usually art students accompanied by an instructor. They asked about the use of picture documents in their professional careers. Several parents came in from Westchester, Long Island and New Jersey for advice about picture files for their schools. The preparation of a list of color reproductions suitable for children was typical of the service performed for such groups. As in past years, Thursday mornings were set aside for consultation work with libraries from special libraries and researchers who wished to study our methods. A letter came from a teacher in Palestine who, as a New York teacher, had made use of this picture service. She wrote for advice on how to start a similar picture library in Tel Aviv.

Many of the more gratifying aspects of work with pictures were put aside this year to give precedence to the pressure of change and growth. Loans of pictures my mail to other libraries and institutions were almost entirely stopped; picture requests by phone were turned down. No exhibitions of new accessions were hung this year, although this is a picture collection and, as its name implies, the visual is the only language it can use to display its service. One display board was filled with typical pictures from subject categories within "Fall into Winter". This small and modest show made a deep impression on the public and elicited "fan" mail. One borrower reported that the board expressed the unity of all peoples in all places and times; a note written by a Broadway theatrical designer read "to whoever arranged this: it is like reading Chekov-melancholy, beautiful, moving, thank you.

For the first 25 years of its existence this collection depended for its picture stock on the accident of gifts, with resultant serious gaps, or overabundance in many subject categories. For many years organizations, firms, and individuals collected

photographs, illustrated magazines and books to contribute to this collection. An average of 150,000 items yearly came in unsolicited. With plans taking shape to make broad changes in the housing of the picture files, it was found necessary to stop acceptance of such materials, limiting gifts to solicited items, photographs, and ephemeral 19th century trade cards. As of July 1948, all other gifts were not accepted: 46,882 items were received during the year.

An appreciatively larger appropriation this year made possible purchases to fill in serious subject gaps. Pictures were bought in quantity for the first time, especially letter-size color reproductions of paintings, drawings of the masters and by the Japanese, and a richer photographic coverage of American folk art.

Although hard pressed by growing demands on the services, the staff continued the processing of new material. It is obvious that the usefulness of this collection would collapse the day that the picture stock fell behind the times; 43,970 pictures were added to the classified stock; as of July 1st the total of pictures classified as individual items was 1,309,057.

There has been an unbroken continuity in the growth of the usefulness and the use of this picture service. Until the Fall of 1948, there had been no improvements in workspace, equipment, lighting nor furniture. Since 1941, the routine of handling the pictures withdrawn daily by the public has been falling behind schedule. Before that, the WPA staff had been able to keep up with the daily routines. Lack of workspace and insufficient lighting with inadequate and obsolete equipment joined to create a constantly precarious situation.

Neither ingenuity nor hard work could overcome such obstacles. New equipment, and particularly new filing storage units were desperately needed. The number of individuals using the collection doubled since the end of the war, and staff found that the handling of requests became progressively more time consuming because of the worn stock, tattered folders and broken filing bins demanded more alertness.

By the beginning of the summer of 1948, an alarming backlog of returned pictures had accumulated. Since there is no dramatic drop in the use of these files during the summer months, it was impossible to clear up this great mass of work. By winter, a peak backlog of 150,000 returned pictures has accumulated. No solution was in sight. Not enough members of the staff could be spared for this filing as the full scheduled time of the staff was taken up with the charging and discharging of pictures and the handling of requests. The staff was literally overwhelmed by the public. Radio, television and newspaper publicity last winter contributed to adver-

tising this service and brought many new borrowers and visitors.

Nothing could be done without more staff, but, in the meantime, the number of pictures that may be borrowed was curtailed drastically and the public given a fairer distribution of subjects in demand. No more than five pictures on a subject and no more than a total of 25 may be borrowed at one time. While this relieved the filing, it brought a storm of protest from the public. The most serious disadvantage came from the insistence of many persons that they be permitted to make sketches since they could not borrow the pictures. The table space allotted to the public became overcrowded and much unpleasant quibbling upset our usually good public relations. However, unless this curtailment had been enforced, the service would have been forced to shut down for several months.

To resolve the emergency, a special project was set up for three months this spring. Four assistants were hired to work on the backlog of returned pictures under the supervision of an experienced organizer of filing systems. It was interesting to receive confirmation that the problem was not similar to that of business and government agencies. The variety of sizes of the pictures and the fact that the files are in use by the public all day are unusual factors.

Instead of just filing this mass of pictures the project called for a time study to determine which of several methods of breakdown succeeds best. Several systems were tried simultaneously both on the basis of one day's returns, and a week's returns. From this experience and study, we could set up a plan for the next winter which should make it possible to keep up with the daily filing of each day's returns.

Room 72 was turned over to this project and space in Room 73 was set aside for the regular staff to carry on the daily filing of incoming pictures. From May 1st on, all pictures were filed the day after they were returned. This can be continued after the backlog is cleared, if circulation is strictly limited.

By July 1st 32,670 pictures were filed by the project staff with a resultant report recommending the type of sorting devices to be bought and which system of breakdown be adopted. To expedite the project, the carpentry shop added steel removeable shelves to the 30 storage units, so that at all times there were 90 sections ready for the first alphabetic breakdown.

Furniture and Equipment

As a beginning towards housing the picture files properly, 8 "Jumbo" size three drawer steel cabinets were bought last winter. This is a great step forward and

presages a replacement for all of the present makeshift wooden bins.

In 1941 a survey was made of other picture files and a study made of the best arrangement for this type of picture stock. It was found that this collection could be broken up into three categories with advantages for the public and the staff and expeditious utilization of floor space. The plan was to separate the material into Geographic (Views), Personalities (Portraits), and the large category of General Subjects A – Z, exclusive of categories 1 and 2 as a step towards this arrangement, several years ago the Portraits were moved and files separately, marked for future removal. When the first steel files were bought, it seemed best to use these files as a Geographic unit. In November, Geographic material from A to London, 113,680 pictures, was removed from the general subject files and transferred to the drawer units. This move emptied the equivalent of 29 wooden bins which could be discarded to free floor space in Room 73. The entire file of 30,000 folders in the wooden bins was then shifted to absorb gaps made by this moving. This took three months since page help was only available during the hours the public was using the files.

Steel file units were also purchased to house the collection of 120,000 postcards. When the complete Geographic file is housed in steel files, these two collections will form a rich source of travel documentation. The work of re-processing the pictures in the new files moved at a snail's pace. Each picture and card required processing and re-entry of the subject heading on each item to facilitate re-filing. Work with the public is so constant that major changes cannot be carried out along with the routine work which consumes every minute of the present staff's time. Working in a crowded room, open freely to the public, makes each change doubly hard; no more can be done without closing the department for the duration of re-processing.

A budget allowance for binding made it possible to buy file folders for the new steel units and for the wooden files – to substitute mechanically made folders for those previously made by hand. These new folders are reinforced along all edges and can withstand heavy use. There are more than 5,000 tattered folders in the public files waiting to be copied.

Undoubtedly, this beginning is a bright one and with continued steps towards housing and rehabilitation of the existing picture stock the work will become greatly simplified. However, the size of Room 73, and its structure of central columns makes any solutions within its walls merely one of expediency.

Annual Report of the Picture Collection, July 1949 thru June 30, 1950

Transcribed from: Picture Collection Records, Manuscripts and Archives Division, New York Public Library Archives. Box 7, folder 4-11, Annual Reports, 1928-1999.

T he Picture Collection remains an effective medium to keep alive the past to implement and give body to the present, to give the artist and designer the visual impact of our heritage and make of it a living influence.

There is gratification in work with pictures because pictures are in demand and no effort is required to attract the public to use the Library's picture service. There is no need to whip up interest in pictures – they are an essential part of the machinery that makes a city tick. The seriousness of the use of the Picture Collection is confirmed at the information desk where typical traffic one morning included requests from the Memorial Hospital, The National Film Board of Canada, The Furriers' Joint Council, a UNESCO unit in Denmark, the United States Secret Service, a practicing psychiatrist, and Collier's Encyclopedia. In each instance only the picture files of this Library could have filled the request.

A State Department researcher came up from Washington because she "knew that nowhere else can we find this material against a deadline and too, find it in shape for immediate use". She selected 200 prints to form a panorama of America's contribution to Letters and Art; these were gathered in the short space of one morning and were absorbed at once into broadcast, publication and exhibition in Haiti and Belgium.

The range of picture requests remains varied, broad and comprehensive: calls came for pictures of union suits and of spaceships; the flight of balloons and cupids; ferries and gondolas; ice and jade; obelisks and privies; beef stew in color and cattle brands. The Holy Year taxed the files for papal pomp and Vatican City views. The Cold War brought students for cartoon evidence from European sources to see America as she looks through Europe's eyes. Hop-a-long Cassidy kept artists busy searching records of the West. From pictures of holsters, spurs, chuck wagons and six-shooters, steamed toys and gear for young fry. The recurrence of interest in the 1920s was noticed in the calls for pictures of the shingle bob, raccoon coats and

speak-easies. In some subjects there was always far too few pictures for the demand, especially in the picture coverage of the American scene and American history. The files were inadequate on the traditional holiday customs of the United States and the seasonal symbols of our land – the dogwood blossoms, the lilac, the turkey and the corn shock. This type of perennial request shows how deeply these symbols are rooted in our culture. Pictures of the magnolia blossom, for example, served on greeting cards, and as patterns on kitchen toweling, in whiskey ads, for costume jewelry, for the cover of sheet music and to give a name to the color of a chintz. For an official publication of the Tunnel Authority, for a fund-raising poster, for the design of the lack of costume in "Peep Show", and for the over-garish display on a necktie, New Yorkers turned to the Library for pictures. New fields, such as Television, have learned quickly that the Library's picture service is an indispensable tool. A copywriter preparing a series of commercials directed to Americans of Mexican origin, studied pictures of the living conditions of Mexican immigrants to the United States as orientation for broadcasts to these people. A film writer for M.G.M. spent days in the picture files studying the faces of famous men who were known to be Jews, to establish to what extent most of them looked "Jewish" according to stereotype.

From shapes of forms in nature, from the artifacts of primitive man, from cross-sections of engines, from the images of the past, the public derived stimulation and ideas for today. Tropical leaves inspired a settling for rare rubies; the wings of an insect spurred the design of a mechanical toy; the shape of compacts came from the shape of African tribal drums; the thinness of the legs and sagging belly of the prevalence of rickets in those days.

The circulation of pictures last year was 472,998, a 23% increase over the previous year, and the number of people using the collection in person and by telephone was about 50% greater. At times, this past winter, the room was so crowded that the aisles were jammed with people who could find no room at the tables. On one of the busiest days, a man stretched out flat on the floor and spread pictures on the floor. He had found that it was no darker there and that it was the first time he had found enough space in which to make a selection. The crowdedness slowed the re-filing of returned pictures as this can be done only during the hours the collection is open to the public. The increase in use placed a serious strain on staff and equipment; it emphasized afresh the need for more mechanized or visual type of control in the charging and discharging of pictures.

Gratification at the continuing vigorous growth in the use of this picture service was all but blotted out by the staff's feeling of acute frustration, aggravated by the persistent lack of space, air, lighting and suitable equipment. Compliments on the service and its organization and the patent appreciation of the public was offset by the constant complaints that there is no room for sketching, that the stock is antiquated and that there is nowhere to sit.

To develop a good documentary picture stock requires a continuous vigilance so that gaps do not arise within the over-all subject coverage; there must be a constant awareness of the pulse of design trends and the changes in art training, to know the needs of the student and the professional worker in the arts. Pictures are not published per se – but are amorphous items waiting the eye of the picture editor or librarian to select them and develop them as documents. There are no ready-made publications of subject pictures that the librarian can buy and process for public use. The staff of the Picture Collection checks current publications in pertinent fields and also keeps abreast of the second-hand market in order to watch for illustrated ephemeral out-of-print items.

Last year, 53,182 pictures were selected, clipped, classified, sourced and added to the specifically classified picture stock, now a total of 1,349,121 pictures. These new pictures came from myriad sources, some from publications in Chinese, Danish, Bengalese, Japanese. Assigning sources to these pictures required the cataloguing of 637 titles (few of them in English).

Until recently the greater part of all additions depended upon unsolicited gifts. With larger allowances for book purchases, such gifts were discouraged, and time lost in discarding bulk gifts was gained. During the year 74,642 gifts items were received, 17,302 photographs. Most of these were solicited to provide coverage of the contemporary scene. These photographs must be obtained at the moment of happening or the record is lost. Through small requests or by staff visit and direct selection photographs were obtained from industry and business. The subjects ranged from the modern cuspidor to parking meters, from people of India to the strait jacket used in mental hospitals. These were all solicited to fill picture requests. The Standard Oil Company of New Jersey, Pan-American World Airways and other firms maintaining photograph files used the Library and are delighted to have pictures of their activity and products included in these popular public files.

Trucking story. *John Oxenrider (left) and Mehlon Focht, local farmers, in Shartlesville Inn, Shartlesville, Pa.* ca. 1946. Standard Oil Co., (N.J.) Sol Libsohn. Yampolsky Collection.

While the development of the picture stock is a major concern, keeping the collection within expedient bounds has been foremost in our minds. This winter a reserve stock covering the decades of the 1920s and 1930s was weeded. At the start there were 800 units of 500 pictures each. By spring, these had been selected, weeded and discarded until only 50 units remained. The first major weeding of the classified pictures was begun and by June 1950 – 13,118 pictures were discarded as worn, faded or poor copies. After more than six years of purchases, the files have been sufficiently bolstered so that discarding can be done apace.

To help simplify the work of handing requests at the information desk, five typed copies of the checklist on cards were completed this year. This is a list of the main subject headings and the subdivisions representing the folders in the classified picture files. These are 20,000 entries in the 169 letter-sized pages of this list. It is

the first "handbook" of the subject headings under which pictures are files, and is in a compact, portable form for the use of classifiers and those doing floor and information work with the public.

The staff continued to read and review current publications in English in the field of graphic and plastic arts – 250 last year. Carbon copies of these reviews were supplied to the cataloging office for later use in cataloging branch purchase. As in the past, a subject index to the reviews was maintained to answer inquiries and to serve as a guide for a forthcoming basic list of recommended purchases in this field.

Each year brings stronger focus on the recognition this collection has gained because of the scope of its subject inclusion and its organization. Because of the pioneer work of the staff with documentary pictures, the Picture Collection is usually the first stop for work involving picture research, the use of pictures and the development of pictorial archives.

When, in the spring, two feature articles about the collection appeared in magazines of national circulation, they brought a deluge of letters. It was obvious that this picture collection is looked to for leadership as if it were a central national picture service. On the same day, recently, a curator from the Minnesota Historical Society and a librarian from North Carolina came to study methods in use here. They had similar problems as both states were about to develop extensive pictorial archives on their respective local history. It was only here that they could find style manuals on subject classification for pictures, on sourcing procedure and subject indexing of pictures. Of particular usefulness to them was the collection of reference tools for picture research and our information index. Also, on that day we advised a staff member of the American Cancer Society and of the New Rochelle Library on our methods of storage and handling of picture material. Conferences of this kind were held each Thursday throughout the year.

Mail inquiries increased appreciably; from Rome, Jamaica, B.W.I., Canada and all across the country, archivists and librarians wrote for guidance in establishing picture collections. Universities asked for the loan of pictures by mail stating they knew of no other comparable source. Replies took time and thought; in place of an easy and sterile "No", leads and suggestions were sent.

The Picture Collection has demonstrated its importance to Art, Theatre and the Ballet, to Book and Magazine production, Advertising, the Applied Arts and Industrial Design. It should have new quarters designed to fit its specialized functions, with planned support for the controlled growth of its stock. It is shocking

that in New York today there is no general photographic file open to the public. Although the Picture Collection includes over 200,000 documentary photographs and as many moving picture stills, these are in storage. As there is no other public source for some of these photographs, we could not turn down requests from Federal agencies such as the Intelligence and Education Section of the War Department when men were referred here to use them.

This picture service needs re-alignment. It has been functioning since 1916 – long enough to deserve a start in life. It cannot continue at the present tempo of increased use without basic overhauling. Gradual improvement in Room 73 is stopgap in result because the room is completely unsuited to work with pictures.

Miss Louise Leak of this staff made a survey this year of the documentary pictures housed in other Divisions in the Central Building and in the 25th Street Warehouse. This will serve as a springboard for an early report to the Director of the Picture Collection. The report will present a comprehensive plan. With suggestions of future policy, for the coordination of all the picture collections of the Library, with emphasis on the establishment of photographic archives and a reference picture service. Unquestionably such a plan and its consideration are overdue as pictures are as important as words for fact-probing and are an essential part of the Library's resources.

Five Year Report of the Picture Collection, 1946 – July 1951

Transcribed from: Picture Collection Records, Manuscripts and Archives Division, New York Public Library Archives. Box 7, folder 4-11, Annual Reports, 1928-1999.

Since 1945, the major changes in the Picture Collection have been linked to the continued increase in the number of users of its services and to the variety of purposes for which pictures were borrowed. Improvements in the service and in the stock stemmed from the necessity to carry on the work at the tempo public demand.

In the past five years, the number of people using these picture files increased 50 percent, requests by telephone and mail doubled. The circulation of pictures

was so great that in 1946, the number of pictures on one subject, and later, the total that could be borrowed was strictly limited in order to handle the public without adding to the staff. This was necessary because the steady increase in use, without a parallel increase in staff, space and equipment, created great backlogs of work and threatened depletion of the picture files. It was impossible to lend as many pictures to each borrower as his work required.

Further curtailment of service was made by the removal of several categories of subjects, such as the moving picture "stills", which were placed in stack storage. Despite these measures, last year 524,027 pictures were borrowed for use outside the building; an increase of about 18% over the previous year. This is astounding because so much of the picture stock was made unavailable for circulation.

The reference use of the collection has consistently grown until it has reached a point where frequently three out of five requests relate to pictorial information without requests for the loan of pictures. The use of the files for reference purposes was limited by the lack of table space for such work, the generally poor lighting and discomfort for the public. In the last few years, inquiries about sources of pictures and identification of picture content have changed the caliber of the work at the information desk and the tenor of the inquiries that come by telephone and mail. The use of the files for such information was particularly heavy by special libraries connected with pharmaceutical firms, broadcasting stations, and advertising agencies. Many more trade unions made exhibitions incorporating material suggested and located through this Collection. By mail picture information was sent to inquirers from Cuba, Ireland, and Germany. Many firms and organizations turned to this picture library for first leads in doing picture research.

In July 1951, the picture stock numbered 1,379,223 specifically classified pictures. In the last five years, 288,163 new pictures were added, selected sourced, indexed and classified by the staff. For the first time a program of regular weeding was made continuous. This was possible by increased funds for the purchase of fresher material so that older, worn copies could be discarded; since 1945, 74,076 pictures were discarded.

Until recently the picture stock depended almost entirely upon the chance of gifts from the public. About 125,000 picture items had been received annually. Beginning in 1947, fewer gifts were accepted; only rare, ephemeral items and photographs were welcome. Last year 50,739 picture items were received and processed. With increased allotment for purchases, a planned buying program was initiated to fill

subject gaps caused by the past accidental growth. This has been a saving in the work of selection and discard and has freed time for the processing of new material. A careful year-round check of secondhand sources was started, and a more thorough watch made on current publications in the picture field. At the same time, as a guide to branch book buying, the staff continued to review books in the Fine Arts.

The stock has improved in quality and is wider and deeper in subject coverage. Much of this can be attributed to the addition of pictures gleaned from over 2,600 titles, many in duplicate copies, purchased and clipped in the last five years. More up-to-date material was acquired, better color prints in the fields of oriental sculpture, ornament, dance and fabrics. Through planned soliciting of photographs in files on modern furniture and industrial design were brought in line with public requests. This enrichment of the stock had immediate effects and these new sources of ideas were immediately borrowed to serve as springboards for designs on Broadway, Fifth Avenue and the pages of national magazines; jewelry and shoes, window displays, and the shapes of toys, stained glass and quilts were influenced by these additions.

More reference tools were bought to enlarge the picture reference book collection and thus help speed the work of identification and classification. Previously this work has necessitated consultation with bibliographic resources in other Divisions.

In addition to the specifically classified core of pictures, many were added to the broad subject divisions of the Reserve files. These now number approximately four and one half million clippings, photographs, "stills" and postcards, and serve as a second line of resource. Pictures from this reserve were not specifically classified until called for. Intensive work was carried out on this Reserve. Within the last three years, the entire Portraits reserve, a collection of 260,000 items was processed, arranged and labelled, making it into a valuable reference adjunct. The collection of 120,000 postcard views was processed, each card identified and the whole made ready for final notation so that the files may be opened to the public. In the last five years, this Reserve stock has been weeded, consolidated and re-labelled.

New furniture and equipment were received at a critical moment when old makeshift storage bins and inadequate equipment had contributed to mass backlogs of work. Five years ago it took from one to three months for a returned picture to be re-filed. In 1949, after a spurt in circulation, more than 150,000 returned pictures had not been refiled. A study was made of the situation, and a special staff hired to carry out a project to file the backlog. After experimentation, sorting devices were

bought; the sorting bins for returned pictures were reconstructed and filing trays were installed. These led to a successful speed-up. Further improvement was the change to florescent ceiling lighting, new tables for sorting, and posture chairs for the file clerks. These changes alone were responsible for the increased efficiency; today a picture is re-filed within 72 hours after it is returned. This is possible entirely because of the improved working conditions and equipment, without increase in the number of staff and despite increase in the number of pictures handled daily.

With more funds available, machine-made file folders were purchased for the public picture files. The work of making these was previously done entirely by hand.

Eight "jumbo" steel cabinets were bought as a start to house properly the classified pictures. Into these was shifted one section of the collection of Geographic material. Still experimental, they are far superior in appearance and structure to the old, wood bins. But functionally they are not suited to the purposes of a public picture file, nor do they point to the solution of the overall problem of housing the rest of the picture stock. Because of the large number of items to be housed and their variety in size and requirement of visibility, it has become clear that furniture should be designed specifically for such specialized requirements.

Recent additions to the staff have increased the number of professional members. This may have been due in part to the growing reputation of the Collection and to the fact that experience and training here is a step towards a career in picture research elsewhere. Most of the new staff have had graduate work in allied fields in addition to a Library School degree. This has improved the caliber of the reference service to the public and has helped speed replies on questions involving extensive searching and quick translations from foreign languages. With such additions to the staff, for the first time, the responsibility for the cataloging of sources, for classification, subject indexing and identification could be distributed.

With less turnover in professional personnel, in-service training was initiated in the history, techniques and theory of work with documentary pictures.

To help simplify the work of handling requests at the information desk, five typed copies of the checklist of main subject headings and all subdivisions have been completed. It is the first "handbook" of the subject headings under which the pictures are filed, and is in a compact, portable form for the use of picture classifiers. During 1950, work was begun on the elimination of subdivisions to save time in the arranging of pictures for filing. A Catalog and Classification Style Manual was prepared in the last few years and became invaluable in the training of new staff

members. Work was also completed and is being kept up to date on the Information Index to sources of pictures. These were particularly useful as guides to the many inquiries who came to study the organization of this collection in order to pattern collections elsewhere on its form.

Each year brought stronger focus on the recognition this Collection had gained because of the scope of its subject inclusion and its organization. Because of the pioneer work with documentary pictures this staff has done, the Picture Collection continued to be the first stop for work that involves picture research, the use of pictures as documents, and the organization of picture archives.

No more than a glance at the picture requests of the last five years discovers a reflection of the changes in the world at the Library's door. Outstanding was the preoccupation with the problems of presenting positive interpretations of American ideas to the world; a search for pictorial records from the past to illustrate the rise of Democracy; the trend to display our cultural heritage in terms of folk art and in the face of the famous and obscure men and women of many races and creeds who created the fame of American arts and sciences.

Changes in taste swung from the sloppiness of the bobby-soxer and the meagerness of dress fabrics of the early 1940s to the high fashions of an inflation period. Dusters and stoles, passementeries and sequins reappeared. More artists were employed in the design of luxury items, such as jewelry and cosmetics accessories. An unprecedented number of requests came for elaborated patterns derived from Siamese, Balinese and oriental sources. New luxury liners incorporated murals in their décor; not since the days of the W.P.A. have so many mural painters been at work. Five wall paintings on one ocean liner derived from reference material borrowed from this Collection. The gay packaging of phonograph records replaced book jackets as the channel for the work of American calligraphers and layout designers. The greater interest in music and the great sale of these records helped employ the best artistic talent for these designs. In turn, these required full pictorial documentation on musical instruments, performers, composers, and conductors. Music, Ballet and the Opera have been heavily called on in the last few years as a source of pattern motifs for all sorts of small objects in pottery, enamel and silver.

The threat of inflation appeared in the many requests for earlier cartoons on the Cost of Living and scenes of the 1920s.

The world reflected in picture requests showed a distant war, an increase in the design, production and advertising of luxuries, all sorts of fictionalized stories of

spaceships and men from Mars, alongside of serious defense propaganda against possible Atomic attacks.

Undoubtedly the newest image was that of the home invaded by the Television. From its very first amateur steps, the broadcasting stations and private program producers found the library picture files indispensable. Hundreds of scenic and costume designers were employed by this new industry; it required the design of hundreds of costumes and backdrops each week. The hairdo of Miss Helen Hayes in her role as Elizabeth Browning and the background of portraits of past Presidents for a televised address from the White House – these were typical uses of the library pictures lent within a few hours before broadcast time. As this industry goes into its stride, it will require more and more pictorial reference material. This will pose the problem that a new heavy commercial use may crowd out the general public. This must be guarded against. Time is such a pressing factor in Television, that broadcasters need a ready-made source of ideas and pictorial facts – it would take years to develop such resources from scratch – in the meantime the Library's collections will be tapped.

The range of picture uses in the last few years was spotlighted one day when a psychiatrist came to study pictures of dreams as delineated by artists in earlier centuries to use as illustrations in a medical book, and a UNESCO film maker was searching for records of the black plague for a filmstrip he was making for the World Health Organization to be addressed to the peoples of India. The next call was from a young East Indian woman who asked for scenes of India. While she was looking at the pictures she burst into a native song; she apologized, remarking the pictures had aroused a homesickness. From requests of pictures of "silent stars" to pictures of steam calliopes, from the design of a package of soap to a vignette on a State Department propaganda leaflet, the uses to which Library pictures were put have been as myriad as the subjects in its files.

Annual Report of the Picture Collection, July 1951 thru July 30, 1952

Transcribed from: Picture Collection Records, Manuscripts and Archives Division, New York Public Library Archives. Box 7, folder 4-11, Annual Reports, 1928-1999.

Pictures borrowed from the Picture Collection served to dress Helen Hayes' hair for a television performance as Elizabeth Barrett Browning; helped the make-up of an aspirant for the role of Caligula in the film version of "The Robe", gave a disc album cover the atmosphere of "The Medium" and inspired the idea and composition for a mural at the Mayo Clinic.

Last year this type of us was overshadowed by a new emphasis on reference and information work with pictures. In probing the reason for this, two causes appeared. One factor is the reputation of the collection as the crossroads of information on pictorial documents, and as the largest public picture file, classified by subject in appreciable depth. This collection has become the first stop for picture researchers, many of whom are sent here for preliminary survey when publications are planned. They came from Los Angeles, Philadelphia, Chicago and Washington D.C. Such picture checking seeded the work of picture editors for the State Department, located early Biblical versions of artificial respiration for an Armed Forces manual. Its extensive coverage served in the layout of the continuity for a documentary film on the life of Lincoln.

In these instances, the pictures per se were not good enough prints for end-use but were consulted for information towards the location of originals and as a quick index to existing picture coverage on the subject. As there is no similarly classified collection in the Library of Congress, Federal agencies have learned to make use of these files as a lead to original prints.

A Paris agency planning an exhibition on the story of Bread selected pictures here and photographed them for use abroad. The picture researcher reported that in Paris it would have taken several months to locate the variety of pictures found in one afternoon in this picture collection.

The major cause of the change in the use of the collection, was Television. This new and lusty purveyor of images groped insatiability for pictorial ideas, back-

grounds and facts for use in programming. Many scriptwriters and program produc-
ers began to use the picture files. Not interested in borrowing pictures, they studied
the collection, staying for hours searching out the historical past. The librarians of
the largest networks held frequent meetings with the picture collection staff to affect
a better and more coordinated use of the library's picture resources. The experience
and specialized knowledge of our professional staff were drawn on for guidance in
the establishment of picture research units at television production studios.

This change in the over-all use taxed the modest reference facilities. It was
partially met by more intensive concentration on indexing of sources and other
pertinent pictorial data. This in turn deprived borrowers of staff assistance, and
indirectly of pictures, because the staff was diverted from routine circulation work.

Despite continued restrictions on the number of pictures that may be borrowed,
and the shutting off of the geographic and the illustrators files, the circulation for the
year showed only a slight drop. Over 500,000 pictures were borrowed. An annual
circulation of more than half a million pictures cannot be handled in a current
flow of filing without any additional staff of clerks. Every effort was made to keep
the circulation down to this limit.

Calls for pictures of interplanetary flight, spaceships, jet propulsion, and flying
saucers joined in popularity with a presidential election year's requests for cam-
paign buttons, cartoons on political corruption, donkeys and elephants. The use
of America's regional history and folklore produced a crop of "rebel" caps for
children and confederate flags on neckties. Pattern and design in mass-produced
china, furniture, packaging, shoes and fabrics derived from many new additions to
the pictures stock. An extensive purchase of Japanese design sources inspired the
use of these motifs in handkerchiefs, jewelry and wallpapers.

In the early Spring, the superintendent of the collection met with picture librari-
ans of the Library of Congress, the Enoch Pratt Free Library and the Baltimore Sun
for an exchange of ideas and experiences in the picture field. From this exploratory
meeting stemmed the first picture session at a library convention. This was held on
May 27th at the convention of the Special Libraries Association. The response was
so great that and extension of the session was held at the picture collection that eve-
ning. At this meeting, a professional organization of those concerned with pictorial
documents was started as the Picture Division of the Special Libraries Association.
The staff of this Library's picture collection took the leadership in this development.

Fresh recognition of the influence of the picture collection came from the pub-

lication of The Index of American Design at the National Gallery. The origin of the idea and the plan for the Index was credited to this collection.

Television and advertising, publishing and industrial design are the largest users of this picture service, yet most gratifying is the use by art students and fine artists. A fan letter was received addressed to the collection by an internationally acclaimed known artist. He wanted to express his debt to the picture collection. He wrote that he had no need to borrow the pictures, but he found in the study of the juxtaposition of the pictures, a rich fare of visual nourishment, and a springboard for painting ideas.

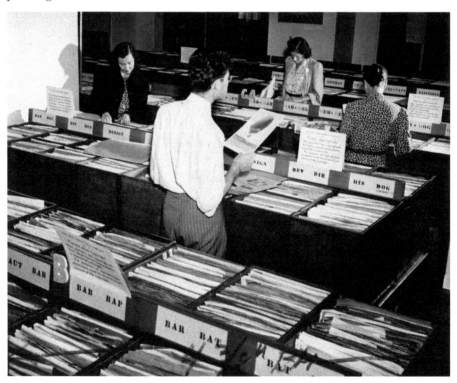

Picture Collection Room, The New York Public Library, 42nd St. at Fifth Avenue, New York, 1955.

Annual Report of the Picture Collection, 1952 - 1953

Transcribed from: Picture Collection Records, Manuscripts and Archives
Division, New York Public Library Archives. Box 7, folder 4-11,
Annual Reports, 1928-1999.

While staff and space loom as the immediate, pressing problems, this collection is actually marking time, waiting for the establishment of an official policy on the whole subject of the Library's role and responsibility in the field of pictorial documents.

If the New York Public Library intends to maintain its prestige in this new field, it must take an immediate decision to accept collections that will never again be available as freely as they are at this very moment. The recent offer of LIFE's negatives, and the chance to obtain the photographs of Lewis W. Hine, are typical of opportunities that will not crop up again. The national organization of picture librarians, now in its first year, disclosed in its meetings that the picture field is fairly seething with activity, with a healthy rivalry in the acquiring of photographic collections while some of the old-time photographers are still alive. A good measure of this activity was sparked by the proven usefulness of this Picture Collection.

The New York Public Library has leadership in the organization of pictures, in picture work, in the uses of pictures, and in the maintenance of a pictorial information service. But its picture stock in many respects is low in caliber and does not do justice to the public it serves. A program of acquisition and care for photographic reference archives comparable with the Library's program for the printed word should be instituted.

July 1, 1953

Recommendations

Staff: The quota of staff for the picture collection is at its lowest point in ten years…

Equipment: A photo-copying machine should be acquired to produce copies quickly. ….

Proposed projects:

Subject Headings: There has been increased pressure from other institutions for a copy of our list of subject headings for the arrangement of picture files. Because principles differ basically from those applied to books and texts, this list should include theory and procedure. The list requires editing, complete checking, and the addition of cross-referrals if it is to serve its purpose. The full time of two top-flight picture classifiers would be needed for about two years to complete this work.

American History; The pictorial coverage of this subject in the picture collection is skimpy and critically lacking; the demand is heavy and constant. Selection of pictures from the resources of the Reference Department and the Library of Congress should be carefully planned and carried out to produce a basic file of negatives. From these, duplicate copies could be made as the need occurs; they would yield excellent display enlargements. This would mean that at all times an adequate coverage on the subject would be available. Good pictures on the history of the United States are needed by the public and by libraries and other non-profit organizations.

The public use of pictures - Not the variety in picture requests but its persistence through shifts in fashions and news, amazes those who work with pictures. Increase in the number of persons using these files was due to several factors: the greater dependence upon American artists for the design of the goods of industry, and the growth of television production. Scenic designers, prop-men, costume designers and wigmakers sought out the Library's picture resources. More actors and actresses use this collection because of the many telecasts of past history.

Queen Elizabeth I was the most frequently called for lady of the past, and the pomp of court life, the regalia, the coaches, the plumes, the most popular subjects. The case of the Rosenbergs had its echo in picture requests for the Civil War hanging of Mary E. Surratt. These picture files, truly encyclopedic, supplied within minutes pictures of: a tailor sitting cross-legged; scars caused by whipping; bloodletting in the 18th century; a close-up of buckwheat for the texture of new carpeting; the finish line at a horse race; the bone structure of an eagle and costume for space-ship travel. A Jesuit artist borrowed pictures of the Evangelists for the design

of a stained glass window in Hawaii; UNICEF mailed pictures of children's games to a London artist as a guide for the design of its Christmas card; Iceland's Minister of Education used pictures from these files for his government's educational program because "...we do not have in Europe public or private picture resources so easily available and so extensive in subjects".

Statistics

Despite the closing of the collection to the public, mornings and Saturdays from July 1 to September 15, 1952 and entirely from April 18 to May 11, 1953, the drop-in circulation was less than anticipated. Last year, 459,238 pictures were borrowed; a decrease of 46,275. This is particularly slight because during the entire year the geographic, illustrators and dance files were closed.

The classified stock now numbers 1,469,822 pictures; 69,586 were added this year; 11,859 discarded. A total of 81,000 pictorial items were received as gifts.

There was a marked increase in the reference use of the collection and in the number of telephone and mail inquiries. There were more calls for guidance in the organization of picture files. Once a week, throughout the winter, conferences were held with librarians from welfare agencies, industry and other institutions to discuss picture handling problems. Specific plans were worked out in detail for the Canadian Broadcasting Corporation, the United Jewish Appeal and the Visiting Nurse Service of New York, and many other photo-libraries.

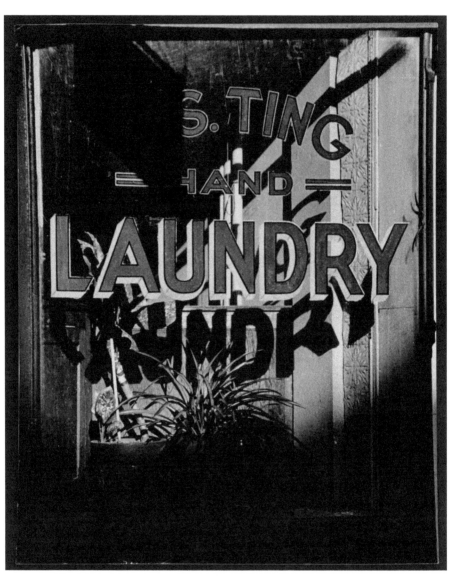

S. Ting Hand Laundry. ca. 1950. Sol Libsohn. Yampolsky Collection

Chapter Seven

Romana Javitz interviews Sol Libsohn, 1958.

Romana Javitz (RJ): There are two things we can discuss: one is what can a photographer give to a painter, and the other is writing up the way Sol shops for windows (window shopping) to photograph.

Romana Javitz (RJ): Are you a frustrated artist?

Sol Libsohn (SL): I would say so, yes.

RJ: Are most photographers, particularly the successful ones, frustrated artists (painters)?
SL: Well, I like photography. I think it can be just as wonderful as painting. Photography has a wonderful, magic quality in some respects. Of course, you don't have the control and the summation – I mean you don't have a step process.

RJ: You are happy with photography as a medium of expression. However, you feel that with a camera you cannot sum up an experience or do not have the control of your materials as an artist has?

SL: You have control of the materials, but you don't have control of the stage setting.

RJ: That is not clear to me.

SL: Well, everyone talks about the composition of something. A photographer has to compose his idea, too, but he is at the mercy completely of how a thing is. You see something happening which is very important in terms of composition – for instance several children playing, what one kid is doing to another kid in relation to the neighborhood, the buildings, etc., and a painter can sum it up and get that decisive moment. But if a photographer doesn't get it immediately when he sees it, that image is lost. Once you have lost an image or a composition in photography, you just have to go on to another image. This the painter doesn't have to do.

RJ: This is supposing this is photography from life.

SL: That is one phase of photography.

RJ: Let us compare a still life by a painter and a photographer.

SL: There is a difference.

RJ: How?

SL: I think the artist and the photographer are on the same level assuming you are talking about etchings and lithography, drawings, etc. But when comparing painting and photography you are in a different area.

RJ: Do you feel that the handicap, and it is a handicap, which the photographer is faced with is the fact that his work is circumscribed by time, since he must capture whatever he sees at the moment it happens, whereas the painter can observe the moment and then juggle the images with his skill as an artist, digest it and regurgitate it in a work of art. Would you say that waiting for it to happen in life, instead of controlling the elements, makes the photographer a stronger visual experiencer and hence able to teach the artist many things?

SL: It makes it necessary to be more grasping and quicker. A photographer has the quality of a street walker who digs around in the street for pennies, etc. You have to be quick to catch a situation. When you lose an image because things are not composed, and yet knowing it is there, you become much more incisive in recognizing how to find images. You have to learn, almost, to see something happen before it happens. You have to learn to shoot at it, to jump to the spot where you think it might come to a head. It makes you sharper in recognizing situations which are fleeting and passing.

RJ: What you are saying is that the photographer, by the very limitation of time and the fact that he doesn't arrange what is happening – but selects what is happening, develops a more decisive and immediate approach to what he sees. And unless he has a quick vision of the thing as it will look when finished, he is dependent on this quickness to produce, whereas the painter can create a painting from memory.

SL: Yes, but the photographer, if he loses his objects, his image, he gains it again as he looks down another street. He anticipates. He expects things to fall into place, into certain patterns.

RJ: Then, although a photographer may lose a certain image, he is prepared by his previous experience to foresee circumstances within other incidents?

SL: Yes.

RJ: And the painter does not need that quickness and vigilance, or a foreseeing eye?

SL: There is something that occurs to me here, and I haven't ever bothered to develop it, and that is the approach to individual techniques – the artist towards his, and the photographer towards his, live subject matter.

RJ: What is the difference?

SL: The approach, where the artist in his leisurely way can take his time, the photographer has a sense of urgency. The painter is able to become much more expressive in terms of his medium and he is able to control his subject, he is able to inject more abstract, visual ideas. I don't mean abstract in terms of an abstract painting but in terms of musical notes – which are abstract in their meaning and body.

RJ: What about this "controlling the medium"? What is the difference of medium control by a painter and a photographer? You say that the painter has a greater control of medium than the photographer.

SL: Let's say you remember the image – there is a blue and pink and a red. The painter thinks it would be better to put purple in and leave the pink out – and you couldn't do that with a photograph – in the abstract sense, whether the photograph was black and white or in color.

RJ: Well, control is arbitrary whether it is on film or on a painter's canvas; they are fairly arbitrary. What is basic in the difference between the medium of an artist and photographer which would point up the fact that a photographer can help an artist?

SL: Basically, I would say they are different languages. I think lithographers never really look at a face (possibly excluding Rembrandt). Very few artists could look at you and immediately get a clear experience image in terms of motions in your face; they will look at you as a form that they can feel, but they can never see the subtle blocks of whites and darks. It is not copying.

RJ: When a photographer and a painter are one person, such as Shahn, it is true,

is it not, that their photographs and their paintings are actually the same? Could you recognize a Shahn photograph as well as a Shahn painting?

SL: Yes, I think one can recognize them.

RJ: Why is it then that a man's photographs clearly stamp his as a personality? Why is his personality expressed in the photographs or pictures he produced?

SL: I have done many pictures of clowns. Some people see clowns as amusing people. I see them as tragic and lonely people. They have a necessity to, or a sense of, hiding. So when I see a clown, I wait for certain things to happen visually to a clown before taking a picture. Someone else comes along and takes a picture of the same clown as a funny clown. My clown is the sad and terrible clown.

RJ: If what you say is true, then there is something that the photographer develops by overcoming the mechanisms of the camera. The camera really becomes a medium of expression. Now if we can express in words what you can force your camera to do for you – not mechanically, but emotionally and spiritually. This is what the photographer learns, and the painter does not learn.

SL: What the photograph can give the painter is, in actual fact, no different from what the painter can give the painter. Only the painters have been very slow realizing what they can give themselves. Most painters are not very incisive thinkers, as painters. They only become so as they became better painters – in other words, the more incisive they become. What a photographer can do is help the painter early in his career to learn to see.

RJ: You have said incisive several times. What do you mean by incisive?

SL: There is one big stumbling block to this whole thing. When you look at a human head, what do you see?

RJ: I see a third-dimensional shape and I see the color and texture and the position.

SL: The quality of light is very important. A photographer must learn how to see light and dark, and how to use light. Light can change the whole shape of a human head or anything for that matter. The young artist generally would not see or find this sort of thing easily. It takes some artists years and years to become sensitive to

this. But the camera can take that, the photographer sees and recognizes light and must learn how to use it. If something is even slightly moved, the light has changed on it and it becomes something entirely different or new.

RJ: I still don't see what a photographer can teach a painter.

SL: Well, as I said, I couldn't teach him any more than a really good painter could teach him.

RJ: But I am convinced that only photographers see – which, if someone could describe, we could go to a painter and say that the photographer would be able to enhance his skill.

SL: The photograph has a kind of microscopic eye. He looks at things as if he would look through a microscope.

RJ: I have seen you on the street with a camera and what you see is not detail as detail, but you see detail as leading to something else – leading to something complete, and the entire vision is something only you have seen and captured. Now, how would you describe what you do? You are in the street, you see a nun in front of Woolworth's with a false, puppet face. You immediately know that it was something, not to store away in your memory – to think about and perhaps make a painting of, but something to capture and record. And you were very frustrated not to be able to capture it. What did you see?

SL: I saw this piece of medievalism; the drapery was like a gothic sculpture. The face was almost formless, very puffy, very strait-laced – almost masculine with a reddish tint. I saw the detail, the detail of something coming right off a cathedral – and it is sitting there in 1958 in front of Woolworth's.

RJ: Say you would have gotten a picture of her. What would it have looked like?

SL: I don't know how it would have come off.

RJ: Would it, had you succeeded, been better that what Shahn could have done with a painting?

SL: I don't think there is a way to compare. But let us go back. The only difference one would have, I think, is that this is an actuality – the nun is inescapably alive and

there would have been an opinion (photographic opinion) that would have given the reality another expression. She was a piece of medievalism in a modern street, if I could have caught her expression at a precise moment. She, without being aware of it, creates forms that have meaning or forms that don't have meaning.

RJ: I still believe that if you walked along 42nd Street and had someone next to you like a writer or a poet and you say "I've got to do this," my own reaction is, when you say that, that immediately there is a circle around what you are seeing. This thing which you are seeing becomes enormous. You have the feeling that he sees something that you don't see. This often happens with a painter, but you don't get the feeling of immediacy, heightened vision, the drama of the necessity to culminate the visual experience and turn it into a photograph.

SL: Yes, the artist sweats over his painting, but the photographer, if he doesn't get a picture at a precise moment, it is lost.

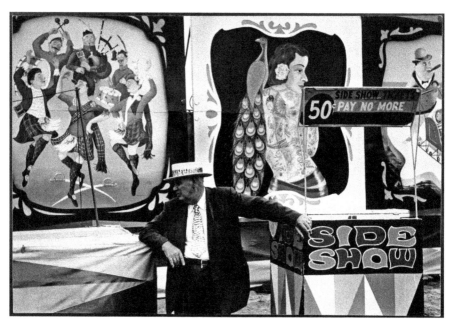

Ringling Brothers, Trenton, N.J. 1954. Sol Libsohn. Yampolsky Collection.

RJ: But I am trying to get from you a description of what he knows and uses that the painter does not need to know and use because he doesn't have to work with such rapidity and under the pressure of momentary events.

SL: In a sense, a guy like Cezanne who had to have his subject matter at hand for months at a time to study the subject, he, in a sense, does the same thing. A photographer has to twist and turn this stuff if he goes along the street, he must walk around his subject from one point and then from another, the way two people look when they are talking together. What is it that makes the comparison so fascinating; I think the fascination lies in the detail. And in photography the photographer is able to capture the magic of the reality of his subject.

RJ: But what can the photographer teach the painter? I have had several experiences with you where I saw you seeing, and I think that if a painter would have been with you, he would have learned a lot. You compose on the spot.

SL: Yes, I do. Take a doorway at four different times in the day. The light, shadows, and character are different each time and the doorway will make an expression for me at possible only one time. This would not hold for a painter. The painter would see it and say: "That looks quaint." He would then have to take it home and re-mold it.

I have to eat what is there. If it is not there, given the specific kind of light and color, I can't eat. I can only eat at the moment it creates a discipline that a painter does not need to look for. The photographer, then, has to have discipline, without doubt, born of his medium, of necessity. It says you must take it now. If you don't take it now, it is not there anymore. The photographer is disciplined by time whereas the creative painter, poet, etc., do not have necessarily to worry about the factor of time.

A painter said to me: "Why do you always carry your camera and what pictures do you take?" I said that I had been watching the stainless-steel telephone booths outside the Library on 42nd Street. What fascinates me is the texture and quality of the row of booths and what these qualities do in relation to the people inside and outside of them, what people look like reflected in the glass and steel. I may or may not get a good picture. It is so alive and real that it is almost unreal, in a sense.

RJ: But you are not enjoying it idly.

SL: No, but it is there, and I know it will be there. I am willing to take the time to watch and wait for the right combination of circumstances at some moment when something I have sensed may or may not come to fruition. It is like designing a stage setting for a play. The play takes on actual dimension.

The painter has a peculiar feeling about photographers. I don't think he had much respect for them. He was fascinated that someone could be curious about just this one little thing and that someone was watching the reflection and detail of those stainless-steel telephone booths. The conglomeration of detail and the reflections in the stainless-steel change constantly. The doors of the booths take on very different characteristics when they are open, or half open, or an eight open. The texture and composition change completely. But you have to wait until at some point all the details add up to something. An artist would see these things and like them perhaps but would never tackle it on the spot.

RJ: Suppose we had a painter here and I am going to try to sell you to him. It seems to me that art students, who plan to be painters or sculptors, should be exposed to the company of a good photographer while he photographs – particularly a photographer who is successful in capturing the world around him. Why should art students watch a photographer at work? What can they learn from a photographer that they cannot learn from a fellow painter?

SL: Very often as I walk along a street, I see people as funny looking in terms of "this is what they are going to look like in 30 years from now." Today clothes people wore in the twenties look funny to us, and the suits made in France which we see in this country are different and look strange. I see the way people dress and there is a strangeness in the way people dress. I don't know whether artists have that feeling. It is an undressing in a sense, as I try to capture the clown behind the make-up.

RJ: Suppose there were a room for art students and they are all drawing an old beggar. You would come in with your camera and take a photograph. What would be the first question these students would ask you, do you think?

SL: Why did you photograph him from there? Or what were you trying to get?

RJ: Have you ever had the experience of taking a photograph which was better than what the painters did?

SL: I have taken pictures which express the same idea photographically. It doesn't of course look as maudlin as a painter would do it. I took a picture of a negro woman who seemed heroic to me. I can remember artists attempting the same thing at the same time and muffing it so completely because they were pouring themselves into this thing. I tried to do the subject as she was, what she essentially stood for. I was imposing my opinion on the subject, but there was nothing I could do to ruin it. They need to recognize the reality of a situation and not impose a sloppiness on it. A photograph can teach simplification – teach artists to be more direct in their seeing, and to not pull screens over it.

RJ: If you were going to give young art students the benefit of your seeing experience, how would you do it.

SL: By showing them that the actual does not have to be thrown away, and how to look beneath the apparent to the actual, that they can express themselves but need to learn discipline themselves to retain and look for the real thing.

RJ: Can you teach an artist through your photographs?

SL: The camera is itself a form of discipline. You are forced to bring things into focus or way out of focus. This is the definition of the camera as the brush is the definition of the artists. But with a camera you are suddenly being disciplined.

RJ: But the photographer has a peculiar eye. What is the photographer's eye?

SL: I don't know. Everything looks sharp and clear, and details stand out. I look at an object. The artist, too, sees these things but I don't think he has the photographer's sense and grasp of detail; the artist tends to throw details away and then, perhaps, pick them up later on, sometimes, whereas details are what fascinate the photographer.

Some time ago, a student of mine brought in a photograph of a woman standing in a doorway with one kid by the hand and another kid behind her who was half hidden. The woman's head, in looking at the kid behind her was hidden, too, and the painter could not have seen that – or he could not have seen a picture in it, he could have seen it the way the photographer saw it.

RJ: We know that the human eye can be as precise as the camera. However, I still

think the artist's way of looking at life (the visual experience of life) is different from the photographer's way of looking at life.

SL: I will tell you what a photographer sees that an artist doesn't see. A photographer tends to see things in many facets, the same thing in many facets (in many details). The painter generally sees a thing as a unit and hopes to remember it. The painter would never, I think it's safe to say, walk around or study a subject as a photographer would; he would never say to himself: "Shouldn't I come back tonight when the light will be different." Some artists would, sure. They study atmosphere and light – something most painters today have forgotten.

RJ: The painter is imaginative and can make arbitrary perspectives, etc. Chinese artists, for instance, developed serial perspectives and give their paintings the element of time. The light in the English countryside changes quickly, clouds form and disappear suddenly. They move on and off, one moment you have sun and light and the next moment shadows and rain, and the English painters tried to capture this in their paintings. Constable caught it, and Turner in his paintings. Monet also saw and was fascinated by the changing light in an outdoor English railway station.

SL: Yes, this is all true, and this is what I am speaking of. A photographer must train himself to see these things – and again this is what I think an artist can learn most readily from a photographer. He can learn from it, too, as I said, if he studies the painters such as Constable, Turner, Monet, etc., but most painters have forgotten it.

RJ: The Chinese created the time element in their paintings and in their scrolls, and you look at them in a time sequence. They were fascinated by things happening in a moment of time – much were the way a photographer is, as he sees things happening around him, on the street, etc. If you study these Chinese scrolls you have very much the immediacy of photography, and with perspective these paintings are enhanced.

SL: You know the wonderful Buddha at the flea circus. The thing that fascinates me is not the Buddha – but the people juxtaposed with the Buddha. I know what these people are looking at – elephant woman, etc. The people on the street are so prosaic compared to this golden Buddha in the window. This juxtaposition which a painter sees; it is more abstract. When a photographer gets a juxtaposition that is incisive (actual in reality) it is so sharp and hard-hitting and so defined from what the painter gets that I think the painter certainly can get something from studying photography.

RJ: Then you do believe an artist can learn from the study of photography – and that is known and taken for granted. I am interested not in what the painter can learn from looking at photographs, but what he can learn from looking at the photographer, at the discipline the photographer has, and what that discipline gives him which art training in art school cannot give to a student artist. I think it is something like an added eye – an added visual sensitivity. An artist would never think of going down on his knees, for instance, to look at a subject, the way you do.

SL: As I know from my own experience in art school, you are right. I floundered because I didn't know why I was there – I was there to express myself, yes, but I was never disciplined in what it was that I could possibly see or in what way I could see things around me. I really can never recall feeling that art was seeing. Rather I had the feeling that it was all expressing.

RJ: I suppose you could say that the artist interprets his thought.

SL: It is good to have a good outcry of expression now and then, but I still say this is essentially not art. The artist is supposed to be a seer, and is a seer, but most of them arrive at it in a second-hand way. When I watch my students, I say to them: "Hunt the thing down – if you see something, don't let it go, run after it, chase it."

RJ: Yes, I have watched you photograph and I would say, when you see something, suddenly you are cloaked as if you were in a tent, the whole world disappears and you are intent as if you were hunting down a prey.

SL: The materials are outside us. Yet they are both outside <u>and</u> inside. The artist has his materials all gathered up inside himself, so to speak, before he begins his summation. But the photographer, as most of his materials are outside and very transitory, must learn to recognize these materials quickly when he sees them. The artist does also to some extent but not in such detail and with the element of time confronting him.

The lens of the camera is sharp – images tend, unless distorted, to be sharp – much more so than the eye. If I put a lens in my eye I am forced, without trying, to see in detail, to see details. I must, without trying, examine things in great detail; my seeing experience, as a result, becomes much more enriched. The artist, although he, too, may train himself to see as the photographer must, he is never forced to

do it – and very seldom does. This is the incisiveness and discipline which he lacks. The more an artist can be exposed to seeing with a photographer's eye, the more beauty and the more of the world he will see.

Every painter who looks at a photographer's photographs suddenly sees all sorts of things he never saw before – even though his eyes should be trained as well as the photographer's. You know the very first thing Prestopino said when he moved to Hightstown was that he would like to have all the prints I was going to throw away. I said that the things I threw away were images I missed – but that they were dear to me. I thought to myself: why don't you go out and see things for yourself and paint your own pictures – use as, but don't use us in that way. He painted a woman from a photograph of a woman I photographed, and that annoyed me, naturally.

RJ: I agree with you. I don't think I could ever see a child in bare feet again and have the same feeling or help thinking of the Hines' photograph of the child in bare feet. The photographer is of his time to a much more extreme degree than the painter – who is ahead of his time. There are very few paintings of machinery or automobiles today, although Cubist art felt the machine better than a photograph of a machine. But I still think that a photographer's eye is a rare eye.

SL: Well, yes. It was as I said before. I, for instance, wait for a clown to appear to form an image which I have in my mind's eye. If one doesn't appear to fit that preconceived image, I don't photograph. You wait and if you haven't got your camera ready and up to your eye – the image you may be looking for will form and pass before you have time to catch it. If what you are looking for starts to develop in a fascinating fashion, it has the atmosphere of wonder for a photographer. You watch it and watch it and watch it and take it at the moment when it projects a mystery or when it fits the image of what you are looking for in your mind. It is the same problem a storyteller has. You become part of your story or your play. You see something, you become a critic, you watch it for a moment, and at the moment when it has the most meaning for you, you take it. The meaning here is the photographer's meaning.

RJ: The photographer, then, learns to synthesize with his eye instead of through his medium?

SL: Yes. I one took a black and white photograph of a clown playing chess with

himself. I made a painting of my own from the photograph except to get some sense of the figure of the clown. I changed the type of make-up, I changed the color of the shirt, I made the face much more expressive. But I wouldn't say it was an improvement. And, actually, if I hadn't been a photographer, I doubt that I would have seen a picture in it in the first place.

There was a clarity and purity in the photograph which I lost completely in the painting, naturally. I saw a photograph the other day of an airman whose face had been burned. It was a typical American football hero-type of a face – but it was so changed (and so immediately changed) that I saved the picture. A painting could never have caught that.

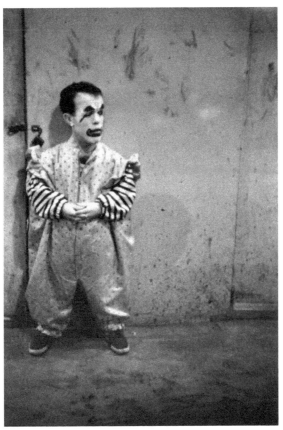

Circus clown. 1950's. Sol Libsohn. Yampolsky Collection.

RJ: Would it be true, then, to say that only the camera eye gives actual truth?

SL: I think that everything is a document. Everything which is a record is of value.

RJ: It seems that you "wander" about and photograph store windows or little old stores. I think these photographs are quite beautiful and I have noticed that rarely are there people in these photographs. I want to know why you take photographs of store fronts.

SL: I don't discriminate against people, first of all. It's that I find I really don't need people in these photographs because the store fronts are so much like people themselves – they have quite distinct personalities of their own, they have an aliveness. My point of view, my seeing position is simple – and in photographing store fronts, I really don't need people. But if people happen to fit naturally into it, I photograph a store front with people or with a person. There is an emphasis in shapes in my photographs and these shapes are derived from myself.

RJ: A photographer then must think quickly and also think in black and white?

SL: In a sense we are the inheritors of the craftsmanship that went into etchings, etc. Photographers are the inheritors of these craftsmen.

RJ: But all print making was a matter of transfer. The photograph, it's true, is a repeatable image, whereas the great glamour of art is that there is only one of each. How long have you been photographing windows and store fronts?

SL: I think some of my first pictures involved windows. I love reflections. Some of my very old pictures were of store fronts. Another thing that fascinates me is the dust coating on windows – which changes the light. I find a great deal of color in black and white and gray. Black and white can take on colors, and the photographer has to see it before he can photograph anything.

What I am really looking for in photographing windows is the inside of the store rather than the outside. I like also to take doorways. There is something very different in the character of different doorways. The light has to be exact, and if I want to take the picture bad enough, I have to come back to a particular doorway when I think the light will be right. The photographer must be able to sense beauty… in strange and even ugly shapes. The photographer must be able to see the organization in disorganization or in clumsiness.

I think one of the major differences between a photographer and a painter is this: I would, for instance, never go through the trouble of draping a couch properly. I would, and would have to, seize it for what it is and as it is. I may be wrong in this or lazy, but it is what I feel. I do not arrange my pictures. They arrange themselves naturally for me. I let objects and situations fall into shape and move themselves into position. If I move them there or there, they become stiff and unreal and unnatural. This is not what I am searching for. [8]

8 Interview between Romana Javitz and Sol Libsohn.1958. TMS. 14 pp. Picture Collection records, Box 2. Manuscripts and Archives Division, The New York Public Library Archives. With permission of Sara Prestopino and the estate of Sol Libsohn.

[Lady in masquerade]. Jacques Callot. (c. 1592 – 1635) Etching, ca. 1620.
Yampolsky Collection.

Chapter Eight

Robert Yampolsky interviews Romana Javitz, ca. 1964

Robert Yampolsky (RY): When you started working at it you didn't necessarily bring all this stuff with you when you started working at it… you got ideas by working. I mean your subject arrangement… classification and natural use of pictures… When you came in there, did you come in with the idea of arranging it for all the public as distinct, from the way you talk about collections for children?

Romana Javitz (RJ): Oh, no. When I took the collection over it had these limitations. And I found that it just didn't work. I thought it didn't work with the public there. And I went to Newark and studied what Newark had, and I realized that Newark wasn't big enough; it just wouldn't do… If you want to do the history from my point of view its very involved, because there weren't any books in the collection and that horrified me. Because the person who started thought if you ought to know what you are looking for and if you don't know you shouldn't come looking there.

The thing is this, that being an art student when I came there and not a librarian, the public would turn to me to help them, and I found that my background was more important in locating pictures than the classification system because the classification system was so geared to educational purposes, that it couldn't help a designer at all. The files were very unimaginative. The pictures were selected from a bookish point of view and not from a visual point of view. I felt that it just wasn't serving the highly articulate public which represented designers.

One important fact was that the library was swamped with refugee artists and designers, people coming from Europe, running away from Europe, who were coming in doing all kinds of industrial design, furniture design, fabric design, and the city was being enriched enormously by their European backgrounds. Now they had left their own private libraries and run away to come to this country, and they were used to going to museums and collections of that sort where they couldn't borrow anything but could see beautifully illustrated books.

One of the first ideas I had was that we had to stop depending upon National

Geographic, for example, for something like 50 percent of our files, and start buying material, where it would enrich the files up to a point where we really helped the public and bring the material that could not be found in books in a branch library, for example. We had to build up the caliber of the collection to reflect the needs of this creative public.

The beginning of the WPA had a very big influence on the development of the collection. That's how photography began there. From the very start I began to analyze what kind of materials all belonged in the collection; that it should include photographs and postcards and anything that would be grist for our mill of pictorial documentation. Also, to establish the standard that nothing is too good. So, we shouldn't be afraid to lend the public good material. From that point of view, we went on to buy books which we could then take apart and remove the plates.

RY: I just wanted to establish the background...

RJ: The thing is I decided that the classes of the John Cotton Dana classification just could not serve an artist public, or a general public... (speaks to her housekeeper, Alma) so the thing is that I became convinced that an A-to-Z file would not serve the public. That a simple alphabetic arrangement, such as Newark had, did not group the material logically from its visual contents.

I decided then that the only thing to do would be to begin recording the language of the public in asking for the pictures, and that was begun as soon as I took over. Since there was no catalog of subject headings available, there was no catalog of subject headings at all by the way, since when the was no catalog when the borrower came in he used his own language, and that language could be analyzed and those (became) headings.

At first it was used to show the trends and needs to guide the buying. Then it became obvious to me that unless we set up a subject heading g scheme based on the language used by the public, we would never achieve a file that reflected its needs. It could reflect a beautiful bibliographical standard of classification, but it would not in any way bring the headings in the way the pictures would file would never reach their deepest use until the heading itself had pictorial qualities and that became a challenge which was greatly met by a study of the language of the public.

RY: Wouldn't you just collect the slips?

RJ: Yes, we would collect the slips and analyze. We still do. That's how we know what's needed and what is coming. It was the perfect foreteller of, for example, changes in fashion, in wallpaper, or what new plays were coming on. You could foretell the next season in fashion. If, for example, there'd be a call for Russian-style button to the side blouses, we knew that somebody was manufacturing them, and we'd probably get many other calls because then they would be imitated by ten other companies. And for example, plaids would suddenly become popular or certain types of designs such as, recently, art nouveau, we knew art nouveau was coming because we had calls for it, or the Edwardian tuck. Because you can tell.

There was a wire or cable or a telephone call to a fashion magazine one day about a Sardinian fisherman's cap. They called us to find out whether we had a file on fisherman's caps. And of course, we did but the thing is that if the public is ahead of us, then you have the perfect guide for the development of your subject headings. And if your headings are good the headings that you've already established from the public's language will serve all the changes and trends because you've already covered it by your scheme of subgroups. I'm very proud of it you know.

For example, the importance of establishing headings (of) pictorial quality is that if they are based almost entirely on their pictorial aspects, primarily by pictorial aspects secondarily by your physical limitations because you have physical limitations of format, and also of quantity—in other words it seems to me that the subject heading establishment can follow a need. But the scheme of subdivisions is the key to the arrangement of the material within the subject headings.

For example, if your heading is Laborers, then you are going to subdivide them chronologically, which is one subdivision. Is it important to keep them arranged chronologically and pooled by century so you have fewer physical folders or units? Or is its chronology secondary to where the chronology occurred? Now we arbitrarily set up lists which has worked beautifully in a file of millions of items.

If it's before 1900, it is filed chronologically. If it's after 1900, it is filed regionally. So that if you want the history of the subject before 1900 you find it arranged chronologically, and then by country. If it's twentieth century, it's arranged the other way. Now you may wonder why. There is a quantitative problem there and

differentiations between countries pictorially because of the introduction of picture magazines and the history of photo printing. So that the quantity for the twentieth century is greater and it's also more regional because of publications being all over the world. In other words, you can find labor unions in China and labor unions in England, and there pictorially may be quite a bit of difference.

In the 1900's and backwards, say, 1600's, you may only have a handful of material. So, if you're looking for 1600's labor and capital, the material is so sparse and will always remain sparse. So it seems to me that the important thing for a labor picture is that it is the 1600's, and that's all we have. You don't give a damn whether it's in England or in Ireland or in France. It's important to find something. Now this is consistent throughout our file and very valuable.

Now for example in certain aspects this works backwards. Anything that is a matter of Costume, which we use for Fashion, is arranged chronologically for the twentieth century, because fashion is an artificial dress dictated each year. It's a social classes Costume. Beginning in the 1900's it's arranged by date without a breakdown. Before 1900 it's arranged by date and a breakdown of country. Anything that's of the social classes, of the high social class, of the rich people or middle class, that is, of "Society", we arrange chronologically because its Fashion.

However, if it's peasant or folk, it's arranged regionally because it doesn't date. That is so with Interiors. A peasant's kitchen is just the same in 1800's or 1910. So that all folk material is arranged by place where- Regionally. That's my international use R, which is regional. It goes in any language. So you have by year – this is my RSTY (Region, Style, Type, Year) – you have an arrangement by year, which is your chronology. You have a regional, which is place-where; these are possible subdivisions which could be done in all languages. In other words, it's a classified arrangement of subdivisions. Take a subject such as Hairdressing. The most important thing to hairdressing is fashion; hence it would go by year. Right?

RY (looking at pictures): This is regional. This is what?

RJ: That's Style. That would be Edwardian, Louis XV, Biedermeier, and so forth. That's a different type, that's by Style. And then there is T, which is Type. If you wanted Hairdressing then broken down by types, wigs and so on, you'd have that too.

RY: You mean these are all possible classifications within any category?

RJ: That's right. This is my mnemonic idea, RSTY. And you can do it in French and German. There are about four languages in which this will work. This is "place-where". Almost everything can either be placed.

What I'm trying to do is destroy the dependence on alphabetic arrangement. The dictionary arrangement does not serve as well as a classified arrangement. A classi-fied arrangement is just as hard to set up. I've done this for IBM, too, and a nurse's file. If you have a classified file or even a slightly classified file, our file is A to Z generally, and you can see that its silly, because Animals have no relation to Aviation except within an alphabet you see. And what we take out of this is everything that is R- Regional. Travel is a main heading under Travel.

RJ: (looking at picture) This is G.

RJ: This is your Geographic file. This is the main head. This is a subdivision scheme. Let's not confuse it. But it's parallel... A general file is from A to Z. It begins with Abacus and goes down to Zoos. This is a specific file, except for what in a book file may be called Travel. We call it Geographic, or the "regional subdivisions", or the "visual aspects" of a country. If you took this entire file and did it regionally then you wouldn't have a subject file.

RJ: So you have to be careful. A geographic file is very limited. It has an authority list so that each country's name is established. Now this is A to Z of every sovereignty, every country, except Paris, New York, as I told you, London. Now these are excep-tions are based on quantity, and under them are every one of these A to Z headings.

RJ: Your great problem is that if your Zoo's included these (in) New York City where you are. The aspects of it that belong to that city are so great, that if you took this all apart – if you took everything in New York City and put it on these main headings, you won't have a file on New York.

This is entirely controlled by public need. We have many people, especially artists, who need everything they can get about Paris. And I couldn't go through all these files looking for a Paris cop. It's an arbitrary decision to classify the file – arrange in a classified style, you see. The same thing (with) portraits. Now, portraits used to be under P. I don't like Portraits, because most of our material is really about person-

alities. So P is for Personality... There is a regional file, or Geographic, whichever you want to call it. Now the Geographic only has geographic aspects of the country. You don't have costume there; you would look under Costume—Regional—Italy.

RY: Does that include architecture, city architecture, that kind of stuff?

RJ: Well, if you look under Munich you would find views of the city. If you wanted Gaudi's architecture, you will find few scenes of it in Barcelona... But under his name, under Architecture—Gaudi you'd find (him). ... There again, that's public need. They may not know it's in Barcelona. They may want work by that guy. Suppose you have looked for (Frank) Lloyd Wright's stuff in every city he was in... you must remember that you have duplication... of pictures, a duplication that we make... so as to put the picture under several headings.

In other words, there is nothing logical in this thing. There is consistency, but there is no logic. Because you can't have logic unless you fit it into one field of human knowledge. Then you can arrange it logically by that. But if you have no navigation file at all if in each country you've left the local fisherman on his boat. That doesn't mean that when you look under Italy you don't find fisherman floating around. But if it's a darned good closeup of the boat, we would put him under Fishing Boats—Italy.

By the way, this is a constant balance. That's what makes the work so fascinating. But if you start to thinking of it pictorially, it's very good. Now, if you call this only Portrait, which was the original heading, people won't look in there if they want a guy sitting in his log cabin or being born; they don't think that's a portrait. So actually, this is the equivalent of a biography. This is Biography; this is Travel, except for the closeup of lives.

In other words, if we have a very good porcelain stove in the Tyrol, we put that under Stoves for Cooking. We have Stoves for Heating, too. That's another pictorial problem. You say "Stoves", it isn't clear enough. So you do these phrase headings, those for heating or cooking stoves. Actually, the whole cookery heading, I think, you will enjoy very much. There were very carefully worked out. So here is a non-alphabetic arrangement, it's a classifying arrangement where you've taken out personalities and their lives.

RY: Geographical?

RJ: Well, the story of Geographic is very fascinating. In World War II, when the United States government decided to go on the Normandy beaches, they needed our material. And if they just took Normandy beaches out.

RY: Yes, they couldn't

RJ: ...it would have been very dangerous. So they came and removed our entire geographic file. And that's how we were able to do this. It was stored elsewhere, and we couldn't lend any of our geographic material.

RY: So they separated it for you...

RJ: Yes, and Miss Lamb's worked on it for 12 years and did a beautiful job. So temporarily we have African tribes there as a main heading. We have every ethnic group... this was all done without money, you know, with no furniture.

RJ: ...but this is so sensible, you have no idea. If you want everything that you can possibly get on Paris, you go to G - Paris and there it is. And that's arranged in class style. There is A to Z every country except the United States, of course. The United States by state, A to Z. And you see if you were in Philadelphia, then Philadelphia is your main heading. ...I would even take New York City out of Geographic and make it a Phenomenon. New York Public Library is a main heading. It isn't under Libraries – New York Public Library because it's silly. In other words, it's stupid to classify it as Libraries. It's *New York Public Library*... So that is a classified arrangement based on a sensible way of doing it. ...

RJ: ...so if you want a good gondolier, he's under Gondolas... it's a main heading. Every type of vessel if a main heading. But it isn't broken down to idiocy. ... if you want a salmon, don't look under S. You don't go to the butcher store or the fish store. You go under Fish - Salmon. The whole animal kingdom has been worked out into popular divisions. I mean we have Birds, but the Fowl are broken down because we don't put chickens under Birds. All poultry is broken down. If you want turkey you look under T; chickens are under C; and so on...

RY: There is a list the public can (see)?

RJ: No. There is a list that the (staff consult). The catalog has died, I'm sorry to say. I have it here. There is a shelf list of folders which is kept up to date. There is a

catalog of subject headings which is in book form, and every cataloger uses it. The public does not need to use it. They do it with slips which is much better for the classifier and the librarian because they just cannot use a catalog unless the catalog is good, and we've never had the funds to set up the catalog.

A man writes he wants cats. Well now, a new assistant there will look up Cats and say she may think it's under Animals, and that's an exception. But they will not – even the staff and the information desk will not use a catalog. It's very funny. But people are very dissatisfied with catalog books when they are looking for pictures. It's very curious. Now, we have a subject index, which is excellent for obscure things that we can't find in Webster's. But the authority lists are wonderful.

RY: But the subject indexes, that's not for the public though, is it?

RJ: It's used for the people, yes. Well, many of our authority lists are still in pencil. I've now been able to get funds for that. No work on the catalog has been supported by the New York Public Library even though it's a unique catalog that's been copied by many people. The catalog, as it is ideally worked out this way, would be great anywhere and has been.

You see, the whole problem is subdivisions everywhere. I know of nowhere they've been worked out as carefully as this has been done. … You know Stoves are arranged by date or type. If they're by Type, if they are oil, gas, or whatever, electric… The source of power is always the main heading… There are rules for consistency, and those rules are established.

See, what they had wanted me to do was publish my list, which doesn't exist at the New York Public Library. I have it here. I've really worked on that. I've worked on that 30 years and it can be applied anywhere because I have personally applied it.

RY: In any language, that's the advantage.

RJ: Any language. It can be applied in any language. I have done this for the history of nursing that I did for the Association of American Nurses. It was very simple. They have a very confused thing, like specific names, and who did it, and which hospital. I threw it all apart and resorted. Caps and graduation and all that. But this thing is very beautiful because if you need it by period you can find it by period.

If you need it by style, styles always cross periods, centuries, and countries. Because they're fashion, and fashion is always hard to use. Fashion almost always comes either by its name or the year in which it was current... another thing is type of Costume, a type always becomes a main heading after you have enough. For instance, Costume - Knitwear.

RY: We have Knitwear here (looking at pictures)

RJ: That can always be a main heading later. Meanwhile, until you have enough, we have Costume - Lounging. We have Costume - Babies; it's a subdivision.

RY: When it becomes a main heading does it stay in the same form? Costume - Babies or does it...

RJ: No, it loses Costume.

RY: It becomes Baby Costume?

RJ: It becomes Infants Wear if you have infants, or Babies Wear or something. Well, for example, shoes could be under Costume, but it's a main heading because it's enormous.

RJ: Shoes are broken down by period and then type, like boots and other shoe types. But anything that is a type for instance if you have a navigation by type of ship, if you find you have too many canoes, you take them out and start Canoes. Any Type heading can become a main heading. You see how sensible it is. It's just a matter of quantity. Once we have quantity, we probably need some division, and you don't want a secondary subdivision.

RJ: Any type of library material, whether its pictures, or books or films, it seems to me is never an archival accumulation unless every effort is made to keep organization in line as it is acquired. I think that if you have collections, and you remain pleased at the caliber of the collection or the name of the donor or what you paid for the collection you do not have a library function in mind at all.

I think it's all right for a museum to have collections labeled by the name of the donor, at which one can oooh and aaah at its quality, where each item is the only item of its kind in the world, and you just keep on having it as a group or, as is so

frequently called, as a bundle. The historical societies throughout the country have carried through the bundle idea, so has the Library of Congress.

In other words, why organize it more than as a unit in the shape in which it was originally accumulated as a gift? I feel strongly that the idea of the relationships of individual items in a library collection, while they may be very important among rarities, collections of rarities, very often the idea of keeping it as a unit has killed its use in our lifetime.

Actually, if it's lost to those who will do an excavation job when it enters an institution, and if its lost to those who are defeated by the cataloging, which is often obscure and discusses a donor and the importance of the collection rather than giving you an idea what the collection contains item by item, then it's just lost, it's lifeless.

And certainly, when you come to the idea of pictorial, when you come to the handling of any kind of pictorial material, you really defeat its use because it does not lend itself to a word description if you want to locate it. It just does not. Word descriptions of pictorial collections are quite useless.

RY: From what you were saying before when you were criticizing, are you saying that libraries as libraries are not doing their function beyond picture collections?

RJ: No, I am speaking specifically.

RY: Those in the libraries or in the museums?

RJ: Both. There are many collections of pictures that simply appear in a catalog as: "Collection of photography containing 48 ambrotypes, 60 daguerreotypes, collected by John Blow". If you get a chance to go through those, you're overwhelmed at the richness of the subject content of these as documents. You can cross-index them as much as you want from photographs by date, and it does not help you.

It (is) inexcusable in that it was an unnecessary handling of all the items in a so-called "lot". It isn't bundles; it's moved down to lot. Change the word bundle that I used. They're done by lot. In the New York Public Library, one way we are coming at it, as you know, is the use of a Source Index. In order to keep the design of the lot by the arranger or donor or maker, we simply assign a progressive accession number, which we call the source number. So that John Blow's collection of daguerreotypes

will be given let us say the next number, which is 13,108. On the source card of 13,108 there will be a description of the appearance of that lot as he collected it.

RY: So, if you needed for some reason or other to get the whole thing together you could just by going to the source?

RJ: Yes. You will get a very clear idea, for example that the group of pictures given to us, which were made by the Farm Security Administration, contained 75,000 prints made by the photographers. The dates are there, and they were made under governmental sponsorship for the Resettlement Administration. There would be the name of the director of the project and the description of the final disposition of those photographs.

On those series of catalog cards there would be no attempt to describe the visual content of those photographs. First of all, a film was made of them, a film was made, film, of most of the prints. But outside of that it just says this has now been distributed in our file, one, since there were so many duplicates, by State. So if you want see the FSA records of the houses that needed resettlement for the state of Georgia, you'll find them under Georgia. You will find anything related to migrant workers, duplicates were placed under Migrant Workers, in addition to being under that state in which they were migrants, they migrated to, let's say California. You may add the subject heading specifically but that may not...

(pause)

RY: Do you want to stop for a cigarette?

RJ: No, I am just thinking. No amount of description would help in those pictures. We know later on when they say it here, that when people are searching for these things, they are not satisfied with anything but looking through the coverage of that subject. They will not ask for one print. (telephone rings) I am going to have to answer that...

(pauses to answer telephone)

Material can be just saved, and there is a great deal to be said for saving it, right? For example, I am not wound up properly, but I will be.

Berenice Abbott saved the Atgets literally. She stored them in her apartment and saved them for forty years. She hoarded them in a way, she saved them, protected them, kept them clean.

RY: Did she make a plan to distribute them?

RJ: No, she sold them.

RY: I mean during that forty years did she…?

RJ: No, she tried to sell them all those years. She couldn't. She wanted to sell the whole collection. Now most collectors collect material out of some vanity let us say and hence it is saved by being out together within the category of their interest.

The guy who collects everything about tobacco, you have that collection. And let us say its saved by being put together. If you only have collections as given by a donor whether it's a library or a museum the all-over picture of human activity is lost. Because let us take the whole story of labor and tobacco. Does it appear in the Arents Collection?

RY: I'm sure it does, we'll have to dig it out.

RJ: You will have to dig it out. Whereas if you have an all-over collection, or if all the collections were indexed, you see. There's a little bit of confusion here because we're talking on either books or pictures and we will have to get off that.

But the problem with pictures is this: That from fairly early times there was a realization that the image, whether it was a three-dimensional image such as a portrait head, has been very important since the year one. A portrait is always important. That the idea of what to do with the image as a document was always a problem. It seemed much easier, with the development of private art collections and the development of aesthetics, to look at all images for their aesthetic value, for the style of a period, for this represented Louis XV's court and the paintings by him.

It was some time before we find a record of images being looked at for their content outside of their scientific use. You see when printing began, the printing of books, the need for illustrations was very obvious in technical material and scientific material. That's why I think it's very simple to trace the development of documentary pictures

through herbals and other botanicals and other reflections of man's desire to learn about the world around him. That one of the earliest printed books, illustrated books, that was successful in Italian was the history of the costumes of people all over the world is a very good indication of that too.

However, this material has been mainly in books. The collection of prints, pictures printed for sale as loose prints, became the province of museums. Because first of all they were rare. They came from the hands of the artist. They were mainly in limited editions. They were hard to come by. Only a prince could afford to collect the loose prints, the relief prints. The so-called cabinets of prints, of writings and so on, were almost always linked to aristocrat's private museum or library. And it was quite early that the librarians or the caretakers of print collections realized that whether it was art or not was usually quite secondary.

The fluctuations in establishing that Rembrandt was really an artist and not a documenter. I shouldn't use that word—not a recorder of his time; and that (the) Tarot(?) was a great artist and not important to the recording of atrocities and wars of his period, this whole idea of the separation of the artist…

RY: I wonder how that got started.

RJ: The earliest that I have been able to start it is in the earliest reports of keepers of prints. The earliest that I could find in my experience was by checking the organization of print collections in Vienna, and in Berlin and Paris. It's in Paris that I found this early art book by Abbe Damerol. That's 1600's. He immediately in his first reports you find that he thinks that if one took the prints and organized their content by subject, that they could be used for the education of the young princes.

And that there is the very seed, the fact that in the Alexandrian Library there's a room of portraits that was considered the Portrait Collection. There are actual heads of—and there in the report on the history of the Alexandrian Library you find a discussion of the importance of knowing your visages of the great men of our time. Even though the attributions are usually wrong, that's all right, whether it was really Julius Caesar or not.

When you think of some of the pictures of our heroes today, you know it doesn't look like them at all anyway. I have no idea what George Washington looked like

even though he was painted in his own time, and neither do you. But we do know that the illustrators of almost every period borrowed material from each other and thought nothing of copying an earlier man's mistakes and passing them off as their own mistakes. Anatomical drawings were never drawn from anatomical specimens. That was a great revolution when it happened.

RY: But they didn't know they were making mistakes they just assumed.

RJ: No, of course they just copied. But it is amazing how much of the early scientific material was done from nature and was drawn from nature. The dissections were made of the plants and so on, animals and human beings, for those early drawings.

RY: Yes, I remember that drawing of a camera obscura with a skeleton hung upside down so the image would be the right way around.

RJ: Reversed yes.

RJ: Well, you know a lot about that. But in (inaudible), which you must have, his introduction is perfect. He lists that when you look at these prints, you can find out facts about the visible world, and that's what we're talking about.

But the libraries cannot remain and do not remain satisfied with the printed word alone. They just can't. They have sound recordings, and they have the visual image recorded. However, while even music can lend itself to organization bibliographically, pictures do not.

Much of what held pictorial libraries back was that through John Cotton Dana, among his other innovations, realized the usefulness of pictures in education, and set up picture files for the use of schools and probably to help what would always be a costly organization problem. He cooperated with the local schools in Newark, and he geared his whole collection for teaching. He wasn't there very long when he realized that they were in the center of a very much, very extended, industrial design throughout Newark and artists began to come in to design products... He was an innovator at the museum in two important categories for us today. One was the importance of beauty in inexpensive objects, and two was the importance of folk art in America.

RY: When was this?

RJ: This was very early in the history of the Newark Museum. You can find it in one of my articles, but I'd better not stop. Then in his recognition of folk art, of course he had all of the paintings and that made all the difference in the world.

However, they would have exhibitions of things that cost less than ten cents up to a dollar that were beautiful. In his recognition of the role of good design, he realized that he could supply the working artists and craftsmen in his city with the sources of the design of so on, so on. That enhanced the whole status of the Picture Collection there. Of course, he'd also done this in Worcester (MA) where he first began it. There is an article.

RY: Where is that?

RJ: In the encyclopedia on that. I don't feel like going into it. But when the Picture Collection started in the New York Public Library, it started accidentally in this sense: It started entirely because of the public. Because there was no picture file in the main library except clippings in the Print Division. But the Print Division was geared to the art of the printmaker and the art of the great illustrators, and they couldn't be bothered with pictures of babies and bread and whatnot. Their facilities would be completely swamped, and they were afraid that their rare material would be mishandled, as it would. Because they had the originals, whereas these artists could do just as well with a good color print or printed picture rather than the print itself. Is this going far afield?

RY: No, go ahead.

RJ: Now what happened was that artists would go to the Rare Print Department and be told, no. So they were sent to a children's library. It was customary to send artists to children's libraries because if they went through children's books, they would surely find what they were looking for since children's books were so thoroughly illustrated. You could always look in some children's encyclopedia, but the artists, especially after the (first) World War... They weren't satisfied with the children's libraries, the collections in the children's rooms. They finally were referred to the central catalog, the Union catalog of all our branch libraries to see whether they could find something in the catalog, which is in the main catalog office... They went to the catalog and a book catalog couldn't help them at all.

And this is particularly true of the scenic designers because that was the height of production *in New York City of plays and of films*. We had several big film studios here, Long Island City, Twentieth Century Fox, and Jersey. These film studios needed to search in depth for pictorial facts of the past and digging through books was just so unsatisfactory. They just couldn't find enough.

The chief cataloger, a New York Public Library man, was very distressed about this constant call of the public for pictures. Since they handle all discarded books, because their accession number was removed from the catalog in those days, instead of discarding the books they cut the pictures out – without a source, by the way. One of the chief catalogers (Emma F. Cragin) was assigned to start a picture collection. Within three years it grew tremendously and artists by word of mouth kept pouring in. Instead of beginning as a school library, as it happened everywhere else, jewelry designers and illustrators and so on began to use it, and the librarian was sent to Newark Public Library to survey the use there.

So this collection of the New York Public Library was automatically set up with the subject headings used in Newark, which was a great tragedy to the artist. Because, almost all of the headings were based on syllabi there, you see. For example, one of the headings was Forms of Land and Water. So if you wanted Niagara Falls you had to look under F, under Forms of Land and Water. And then you'd figure out what Niagara Falls was a form of. There were other headings of that kind. Like: Revolutionary War Causes.

RY: But you said Dana had a picture file setup.

RJ: His was set up for schools, even though artists used it. Until I came along, actually, there was no picture file set up to serve other than for school purposes. Actually, the New York Public Library does not serve schools. I felt strongly that it would be impossible for us, the public library, to serve the general public with its "sophisticated", by using the term sophisticated I mean knowledgeable use – for broad purposes such as the illustration of books used in education, and to have that file also serve the school teacher on a grade school level or a high school level.

Unfortunately for our system of education, the schoolteacher, the teacher at the lower level, I mean grade and high school teacher, would want certain materials, such as the cause of the Revolutionary War. Now we found that the artists' needs

were much more specific and more individual, and that his choice has to be freely available. A choice had to be available. Whereas a teacher didn't need choice; she wanted size and color. That meant the quantity in large color prints and a great many duplicates, would all that would be needed.

I took it upon myself arbitrarily to decide that the public library couldn't possibly serve as a deposit collection, to be used, let's say, four times a year of large colored, school-classroom-sized prints made up in sets to teach geology, to teach astronomy. Then each year those would have to be updated. We couldn't possibly have the general public librarian trained for a special library such as this know enough to service a teaching unit. In other words, I think the Board of Education should set up its own pictorial library. It is desperately needed, by the way, throughout the country.

RY: Have you?

RJ: No, I've worked on it many times. I've sat with teachers, with the heads of the boards of education. But they have been terribly tempted to but obvious things such as filmstrips and recording. Meanwhile, the still picture still delights. I didn't mean to pun with it. But the still picture delights more people and is given more attention from the point of view of your clocking the time paid.

Looking at a still picture, you'll find it's much greater than anything else. I've observed it over and over again, and I have pictures showing that the amount of time spent looking at still pictures outside of a movie house is fantastically long. I have seen young children look at still pictures endlessly. Even for a longer time than they're reading a book. They will go back and look at the pictures and discuss them and call someone over to see what they saw and discuss what they saw. And then bring the picture over to someone else and ask them about the picture.

In other words, there's a great fountain of information and exchange of information when a picture is held in your hand. That is one reason, too, why setting up a picture collection where the public can help themselves to a great degree after the material is handed to them, that you do not make a selection of the pictures they are to borrow and see. You only locate for them the coverage that you have of a subject. They are left to study it and make a selection.

On this basis, an artist wrote an article in Publisher's Weekly or Wilson's Bulletin

complaining about the Philadelphia Public Library and making a comparison between the picture collection there and the Picture Collection of the New York Public Library. In her article she interviewed the librarian at the head of the Philadelphia Public Library, and then she interviewed me, see, at the New York Public Library. She decided that the reason that we allow the selection and withdrawal of materials by the public, whereas in Philadelphia you have to tell the librarian what you want, and she selects it for you, she decided it was because I was trained as an artist, and the librarian there was trained as a librarian.

The important thing to remember in setting up any type of picture collection, whether you're in industry or for that matter even in a museum, I don't care what type of picture collection it is, it is impossible for you to visualize the image that's in the eye of the person asking for a picture. It is impossible, don't attempt to do it. You can only give them broadly what they're looking for, and then they can find the specific image they need. There is nothing that is more frustrating to a seeker for an illustration to be handed: This is what you're looking for.

RJ: It is very irritating because you can't possibly know. Of course in a museum it's simpler. If you have an art file, and John Blow wants "Mona Lisa", it's going to be very easy. Except you bring "Mona Lisa", and he says, "I don't want this color print. It's no good.", hands you a black-and-white.

In other words, it boils down to organizing the collection in such a way that the public has a choice of selection, that you will function as the organizer of these images from the point of view of their broadest usefulness in the type of collection you set up. If I had a picture collection that was only the history of medicine even then suppose you started out logically by categories within medicine, you will find that you still have to use pictorial terms. You have to have a sense of pictorial content. I don't know if I have gone off the beam or not.

RY: How long had that thing in the public library been functioning when you came in?

RJ: It was before World War I. World War I brought the heaviest, about 1913. I'd love to get that original diary...

RY: There was just one thing that occurred to me when you were talking about the

early arrangements of pictures. Would you say that your ideas about pictures, the way you arrange them, would have been the same, say, if there wasn't any photography at all in the world?

RJ: Yes. It had nothing to do with photography. The coming of photography just I think enriched each file on any subject it enriched it in a peculiar way because in some respects it amplified the stature of great artists, the renderings of the same subjects.

When you saw (Robert) Capa's, this is very important, when you saw Capa's Spanish (Civil) war photographs, and those were filed in Spanish History in the same folder with the Goya drawings, you begin to realize how powerful what the artist saw, and despite our being so attuned of the so-called realism in photography, we learn that realism in images is always there. It's a very exciting point.

As I have told you before, I have never seen a photograph of love or... I have never seen anything erotic in a photograph, never. But I have seen much erotica in the drawings of great artists. A photograph can never be erotic because its reality is too superficial. There's the statement of the year. You can quote me.

RY: Yes. No, that's a great thing actually.

RJ: That's the whole excitement of the real artist. It's the same thing as if you – I have seen a machine produce art just as the oscilloscope does. But the thing is that there is no substitute for the human who's personally involved. [9]

9 Romana Javitz interview with Robert Yampolsky, ca. 1964, transcript from magnetic tape, 1994. With permission of Dr. Philip Yampolsky.

Nineteenth-century shop front. Charleston, South Carolina. March 1936.
Walker Evans. Yampolsky Collection.

Chapter Nine

Richard Doud interviews Romana Javitz

RD: This is an interview with Romana Javitz at the New York Public Library, February 23, 1965. The interviewer is Richard K. Doud. You mentioned something about there being two sides to a picture file.

RJ: Oh, I would like to begin by stating any views I have about any collection of photographs or even about one photograph I have a certain basis for my point of view and these are quite unlike that of a photographers or museum staffs and I'd really like to sound off about it.

First of all, whatever our private point of view is about enjoying a photograph or its visual content or let's say its aesthetic meaning or the concept of the photographer, putting aside what may be your first pleasure in a photograph, as a librarian I find that I very much want to read the facts in the photograph. I immediately turn the picture over and try to find out what, who, where and when. That does not mean that I am looking at these photographs from a journalistic point of view, as history. I want very much to enlarge my experience of the image by adding as many words as I can find that came out of the circumstances in which the photograph was taken. And I do quite a bit of teaching in how to look at pictures from the point of view of documents.

The facts that amazes me most of the beginners in picture work is the way the image changes as you know more about the content in terms of words. I have a particular fondness for watching people read a paper such as the *New York Daily News* which is one of our best picture papers. I mean best pictorially and from the use of words to drag the reader's eye into the picture and make him look at the picture. And no matter how crowded a subway or bus is the reader reading the *Daily News* will flip that paper back and forth from the story to the picture, from the picture to the story until he has found everything in the picture that the story has told him to look for. Well, that is very much the way we look into a picture from the point of view of a library archive.

In a museum the same photographs have been absorbed by studying their outer, their visual content without worrying about who done it and why. And then they can be very selective because after all it is a museum, they are art buyers of taste, they are to decide this is a great photograph by a second-rate photographer or a second-rate photograph by a super first-rate photographer. They have the great privilege of labeling the photograph as being Expressionist, Realist or otherwise.

Now there is a third category of people who handle pictures and that is a true archivist, let's say like some at the National Archives. They don't even look at the pictures, if they come to them in groups, they're very happy to keep them tied together as a group because each picture affects the next picture. And so, they keep it as a body of documentation and they never separate the photographs from anything with words attached to them. If there's a letter or diary, that is all kept as part of the photographic document, so you see there are really three different ways of placing a documentary photograph.

I think that the one I represent as a librarian is perhaps the richest in its role because the way we handle the picture is the least narrow, the least prejudiced and the least editorial. We do not judge – you're not supposed to argue with me or agree are you, right? Let's see, where was I?

In other words, we don't appraise the picture for its value, we accept it and try to organize such pictures, let's say, and add this one to the organization so they can reach the highest, widest use. And our main motto is usefulness. It may be immediate, or it may be in the future.

Through the many years of experience that I've had with pictures I find that no matter how ephemeral the material seems to be, it has a very long life if it is being used. Once it is put away it seems to die, it is very curious. There is something about a photograph when it is constantly used that seems to give it life and one reason that it seems have life is that as different types of people use that picture you who are issuing the picture and lending it in this case, you see all these new things in each picture. The scenic designer looks at it and designs an abstract set, well, you never looked at a photograph before from the point of view of its abstract qualities as the basis for a setting that would be authentic for the 1930s. And a psychiatrist picks up this picture and says this is exactly the kind of antagonism I was looking for, well, you didn't even know there was any antagonism in the picture. And suddenly all

these photographs become part of our living and that has really been our experience with the FSA (Farm Security Administration) photographs.

RD: Could I interject something here?

RJ: You may with pleasure.

RD: This brings up a point which I think is well made or well taken by some people who feel this way particularly in the case of the FSA photo file; I say particularly because they're more concerned with it than other files. This business of certain pictures perhaps living because they are in continued use or more often used has served to more or less invalidate the remainder of the pictures in the file in that whether or not the pictures that are used are any better than the others is of no consequence. Possibly they are considered better because they are more known, more accepted through repeated usage. Do you think this is a danger in any picture collection, that people will not take the time to seek out perhaps different exposures of the subject?

RJ: They are extremely delighted to find that chestnut is one of 400 views that they could have been using and they will go into those 400 other views. The chance that that one Madonna of the Migrants was used over and over and over again does not blind the eye to others.

In fact, I think that before you make a general statement such as you have – it's not your statement I realize – I think that the people in the picture business, I mean publishers, have a perverted idea of what the reading public looks like. They visualize the reading public as being one big monster who always goes to the back of the magazine, never reads it in progression, etc. etc. Actually that monster is broken up into many different types of people. The so-called chestnuts, the skull in the sand and the man with his son, against the wind and even the Dorothea Lange's, while they have been overused, have had an influence on the artist in our midst. I say artist in a very broad sense. I mean the poet and writer and so on.

The artists who always come back and say, "Aren't there others in the same series?" Because particularly in Dorothea Lange's and Russell Lee's you have a sense that every picture is just like one word of a sentence. It's not the whole story and you have a very strong desire to see the rest. I have in my own experience – we had a detail of a Shaker little girl holding a rather cracked doll against herself. The doll

looks pock-marked on its head.

Well, I often wondered what was happening all around and it really wasn't until about two summers ago when I worked on *Bitter Years* (1962 MoMA exhibition) that we had time to go through those and everyone who was working on the file began to give forth with great excitement because they found the rest of this little girl. And everyone felt so much better because most of these still photographs were not taken as one picture and as they were taken for a picture essay or picture story that these photographers were skilled and I should say it was sensitive enough a story so that they made no attempt to tell the whole story in one picture.

And I think that one thing that comes over from FSA pictures is that there are no isolated images. The image is a part of a long continuing tale. You meet the coal miner squatting waiting for the bus, you see him walking towards his house, you see his children, you see him on the porch, you seen him going to work and you just feel this thing is a non-isolated image, and nothing will hurt that feeling or take away from it except museum shows.

The museums are – I have a prejudice as you notice. I am trained as an artist; my education is that of a painter. Of course, I couldn't have lived without a museum. I think museums are extremely snobby in the attitude towards the intelligence of the public. I really do.

RD: I'm afraid you're right.

RJ: Any museum that would show an Egyptian mummy, a Rembrandt and a cash register at the same time is confused. You drag into the Metropolitan Museum the first thing you see is a nice, shiny cash register in their shop, and then you're with a child, the child drags you over to look at the mummy and then you want to go in and see Gothic art or you want to see a Rembrandt. It's like, it's as if you went into a concert hall and the Beatles were in one corner and Beethoven in another corner and a guy with a juke box playing, I don't know what.

RD: It's a nice way to put it.

RJ: The museums are very confused and when it comes to photographs, they're so determined to make photography an art they don't know where they are. I mean, I think they're doing a wonderful job for photographers, but I do think that – I think

the term 'documentary' was very painful but necessary.

It has hurt films too, you know this idea of a documentary film, there's a great confusion about it. Art films, documentary films, films for TV, films for advertising, films for entertainment. I think the whole image thing is so young that we have fallen apart finding the language for it and I think it traps us. These are documentary photographs, they tell you, then suddenly you go into a museum and the documentary photograph hangs as art.

Well, all of art is documents. I mean, Rembrandt's are documents. Daumier's are documents. All of Goya is a document, "The Horrors of War". That reminds me, I was once thrown out of a session at the museum, not literally, but sort of sat on because they had brought out the Tarawa photographs.

La seguridad de un reo no exige tormento (The Custody of a Criminal Does Not Call for Torture), c. 1810. Francisco de Goya (1746-1828). etching and burin [trial proof printed posthumously before 1859].

RD: Have you seen those?

RJ: Well, these I think are the censored ones, they were terrible. So I piped up and I said I'd just been to Boston and saw all of the Goya's Horrors of War and it was very odd, I was able to stomach the Tarawa photographs, but I had to turn away from the Goyas. The realism through the artist's synthesis was much more terrifying than the war analysis. And I mentioned that and

heaps of abuse were put on me. "Nothing could be more real than a photograph!"

That's not true. I think it's terribly exciting to give each art its place and I think the great photographs are as great as great paintings. I mean, I appreciate the museum place for photographs, but I think they ought – I think the field even though it's 100 years old is still very young.

Now from our point of view when the FSA came, when the photographs came to us, they just gave us a completely new eye. It really was a third eye for all our trouble. You have no idea of what richness it meant to us. First of all, it was the first time that we had images that were clean cut. They weren't made to sell records or soap or whatnot. Before that our records, our pictures were very tainted by commerce from the point of selling. They were pretty. They were *Saturday Evening Post*, definitely *Collier's*, old *Harpers*. Remember even then the Civil War photographs which were available were slight.

The best things we had were clippings from the rotogravure section of the newspapers which were tremendous and still very important. I don't know what we would do without the rotogravure. That's your photojournalism before *Life* and *Look*. We had any amount of material on society because of the rotogravures and *Harper's Bazaar*, *Vogue* and *Vanity Fair*, all those magazines and the inflation of the 20's. We can give you what the society woman would wear on the Riviera and what her dog looked like in South Hampton. But we couldn't find a sun bonnet.

Actually, the Index of American Design began when the first refugees came here, and they were extremely sensitive about America not having a "culture". And they would sort of say – "Well, isn't there anything that's American? And we tried to think what American design is, just as today we're asked for Spanish design, you know. There is no Spanish design. You know we have to use Moorish-Spanish design. Well, we decided that ricrac was probably the only really American design or like jeans and overalls were, what do you call them, Levis aren't they?

RD: Yes, Levis.

RJ: Levis. I get mixed up because my doctor's name is Levi instead of Levy and I always have to remember that; so Levis. Well, that was American. And then we had never seen our sun bonnets really. The way the old sun bonnets were cut, it's

not common elsewhere. I couldn't find any decent pictures of sun bonnets. And I used to be very annoyed about, what's American and what isn't American because everyone has a tradition. It's a lot of nonsense.

We had a tradition and I worked very closely with the building up of our Negro history collection, that was one of my pet interests, because this Negro from the West Indies was determined to show the Negro that he had a past. And he began this marvelous collection which he had in Harlem called the (Schomburg) Collection of Negro History and Literature. It's a very extraordinary collection and I helped from the very beginning because he thought that we could get pictures on the past of the Negro which would be important. And here we were working to give the Negro his past. You see, it was terribly important. And yet we could never say, "Well, this is American culture."

We did not have any museums of folk art then, no one except Miss (Edith) Halpert was collecting folk art. I mean, you would talk about American weathervanes and this and that but there was nothing, nothing, nothing, and from that was born the *Index of American Design*. Now at the same time if you wanted a picture of an American farmer you'd have to go to drawings by Frost. Do you know those at all, or Campbell? They're caricatures. They have this right-angled beard you know, wonderful.

Actually, it was only in the work of illustrators that you had any concept of our countryside, our people, and if you go through our clippings before this really revolutionary step forward in our record of the American scene, you will see how paltry, prejudiced and distorted are the pictorial records of our people.

For example, if you would pick up a comic magazine of the early '20s or the '10s and look at the drawings and the Saturday Evening Post and Harpers and Century and so forth, even go into the fashion magazines of the day – you can hardly find a man. It's very hard for us to find what men looked like the first few decades.

Although the camera was busy, you know, there were not cheap enough photo-mechanical methods for reproducing. If you went to the Rotogravure, which was our source in society only, here was this democratic society with the society pages and the life of the movie stars. They were very amusing.

RD: What part did the old mail order catalogue after the 1880's play in this?

RJ: They're our only source. You know, they're all on microfilm and they've all been preserved. The Sears Roebuck people have spent a fortune to preserve those pages, they are one of the depositories. I remember Shahn wanting something for one of the campaigns of the government. He needed a pair of shoes for less than one dollar and, of course, the only way to find that is to check the Sears Roebuck catalogue. Actually, without trade catalogues you are lost.

The FSA if it had only continued, if there had been a continuing history, we would really have a heritage of our visual, of the visual aspects of our life. It is extremely empty. I had a man, he's been working here for about a week now, we had somebody from the State Department working all last week here on trades that the Negro man had been active in. Now if you want to find the history of the blacksmith and what he looked like outside of very romanticized Longfellow's Chestnut Tree – those local photographers who took pictures didn't know what to do with their negatives. Most of those were thrown away.

Of course, many dedicated librarians and particularly archivists in historical societies throughout the country have rescued the work of amateur photographers. I know one day I was asked to go to Philadelphia to look at a collection of pictures, clippings, and they were offered to us for a very small sum of money and I didn't want them because they just duplicated what we had. We're offered photographs every day we can't accept. And so, I looked at them and they were pictures submitted in an amateur contest for the *Boy's Youth Companion* magazine in 1905. These were submitted from almost every state in the Union. They're very small photographs, they are beautiful, and they are the best pictures we have ever found of the traditional farmer with his right-angled beard and wonderful covered bridges and baby carriages and a marvel-ous set of pictures on the Negro living in cabins. I have one, the State Department is borrowing it, it's a woman and her children with great big tubs in which she did the laundry. She was apparently a local laundress and even the littlest boy is wearing a blouse, shirt, it was just beautiful. She had black gloves on for some odd reason. But there are things like that. It's not a great photograph; it doesn't belong in the museum collection. From the point of view of an archivist, he would be unhappy because we don't know where that is, we don't have any idea where it comes from but for an artist, for a writer, just seeing a picture like that is exciting.

Very often artists and writers will take a flock of material, let's say he'll take a folder

of FSA photographs. They will just browse through them and never take one, well, they just want to immerse themselves in a period or in the lives of some families. And you don't know what it's going to come out as. It may come out as abstract art, pop art or a poem. What is the difference?

In other words, you have – it's a sort of a yeast, it's a very, very rich and important element in the lives of all those who have looked at them. We have had young men work here, artists, writers and composers who handle them just for filing and when they leave, you know one of the things they say always is, "I'm gonna miss handling those FSA photographs." They have felt that there was a sort of, "It cannot be believed" element in them.

RD: I think I know what you mean.

RJ: And they cannot be believed. I want to tell you that the Negroes who have used this file – and I must say its earlier than this Negro revolutionary movement we're living through. This was some time ago. I've studied them very carefully and one sociologist told me that – well, he came here, he was trying to arouse an interest in a group of young Negroes he was teaching. He wanted to arouse an interest in them to see their own past. It's very difficult for them, even the educated Negro to fight within himself something that was pounded into him that the only past he has is a savage past.

I've worked with many Negroes that have this feeling and he was determined with his group to show them that much of what they thought about themselves, that had been pounded into them as being Negro was not Negro at all but that it was because of circumstances. So he wanted to know whether in the FSA archives of files he could look for materials showing white people doing things, living as, the Negroes have been told they do because they're Negroes. And he found wonderful things, dirt, filth, children neglected, children full of flies, a drunken white man, families all messed up and he took no pictures of Negroes, he took all white people and I think that was a very exciting use for those pictures.

RD: Well, could you sort of give us an introduction to your first experience with this whole thing? What you were? This is sort of historical, I suppose.

RJ: Yes, well, let's say in the beginning, right? In the beginning we knew that several

of our public, we can all them that, people who are artists, and others who use the Library picture files and who are now working for the government on governmental projects involving pictures. One of the first was Walker Evans whom we knew as a photographer and had always been interested in the potential of photographic files in the library.

Walker Evans and Ben Shahn began to tell us about this project and then Roy Stryker came too. They brought him here to see a picture, a documentary picture file in action. At the time we were serving many public projects, such as those making murals and we had letters from all over the country, wherever murals were being painted. We were supplying the pictorial research for them and very soon several conferences were set up, particularly on how the pictures should be taken care of after they were photographed.

I remember going down to Washington and making a plea to Stryker that the subject content of the pictures must be analyzed as soon as they were made so that immediately you could find any subject, for example, privies or sheriffs or some crops such as cotton, and the subject, for example analysis must be handled at the same time as the photograph is being made, and I tried to impress upon the importance of the gathering of data with each picture. And we had very regular reports on how the project was going from the men on the project.

Whenever they came to New York they would come by and discuss particularly the subject, the problem of the organization of these pictures after they were gathered. Somewhere along the line, I don't know when – I do know because Bill, Jonathan Daniels, right? Signed, ah, put that – you know this story of how they saved and impounded…

RD: Yes

RJ: Well, two weeks before that so don't make me look up the time, but two or three weeks before that I received an anonymous package of photographs. Actually, before that whenever I saw Stryker, he came here and we had lunch together, I would gripe about certain things I could never find pictures of such as ice cream cones and other Americana, privies and so on and I would complain and very shortly I would get a picture of that, you know, someone would take a picture, it would be delightful.

When this package came, and we opened it out poured these treasures. Beautiful prints and the next day more prints came without a single sign of where they came from. One day in great triumph Mr. Stryker appeared in person and said, "It's all right now, we can tell you. But we had a meeting and decided if Congress was going to impound all these pictures. As you know, some Senators were eager to have it done, at least a duplicate file would be available in New York but we didn't dare send it to you officially until the decks were clear. And now!" And he told me how he slipped… Jonathan Daniels put this memo on top of all the other letters on Roosevelt's desk, so he signed it first – you know that? And so, they went to the Library of Congress and then we were all clean. We could admit where they come from, by then we had an extremely good file and rather than make it a precious museum file or archive file we decided to handle it very freely. There were many duplicates, many were unlabeled, many were labeled and today, of course, we have about 40,000 of them.

We had taken the time to take out every Negro item because of the need and they had been used up and about the last three months those have been used by everyone, from film makers to government because they find them more easily here. It is an extraordinary collection when seen by any one subject. The mere fact that they were here made it possible for Steichen to handle about 150 thousand pictures by hand before they put up an exhibition. The film, we do not own the film strip due to Mr. Vanderbilt's attitude towards the New York Public Library which I think was unfortunate at that time.

There is very little understanding of the library's role in the community when it comes to material like photographs. We are the only place where the Democrats and the Republicans, where the opo artists and realistic artists, where the amateur and the professional all get together. In other words, you will see at our desk and our table the same material being used by both sides of the fence.

And our greatest artists, easel artists and sculptor love this file because it is not selected for you. So you must always have a library file, you must have your material somewhere in a library. Otherwise, you see, you can never help the artist because he's ahead; he's ahead of the museum. He's ahead of publications. The artist is always a step ahead. It is just like the artist went to the moon before we did. We had pictures of flights to the moon, people imagined flights to the moon, optical

illusions have been in our files, now they're in the galleries, now the museum – we've always had optical illusions here.

We are not telling you what is good and what is bad. And the nice part of it is this, that after a few years our material becomes extremely valuable because by then the museum decides this is art. We have had – I bought Atgets immediately, I've had Atgets here for 30 years, When Miss Abbott was very hard up, and I discovered that she had all these Atgets I went down and bought a few. When a young photographer comes in with pictures and they're of interest, I buy them and a year later he's a salon photographer.

Now we have the work of many young photographers which I buy for their subject content. Well, some of them can't get a foot into a museum, you see, but they may walk into a library because they don't feel the material has been labeled and hence all FSA whether it's a Dorothea Lange, or a Ben Shahn or an unknown photograph are there for the public to use.

You have a file here that is in use every day of the year, even though we have had no money to house them, we've had no money to care for them, we have no paper to mend them with but there has not been a day they haven't been used. And one whole group was used to a frazzle practically because it was used by the WPA. At that time the painting murals and posters and in other words a duplicate file such as we have here is a file for use rather than preservation.

But we have discovered, this is just really amazing if you were a mystic or something, that the material that's in use seems to have more life than the material on the shelf. There is something about something not being used – it atrophies. I have one picture here that's been used and used and used for such a myriad of purposes. I really should quote Dorothea Lange for you because she said of all the places in the world where she'd rather have her material it would be in the library. She made up a collection of photographs which have appeared, been used in TV and all sorts of purposes. She's had more inquiries for her pictures here than from anywhere else. It's true, maybe someone who wants to design a cameo using Dorothea Lange on a cameo, it may be for a hairdo in a Dutch boy style but ah…

Grandmother from Oklahoma and her pieced quilt. California, Kern County.
1936. Dorothea Lange.

RD: If you don't mind talking about people or personalities along with photographs, I'd like to have you say something about some of the artists involved. There are a couple about whom we know very little because we haven't had an opportunity to see them and may not get to see them, particularly Walker Evans who has been quite a figure in this whole business and yet seems so unavailable.

RJ: Well, Walker Evans – do you want my appraisal of these photographers?

RD: If you care to give it, any comments are valuable.

RJ: I have very strong feelings about the work of these people. Of course, look I'm not a museum curator. You want to know what I thought of the photography, why is that? Just for fun?

RD: Well I think you're as good a judge as anybody in the country at this point

visually, so if you could just sort of –

RJ: Now, you say you want an opinion of what could be done, so forth, and oh, assessment of one photographer after the other?

RD: No, I don't think –

RJ: Particularly Walker Evans?

RD: I'm interested in Walker because I haven't seen him and may not.

RJ: Walker Evans undoubtedly set the pace of the entire collection; off the record he didn't agree with Stryker but it's on the record.

RD: Well, everyone knows it anyway.

RJ: Here was a man of exquisite taste, I'm saying that advisedly. Neither Shahn as a painter nor Dorothea Lange as a photographer or any of the others on the project had the complete assurance of his aesthetic taste, no question about that. His eye was the purest, it was never diverted by story and yet he was a word man. He earned a living since then with words as well as photographs. He was extremely swift in decision and very deliberate when he began to work. In other words, he took loads of time.

For instance, I would say here I've watched him work and he seems to be taking so much time that you were sure nothing would come of it. But when he was ready to shoot there it was, one, two, three and it was so sure, and he had selected the most beautiful elements of all. Of them all I think he had the greatest sense of beauty and I think his pictures are immediately recognizable for their beauty. No matter how bitter the scene, or maybe sordid, there's a great beauty in it.

And I know a young photographer today, for example, I had a visitor from, I had a group of students, visitors from a Philadelphia photographic school, included a young boy from Ecuador who had been educated in London and was a sophisticated young person and I had arranged for them to go through our photographic collection which is arranged by the name of the photographer. When this boy, this young man, reached Evans, he jumped out of his chair and ran around and tried to show everyone what he found in these pictures. And there was one picture of

a girl – these were in streets of Cuba by the way, these are not FSA photographs, these were the Cuban series – and there was one of a girl, a young woman on the street and this boy just became completely ecstatic, couldn't speak about this picture because of a spirit in it and sheer beauty. He was just speechless about it. Now he has gone through Dorothea Lange and even Helen Levitt whom I admire greatly, and he had gone through Abbotts and Atgets and what not and these Evans just drove him mad and many of us felt that when you plow through many, many files of the FSA looking for something every time you meet an Evans you stop. You don't know it's Evans. This sounds like a cult, but it isn't. There is in him such a drive of perfectionist, he is most fussy person on earth, that when he takes a picture, he's put everything in it.

RD: What was his background, what was there in him that would lead toward this type of an approach?

RJ: Well, he's sort of a born aristocrat. I don't mean that his background is aristocratic, but he's quite born.

RD: A New Yorker?

RJ: Well, the person who knows more about Evans than anyone else is George (Leighton) who happens to be a friend of mine. Evans can see through nonsense. He doesn't stand for any nonsense, he doesn't stand for red tape, he doesn't stand for mish mash of forms and conforming etcetera.

I think the best treatment to Evans is the Agee book, you know Agee was a very close friend of his. When I say he's a born aristocrat I don't mean to refer to his family. He's (an) extremely creative artist. Above all he's the artist with the camera and he's an unsmiling person. Walker Evans was, as far as I know, was the only dedicated photographer at the very beginning. The others came from other fields and were given a camera and sent out to photograph.

There were economists, for instance. Rothstein was an economics major at Columbia, Shahn was in mural painting, Bernarda Bryson was a draftsman. Some of the others were writers fundamentally. I think we had more writers than painters from that first group. Rosskam was a painter. Ed Rosskam was a painter. Ed Locke was a writer. I think he had a kettle of fish there with this one photographer on

top and here was this man I say who was blue blood as far as art is concerned with extremely high standards which he maintained throughout. And here he worked with all these people who don't even know a camera from the end of a horse, particularly his boss. After all, Stryker was not a photographer, he was an entrepreneur.

And Walker Evans never could take being told what to do. I had an experience with him once when he was on a *Harper's Bazaar* assignment which I think was lucrative and I didn't know anything about it. I got a telephone call from our public relations department saying, "There's a completely mad photographer here. He said that he would not take photographs in this building if we accompanied him. He said that he wouldn't mind if you came along 'cause that wouldn't count', so I said, "Very well, I'll go along." The point is he had to be alone and he had to brood and he knew exactly what would have to be done if he did it. But he was a prima donna and I think it was extremely painful for him to have all these characters who really knew more about setting up projects, I'm sure, than he did, suddenly telling him how to take photographs. I mean, it was painful and then he had to really show them what was meant by the photograph and it took Shahn many years to give him credit for it and in his biography by Rodman there's a very good paragraph about what he owes Evans, which I thought was long overdue.

Evans is the only photographer I've ever had who didn't talk about photographs. He doesn't talk about photographs, but he does talk about the subject of the photographs and hence he's much more interesting than most photographers. I remember his telling me about early railroad stations, you know, that are left. Well, he did a tremendous amount of research before he went off to photograph anything. He was a reader, he studied up everything he possibly could about these old places and then he went out and photographed.

RD: Did he do a thing on the Long Island Railroad, commuter or something?

RJ: He did a beautiful series of old stations for *Fortune* magazine in color, just beautiful. The colleges he did, Wheaton College, beautiful portfolio. I think that the standard he set probably gave the flavor to the whole project. I may be exaggerating but it seems that almost all the photographs that we have were made possible by this great chance of high standards. It is amazing that considering the purpose for which the project was set up that such a high standard was maintained. And you certainly can't say it was due to the content of the pictures.

218

RD: No.

RJ: Because in some other hands that same content would have been the razzle dazzle journalism or sentimental and drippy kind of pictures. They could have been very corny pictures and they were not.

RD: Well, in that case, don't you feel that a lot of credit is due to the other people who could meet this standard and to the people who would insist upon the standards which perhaps Walker Evans set up, insist that they be met and could appreciate the value of this standard?

RJ: Well. I think that it was that, the spirit of it, in whatever way it is engendered, is what made that so extraordinary and I think as you go through the files, the conformity of standard, which is a good conformity, is outstanding. And you don't find it today even though you can recognize the life attitude in photography; it's interesting that you don't have that sort of homogenous state all through it. I think it's very outstanding in these photographs that though they were done here they are… that you can see, spot, you can spot as I say (a) photograph, and it isn't always that subject.

RD: It's probably not fair to ask but do you feel that any of the pictorial outlets today are maintaining standards anywhere near the level of the Farm Security thing?

RJ: They can't afford it; they can't afford the amount of let's say 'wasteage' that was possible then. There's another thing, I think that picture magazines are lost because they have to wallow in advertising and their reader has to wallow in it. I had an extremely interesting meeting with the picture editor of *Look* a week ago. We had a very good talk, Mr. Holbrook, do you know him?

RD: No, I don't.

RJ: He's knowledgeable, a man of very good taste, quite an extraordinary person and one reason I was with him was to discuss the future of pictures. But, the reason I was happy to see him was that I found since he changed *Look* that the curse of the advertising is much lessened. Did you ever see *Look*?

RD: Yes.

RJ: Well, you know it's infinitely better than *Life*, there's no comparison, and he had done actually by physical manipulation rather than contents of the photographs. I do not think that there is lack of good photographers, I do not think there were better photographers among the FSA than I see among young photographers today.

I do think that the use of photographs, the production of photographs only for commerce limits the field dreadfully. In other words, there is no government-sponsored photographic project to speak of. Most of the younger people in photography have one dream and that is for the FSA to come back. I have had many artists say, "Oh, for those days, imagine working for the government and recording what you see." Now the reason they say this is not the greed of wanting to work for what might be a cinch.

The young people today, and I'm speaking of those in their twenties, are seeing so much happen that someone should record without wondering whether it would sell a girdle or a cigarette. But they don't know what to do. Paper is expensive, they itch to photograph what they see and can't afford to.

A young man who worked for us finally skipped away and was able to go abroad. He's a Negro and never before had he been anywhere without being afraid. His first day in Paris he learned what is was like not to be afraid, the first time in his life. I had a daily letter. In London he looked at all the camera magazines and decided there was only one good one. He earned twenty-five dollars so he could get to Lucerne; he went to Lucerne, went into the office of what he thought was the best camera magazine in the world, left his photographs of Negroes there and they offered immediately to publish them. In fact, they wanted him to do a book.

He wouldn't have a chance here. You have to pitch it towards selling. Well, now he's back here, I have his photographs, he hasn't money enough to print what he took in Europe. He went on to an agent here and they're trying to figure how he can make a living on photographs. On the other hand, he is torn because he wants to do what he's seen, and there is no way of doing it. If he were writing he could sit around and write without any tools, to write you only need a pencil and pen but for a photographer it's so expensive and if he's taken beautiful things he's extremely unbitter and he has an extraordinary view of white people that comes out in his photographs.

Well, here's a young man at 24 years of age and he just went down today to get a hack license. He thought he'd drive a taxicab to make enough money to make his prints. But I could multiply this by hundreds. The thing is that there should either be local or national support for a minimum recording of our own times. That was such a blazing-the-trail program. Why would they cover things that we can't believe about the United States?

RD: Well, do you feel that either state or federal government should mount a photo project for the sake of recording our times as well as for the benefit of the talent that might otherwise go to waste?

RJ: No, I don't think that the purpose is to encourage our talent. I think government patronage is important in many fields, but I think this is more than patronage of the arts. I think it's beside the point that it uses talent. I think it's a very important support, but I think that America showed in two programs to the world that we are not afraid to look at ourselves and we are not afraid of recording what we look like and also we should show that we have a sense of history.

We've been scorned so often about being so young, not having a past and all that rot. Nothing is as important today as a knowledge of the past and we have certain records of the past that are constantly available, but they're distorted because of so little of it is true and so little is contemporaneous. And more and more we know we can learn more about our past from other sources and nothing excites people more than to go to a place where the thing actually happened and the reality of it is very exciting.

Now we are barely teaching our children with true visual documents, when you think of a really poor, pictorial material dished out to children, it's disgusting. They see events on film, and they see it on TV with great clarity and vividness: the funeral of Churchill or of Kennedy or the atomic bomb has been shown to them photograph-ically and is as much part of their heritage as singing the "Star Spangled Banner". Yet we have no government program to produce source material of our own day from year to year, all the changing, and the customs and what has been and what has gone and a lot of the glory of our art just as the glory of our architecture has barely been recorded by government.

Here we have one of the greatest arts of all time, we have the works of our artists

and engineers and our architects, great works and that is not recorded systematically at all. We build a Verrazano Bridge and depend on free enterprise to photograph it and free enterprise does a very good job. We have whole migrations of people here, we have disasters and good things, we have the absorption of immigrant people, we have changes of custom, we have a whole story of teenagers which is fascinating, amazing side of the story. Has anybody recorded here the revolution in clothing of the teenagers? How they revolutionize everything we wear? You try to find that in the pages of fashion magazines. It's very difficult. I think minimum investment would pay off very well.

In other words, we need documentation of our times. And what we need in governmental records instead of their making six carbon copies of every senator's speech, they should make no carbon copies and put that money into a photographic record of our times. Its – you can't even talk about certain living because the building was destroyed, and you can't prove anyone lived that way anymore.

The photographic history of our industry is just dead, the photographic history of labor doesn't exist. There are about two pictures of ? Of course, you can't have hindsight and know if that's going to be an important step, but we pride ourselves on labor, yet even the labor unions are not sponsoring any intelligent, consistent program of any continuity to record the scene. And this is something that we could do that no other nation has done. You know, the European nations have envied us the Index of American Design. I read quite a blurb in an English paper on how disgraceful it was that England never thought of doing something like that.

RD: Do you think the people would appreciate or understand it if it were being done? What I'm trying to get you to tell me now is whether or not people at the time of the FSA operation appreciated and understood what was being done?

RJ: Well, the Agee book explains it pretty well: the intellectuals who were taking part of it were saying that people we're photographing were hungry. That is what it amounts to. People resent photography and feel it is prying but I don't think that's important because if you're making documentation of that time you are making it as a record for the future. I think TV has done beautifully in certain areas except that they are conscious of their sponsors. I think the job of the, I was supposed to go see it, of the town in England called the "Strangers." Did you see that by any chance?

RD: No, I didn't.

RJ: The effect of – Stilzwick(?), I think was the town where the East Indians were living, and the entire town was prejudiced against these Indians and voted for this extremely reactionary man and got him into parliament on the basis of a very racist attitude. It's a beautiful video tape, just beautiful and very sensitive. You see, business uses a rounded talent in that they use the best writer they can get and the best photographer they can get and the best editor whereas the governmental project was set up like this, or if it was set up with foundation money I guess, they will have a top photographer and have a second-rate writer.

If you really wanted to have powerful documentation of our times for the future, then you have to get a top writer or a poet to do the scripts for a really good job. In other words, you need writers and artists and it could be done I think if it were done on a pilot basis first, with one community and one project could be set up for the rest of the country. And from the point of view of using the town of course, Dorothea Lange has done this, you know she's written this all up. I think we all worked on it.

I think the use of the human talent, of our talented artists is a secondary although terribly important factor. I think the most important factor is that we, having this tremendous, powerful new tool of education, do nothing to use it, to record our own history. I have just been given a I don't know whether it's a – I guess it's been painted here and so can be put back if I can find it – *American Heritage* just put out pictures, history, cards and they did take contemporary drawings but here is a whole period of (colonial?) art and they show but one covered wagon rolling around with two oxen, you have no field with people working or anything where of course if you, if we wanted, well look at that little film you saw. What a heartbreaker! That's education. You have music recorded, you have literature recorded and you have the visual.

RD: Well, this sort of brings up the point of the uses of this type of material specifically, the Farm Security material…

RJ: Would you evaluate the total FSA photo project – is that what you want me to do?

RD: It's probably too broad a question. Maybe not, specifically.

RJ: I'm going to evaluate it. I think the body of the FSA photographs is one of the most precious treasures in the Library of Congress. I feel it is not appreciated there for historical reasons which I'm going to sound off about.

Mrs. Bill Stagg with state quilt she made. Mrs. Stagg helps her husband in the fields with plowing, planting, and weeding corn and harvesting beans, and quilts while she rests during the noon hour. Pie Town, New Mexico.1940. Russell Lee.

Here is a tradition that prints per se, that is the rare engravings, woodcuts and lithographs and Currier & Ives have a more intrinsic value, kind of a literal and monetary value than photographs and as long as you have the museum mind taking care of prints, collections that include photographs, you will find that the photographs are considered as just photographs and they're not looked at as works of art naturally, but they're also not respected sufficiently.

I feel that the FSA photographs in the Library of Congress need new stature. I think that a foundation or a source of money should be found, and they really should

be put into better shape physically. They should really be analyzed, duplicated, made available throughout the country. I think selected groups from them should be published. I do not think it would make a negative picture.

I think somebody could go through there and simply use them for art, for their photographic merit, portfolios of 50 pictures or 100 should be available at every school throughout the country. I think groups of them should be published for, as an historical comment of the period and I do think that they, as a whole, are an extremely indestructible influence and have been a very deep influence and will continue to be a very deep influence on many thinking people.

There's a whole generation who have not seen them at all and they'll get terribly excited when they see them. And they're not so sufficiently available, they're only available in a very selected and what we call refeened rather than refined, sort of super-refeened selection you know. That is, I feel that they have not been exploited sufficiently by government. I think they ought to be published in nice inexpensive but well publications, well printed.

RD: Well, could I just project here now a question along the same line. You mentioned some of the uses to which the file has been put through your own pictures here, could you talk some more about that. Whether or not interest has been increasing or decreasing in the use of these pictures?

RJ: It has been increasing, it has been extraordinarily increased. One, because to quote a term I use the parallel of poverty because it's such an – so lazy to find a parallel so that all the attention on poverty today immediately recalls the poverty of that day and everything has been dragged out of those files and there is the same old poverty. We were amused. I don't mean amused in a funny way, but we were amazed, I should say, because I discovered in checking through that the tatters and the worn clothes, and the worn blankets are just the same, they don't seem to change in fashion.

RD: No progress in poverty then.

RJ: No, the tatters are just the same. You wouldn't know, one never thinks of that, the rags are just the same in other words and here 25 years ago by and the rags take on the same shape. Then the whole Negro, the tremendous way of interest

in the past of the Negro which you can't begin to keep up with – ah, we have just been overwhelmed but every type of agency in government, out of government, churches, on TV, on radio, on film, for material on the past of the Negro.

It's beyond our capacity to meet these requests at all, and as I've told you we've taken the time to go through our photographic material and we have drawers upon drawers just filled with Negro records, and it is very painful, very sickening and extremely dramatic. It's a very important record for Negroes, if you want to be bitter there's the seeds of bitterness right in those pictures and right next door is the records of white people and that's bitter too, unbelievable. The thing that rings at you all the time is, this is American, and you can't believe it. It's just so hard to believe it's in our country, the poverty, it's just unbelievable.

It's a terrific experience and that is if anything they are more useful today than they've ever been. I think they'll be more and more useful, and it is true that one or two shocks have been used over and over again but I don't know, some of them wear and some of them don't. Some of them you just can't bear seeing anymore whereas others you don't mind, some of them you mind. As far as further use there is a use that's not intended but which I've enjoyed very much.

For example, if I want to show a group of students that the urge for beauty or the urge to add an unnecessary, useful thing in your home is universal, I have collected many pictures of FSA miserable homes and there isn't a single one there that hasn't either a little paper flower over the mantlepiece or pictures taken out of newspapers and put up. For anybody who wants to do a study of décor in these terribly deprived homes, it's very interesting material, the arrangements, the desire for beauty on the wall, the study of the children and the children's reaction to the photographer. There is loads of material to study there; different aged children, the groups and the children with the very old grandparents, the feet, the diseases, the clothes, the artifacts in a poor home, the table – we've been asked about the eating of food of these people and the amazing collection of facts. They have not begun to be explored.

I mean, if you want to be real stout about this stuff but there is plenty of material to explore. Visually there's a lot to be studied; architecturally the home, some of the only records we have of certain types of homes and farms, farm buildings, garbage, good study, i.e., of salvage and junk. Also, the urban dwelling is interesting, urban

life. I think it's terrifying in some ways because it's still, I mean, there is something about seeing endless, quiet photographs. I know on the back of Shahn's photographs he put down what they said sometimes.

RD: Yes

RJ: He met up with one little child who was running after a little baby, running with a long dress.

RD: I don't know, I don't recall.

RJ: And they saw a ? and on the back it said, "But it isn't a cow, it's a bull."

RD: Very good.

RJ: Very nice.

RD: Well, I can think of two specific projects, bigger projects that were put together from your collection of photographs in the last few years. One was the "Bitter Years", exhibition in the Museum of Modern Art and the other was that wonderful film I saw this morning, Mr. (Raymond) Sipherd's "Years Without Harvest."

RJ: Oh, you just saw it today?

RD: Yes, just this morning.

RJ: Did you give him my best?

RD: Yes, I certainly did. I was wondering if you could point out other projects of this nature that might have been, might have relied heavily upon this picture file. I think there's something going on now, some movie you mentioned.

RJ: Oh, there are plenty. I couldn't name them all. The Negro thing, of course, these have been used over and over again although not as publicly. For example, I use a filmstrip in teaching how to work with pictures, documentary work with pictures for librarians. It's a postgraduate course. In addition to that I give a seminar in pictures which is the only thing of its kind, and in training them I use many FSA films, pictures, from the point of view of classification and I have also shown this filmstrip to an audience of a very miscellaneous public and the underlining purpose of this

talk and filmstrip is to show you that pictures is another language and we ought to learn to use pictures the way you do words and I suggest to these mothers and teenagers is that they can take pictures out of newspapers and learn to use them.

Well, that last time I showed this filmstrip we had a very large audience in the library, very miscellaneous, people who drift in from the street. They're the wonderful audiences and at the end so many people want to speak to me I couldn't handle them. And several of the women were sort of housewifey type and one woman came to me and she had tears coming into her eyes and said, "I thought of pictures that way, this is going to change my life, looking at magazines and showing them to my children."

You see, everyone has babbled about photographs as art and you know these great photographers and the picture stories, and no one has bothered as yet to teach children and teenagers to look at pictures and see what they can find in them. They learn a lot about the aesthetics of art when they go to a museum and you know learn the dates.

My very first job in the library when I was at college, I was studying to be an artist, not a librarian, and on Saturdays we (were) asked to work in the library, which was very short of people, and so my first job was in the children's room. And when I arrived this librarian who looked ancient of days to me, she was about 30 I think, I was 15 or 16, she pointed to a round table at which children were looking at books, little bitty children who were too young to read books and it was called "easy picture books" and each one sat and they would turn over pages of picture books and this librarian said to me, "Now you go over there and make them look at pictures."

I thought she was crazy. Well, these children were having a wonderful time turning pages of the picture books. I couldn't imagine what I was supposed to do but I trotted over there sort of wondering and I discovered the children were not looking at the pictures, they were turning the pages. And having a wonderful time. So I tried to make them stop and look at pictures and I looked at the pictures with them.

And most people do not look at pictures; I think if you take the opportunity to take a group of FSA photographs as I have had to do and discuss these pictures from the point of view of content and what you can find it becomes a very exciting experience. When I finished talking to one group of teenagers who were extremely progressive, they went to a progressive school, I was a little bit nervous because they

were questioning and restless and a week later they called the library and wanted to know if they could come and see me because they had decided to do a world ? newspaper with pictures which is something I had suggested, that they could cut magazines and things, take out pictures of interest to them and try to use them after studying them to see if they could make their own picture story.

Well, a committee came to see me, and they said they decided to have an exhibition on pornography, so you can imagine the whole situation. So I said, "Well, what is the problem?" They told me they had dug up an essay by D.H. Lawrence and had been reading all kinds of references to when is a picture pornographic. They had found nudes, art in art and had found pictures they thought were nasty and so on and what they came to see me about was since school had youngsters in it below teenage, could I advise them how they could have an exhibition on pornography that would not injure the very young?

Now I thought I was extremely excited because they had learned to use pictures, you see? And the same thing with these grownups that I've used FSA photographs with. At first, they will not look at them and then when these pictures are presented as for what's in them you see, what the implications are, what's going on too, when it's used in history too. Just as the Daily News says the girl to the left is really the dope addict who murdered the man to the right and so on.

In other words, these newspapers feed you enough so you can go back to that picture and dig out. Well, there's nothing done very constructively with these things, of course. In other words, you could go through the FSA photographs and do a tremendous essay on the Negro in America in the 1930's; he was the first to be fired and the last to be hired and so on. Or you could go through and say this must not happen in America. On the other hand, you can say these people who have never seen a city, who have never owned anything. I mean, these homes, these beds made out of cartons that come out in these pictures, in other words, how can you explain that?

What is there to learn out of these pictures? There is no body of information of how to use pictures as teaching tools. There are some interesting historians in this like Professor Hazerd at Penn U. and others. But nobody can afford to have photographs for use in classrooms. Take American industry: we're a free enterprise country, if you want to show the influence of one factory in a town or go back to

some cause of the Civil War, I mean the cotton industry, you can go mad trying to find it. Even the history of our industries, it just isn't. Companies have thrown their stuff away. I wrote to one company, I wrote a letter to carriage company which we found listed somewhere and the man wrote back and said yea, his grandfather had this carriage making company and now he had oil wells in Texas and he dug around and got early scrapbook photographs of the first carriages. But much of industry hasn't kept its own records, we're called all the time. We had a call from Ford Company, one of the earliest little factories was somewhere in Brooklyn, but they've never been able to find a picture.

RD: Oh, for goodness sakes.

RJ: This is something we really ought to get the Xerox people to support.

RD: Well, I think we sort of talked through or around most of the questions.

RJ: Why don't you think (of) anything I've left out while I reach this phone call. I don't have to sign this?

RD: No, in fact you have a chance to edit it.

RJ: I don't want to edit it. I'm not an expert anyway. Where were we?

RD: You were going to tell me what you really think.

RJ: Oh, about this business of some great photographs being the earmark of the entire collection. I think that the importance of this collection is not the importance of a few so-called great photographs, what happened is this: Curators of photographic collections – and I'm going to include Steichen – tried very hard to present photography as an art but actually photographs as documents is a much more exciting subject.

For years curators of rare prints in museums would publish in their annual reports which I checked from the early part of the century on, this is in the British Museum and other museums of that caliber. Every year in the annual reports which it said people would come to look at prints by Rembrandt, Whistler and Durer but what they really asked for were engravings of cats, engravings of the Madonna and other subjects. It discourages me very much as curator of prints that the essential

interest is in the subject of the print. Now we're talking about rare prints, now the greatest authority on prints, Hind of the British Museum who has written books by the dozen – he is a great god of printmakers – kept complaining that people always saw the subject in a picture.

Now what are you going to do, we have eyes and the first thing we do is look at the subject. Well, now the aesthetic boys want you not to look at the subject of the picture but just to enjoy it for its aesthetic content. My background is completely that of a painter, so I have a right to speak. I feel that the importance of subjects in pictures is a very valid importance but if there is a subject in the picture you have a right to enjoy that picture and it's very stupid to try to put a veil over the picture and say look, pay no attention to the subject, just drink the picture in. It's nonsense, you keep people away from art by telling them they mustn't see the subjects. That is just ridiculous.

Now the photographic aesthetics people decided that subject was unimportant. We had tremendous battles at the Museum of Modern Art. I had served on the counsel for a while because we were divided on whether the subject mattered or the subject did not matter.

Meanwhile, Steichen went into the war and took documentary photographs. He was in charge of the documentary photographs including that beautiful movie, "Aircraft Carrier." Do you remember that? Beautiful movie, it had tremendous aesthetic quality – a documentary, by the way. It was so beautiful you were just breathless. It was a Japanese attack on the ship but you could enjoy aesthetically; at the same time, it was documentation.

Suddenly the museum decides that it was all right to recognize subject and they did the "Family of Man." How dreadful! Now beginning about 20 years ago museums also decided they couldn't fight it, let's get with it. People will look at subjects. Now, the subjects were to drag the public in and once the public began looking at the subject you gave them much written material so that they could enjoy the aesthetics of it. But the first impact and the real excitement came from the subject, and the "Family of Man" was the first time that the Museum of Modern Art faced the fact that the subject might be more important, and that exhibition was the most successful exhibition of its sort the world had ever seen.

Now the subject could be looked at really and not apologized for. However, in order to take the sting out of having the necessity of subject shows they had to, within the subject, pick out only the best work, that is, the best aesthetically, so a little trap was formed, they would only take great photographs and who was to decide they were great? They had to be decided they were great photographs in spite of the subject so there became a whole aesthetic creed which is very hard to accept because it's unsound.

Many of these pictures that we consider great and beautiful photographs are great and beautiful first because of their subject content and secondarily because of the skill of the photographer and I will stand up for the art of the photographer. However, I think the museums confuse the people and I would like to go back to what I said before. I felt in going through the FSA you never felt it was a one-picture deal and that you always want to see the rest and that you had this sense of drive that you want to see the rest, you want to see more and haven't we sort of given ourselves.

I know I have said there must be more of this man. I remember him again and again and again. And the subject content is so overwhelmingly important in this type of documentation that no amount of little blue ribbons saying this is better than that can give you any feeling of, well, I don't want to look at the rest. That is museum life and I'm "agin" it really. I think it's a false premise. Now I have spoken my piece.

RD: Well, I should let you go back to business, I guess.

RJ: I'll have to find it. Are you happy?

RD: Much greater than I thought. Yes, I certainly appreciate all you've given us. Thank you very much. [10]

10 Oral history interview with Romana Javitz, February 23rd, 1965. Reprinted with permission: Archives of American Art, Smithsonian Institution. *Archives of American Art Journal*, 2001, Volume 41, pages 2-17. See also: https://www.aaa. si.edu/collections/interviews/oral-history-interview-romana-javitz-12963

Appendix I

Picture Collection online with links to respective digital collections and a compendium of Picture Collection holdings transferred to the NYPL Research Libraries

Picture Collection Online – Part of the NYPL Digital Collections portal consisting mostly of images produced in the early twentieth century and before, the non-circulating Reference file complements the division's primary circulating image holdings and is organized into the same 12,000 subject categories as the main collection. This digital presentation is of over 34,000 Reference images and postcards from a broad selection of the most requested image subject categories, including Costume, American history, New York City, Design and others.

See: https://digitalcollections.nypl.org/divisions/the-miriam-and-ira-d-wallach-division-of-art-prints-and-photographs-picture

Photographs Transferred to The Miriam and Ira D. Wallach Division of Art, Photography Collection

Resettlement Administration (RA) and Farm Security Administration (FSA) photographs – NYPL's Resettlement Administration and Farm Security Administration collection is comprised of approximately 40,000 photographs taken from 1935 to 1942 and includes examples of prints from all the photogra-phers hired to document the plight of Americans during the Great Depression. Later, under the Office of War Information, the agenda shifted to themes of patriotism and war production. NYPL's RA/FSA photographs were trans-ferred from the Picture Collection to the Research Libraries' Miriam and Ira D. Wallach Division of Art, Prints and Photographs in 1997. See PC Source #5979, 5980, 5982.

see also: *The Duplicate File: New Insights into the FSA.* by Mary Jane Appel. Archives of American Art Journal. Spring 2015. Vol. 54, No. 1. The University of Chicago Press on behalf of The Archives of American Art, Smithsonian Institution. pp. 4-27. Retrieved from: https://www.jstor.org/stable/10.1086/683147.

See: https://digitalcollections.nypl.org/collections/
farm-security-administration-photographs

Dorothea Lange portfolios – In 1964, while working on her retrospective
exhibition for the Museum of Modern Art, New York, Dorothea Lange con-
tacted Javitz about placing what became three sets of photographs of her work
in the Picture Collection files: A portfolio of what Lange called The American
Country Woman; another a series on the Amana Society of Iowa, made while on
a 1941 Guggenheim grant; and a third group a selection of over 200 exhibition
prints and working proofs presented as a gift. Lange understood the mission of
the Picture Collection and wanted her legacy of photo-documentation to be a
permanent part of it. Lange wrote to Javitz in 1965 about the American Country
Woman series:

"There are about sixteen personages in the box and in many cases as accompa-
niment to the Women is a photograph of where she lives, her habitation. I have
worked on these photographs for years, on and off, and they are captioned and
in some cases documented. There is some historical importance to this collection.
The photographs are not *pictury*, but forthright." (italics added)[11]

The portfolios she eventually submitted act perhaps as a counterpoint to her
MoMA retrospective. They sum up the shared vision that Javitz and Lange had
for the role of photography in documenting America and its role in disseminat-
ing that vision to the public at-large. It is a true measure of their friendship.

See: https://digitalcollections.nypl.org/collections/
photographs-from-the-american-country-woman-series

Walker Evans – Walker Evans worked in the New York Public Library's Map
Room from March 1924 to the fall of 1925. It is likely that Evans discovered the
Picture Collection at this time and became enamored of its post card collection.
The post card collection has long been a major source of pictorial information
for the Picture Collection. Evans, a life-long collector of postcards, would
eventu-ally use some samples for the May 1948 issue of Fortune magazine.

11 TMS on letterhead. Lange to Javitz, 2 pp. June 5, 1965. New York Public Library Archives, RG8, Picture Collection
records Correspondence Box1.

Javitz was working in the Picture Collection at this time and eventually she and Evans became acquainted. Over the years Evans would photograph the subject-themed exhibits the Picture Collection staged in its corridors, including the *ABC* show (1932), *Romance of Railroading (1934)*, *Peddlers and Vendors (1935)*, and *Arrivals and Departures (1938)*. Soon after publication of Carleton Beals' book "The Crime of Cuba" (J..B. Lippincott Company, 1934) Javitz acquired 34 prints from Evans which were used in the publication. These prints inspired Picture Collection users for decades and continue to inspire as part of the Wallach Division's Photography Collection.

Lewis Wickes Hine: Documentary Photographs, 1905-1938 – The extensive NYPL holdings of photographs by Lewis W. Hine (1874-1940) came to the Library in different ways. Hine was known to photograph for the Branch Libraries as early as 1910 and his work can be found in the New York Public Library Archives (Visual Materials, RG10). Once the Picture Collection was officially established in 1916 many of Hine's photographs also began to populate its stock. Hine himself began to donate photographs to the Picture Collection in 1931 and possibly earlier, including his series of the Empire State Building. In 1949, the Russell Sage Foundation transferred to the New York Public Library several series of Hine prints (among them Ellis Island and NYC tenements) which it had commissioned from him for its library. Many of these photographs were transferred initially to the U.S., Local History & Genealogy Division and in the 1990's to the Photography Collection of the Miriam and Ira D. Wallach Division of Art, Prints and Photographs. See MFZ (Hine) 95-33. Hine prints can still be found in the Picture Collection's Reference File under various headings. See also: https://digitalcollections.nypl.org/collections/lewis-wickes-hine-documentary-photographs-1905-1938

The Romana Javitz Collection of Photographs – Between the 1930's and the 1960's Romana Javitz purchased or was gifted photographs for the Picture Collection directly from many photographers. Sometime in the 1950's a decision was made to separate most photographs in the picture stock to form a "photographers file" likely to facilitate storage and handling issues. Many include urban views of New York City and Philadelphia by members of the Kamoinge Workshop and other Harlem area photographers.

A subset of this collection, designated the Franziska Gay Schacht Memorial Collection, is dedicated to Schacht who was a senior Picture Collection librarian and contributed to and helped edit *Picturescope*, the newsletter of the Special Libraries Association's Picture Division. She died rather suddenly of medical complications in 1962.

For more information you can search these photographer's names in The Miriam and Ira D. Wallach Division of Art, Prints and Photographs Prints & Photographs Online Catalog. wallachprintsandphotos.nypl.org/catalog

Photographers represented in the Romana Javitz Collection include: Berenice Abbott (American, 1898-1991), Joel B. Aronson (American, active 1960s-1980s), Eugène Atget (French, 1857-1927), Elizabeth Alice Austen (American, 1866-1952), William A. Barnhill (American, 1889-1987), Cecil Beaton (English, 1904-1980), Joseph Bellanca (American, 1930-2013), Mathew B. Brady (American, 1822-1896), Esther Bubley (American, 1921-1998), Elizabeth Buehrmann (American, 1886-1965), Walker Evans (American, 1903-1975), Don Donaghy (American, 1936-2008), Charles W. Fitch (American, active 1960s), Trude Fleischmann (American, 1895-1990), Godfrey B. Frankel (American, 1912-1995), Joseph Franklin (American, active 1960s-1970s), Rosalie Gwathmey (American, 1908-2001),), Lewis Wickes Hine (American, 1874-1940), Arnold C. Hinton (American, born 1940), Roy J. Hyrkin (American, born 1927), William Henry Jackson (American, 1843-1942), James H. Jowers (American, 1939-2009), Pettus Kaufman (American, active 1940s), George Krause (1937-), Dorothea Lange (American, 1895-1965), Gita Lenz (American, 1910-2011), Helen Levitt (American, 1913-2009), Sol Libsohn (American, 1914-2001), Felix H. Man (British, 1893-1985), Edward Robert King Miller (American, 1919-1999), Willa Belle Percival (American, 1916-2009), Herbert Eugene Randall Jr. (American, born 1936), Erich Salomon (German, 1886-1944), Edward Schwartz (American, 1906-2005), Leonard Shields (American, active 1950s), José Sigala-Venegas (Venezuelan, 1940-1995), Aaron Siskind (American, 1903-1991), Neal Slavin (American, born 1941), Herb Snitzer (American, born 1932), Paul Strand (American, 1890-1976), Dave Turner (American, active 1960s), David Vestal (American, 1924-2013), Shawn Walker (American, born 1940), Todd Webb (American, 1905-2000), Diane Witlin (American, 1924-2005), Ray Witlin (American, born 1920), Minor White (American, 1908-1976), among others.

In 1991 the Romana Javitz Collection (approx. 1500 photographs) was transferred from the Picture Collection to the Miriam and Ira D. Wallach Division of Art, Prints and Photographs' recently established Photography Collection. The founding curator of the collection, Julia Van Haaften, received a grant from the National Endowment for the Arts to catalogue the prints in 1992. This collection was subsequently used in 1994-95 for the first digital imaging project at NYPL called the *Digital Image Access Project (DIAP)*. The DIAP was sponsored by The Research Libraries Group and consisted of a consortium of several major research libraries and universities who were interested in developing access to online images and its respective metadata. [12] In January 1998 the exhibition *Subject Matters: Romana Javitz, Photography, and The New York Public Library* was held in the Library's Stokes Gallery and curated by Julia Van Haaften and Anthony T. Troncale. The exhibition included a prototype computer workstation demonstrating the image searching capabilities of *Photologue*, the user interface developed for the DIAP consortium. [13] By 1996 the World Wide Web and Netscape brought image delivery to an international level. One cannot help but think that the World Wide Web and the eventual use of the #hashtag would have pleased Javitz immensely.

Federal Art Project photographs- In 1943, Javitz and her staff selected up to 42,000 photographs for the picture stock from various Federal Art Project Divisions. These recorded the works of artists and art classes from 1939-1942, including the Federal Music Project, Federal Theatre Project, and FAP Photographic Division series. See PC Source #5980. A master set of Berenice Abbott's *Changing New York* series and many of its duplicates were given to the Picture Collection in 1943. Also included are Federal Art Project photographs by Abbott of Community Art Centers in Harlem and other locales.

In 1957 a large subset of these Federal Art Project photographs were subsequently donated to the Archives of American Art, then based in Detroit, Michigan. These included over 20,000 photographs and over 3000 chromolithographs, engravings and other reproductions. See Picture Collection records Box 1, Correspondence.

12 RLG Digital Image Access Project. Proceedings from an RLG symposium. Mar. 31-Apr. 1, 1995. Palo Alto, Ca. Edited by Patricia McClung. The Research Libraries Group. 1995. 104 p.

13 See Arnold, Kenneth. *The Electronic Librarian Is a Verb/ The Electronic Library Is Not a Sentence.* Biblion: The Bulletin of The New York Public Library. Vol. 4, No. 1, Fall 1995. pp. 139-159.

Berenice Abbott (1898-1991) was a personal friend of Javitz as was her partner, Elizabeth McCausland (1899-1965). Other important series held by the collection are Abbott's photographs of U.S. Route 1 from Maine to Florida, a range of photographs of Greenwich Village and other locales in New York City between 1929 and 1958 and a significant series of scientific photographs for the Physical Science Study Committee at the Massachusetts Institute of Technology. A set of her Paris portrait series are also part of the holdings. Sitters include Eugène Atget, Jean Cocteau and James Joyce. Prints made from the original negatives of Eugène Atget (1857-1927) were also acquired by Javitz from Abbott in 1950 and 1952. See PC Source #8391.

Standard Oil Co. of New Jersey photographs

Roy Stryker worked closely with Romana Javitz for decades in the distribution and exhibition of all manner of photographs. From 1943 to 1950 Stryker led a team of photographers at the Standard Oil Co., N.J. The Picture Collection's files from this project are heavily represented by Sol Libsohn and Esther Bubley. Additional photographers acquired by the Picture Collection from this series include Gordon Parks, John Vachon, Arnold Eagle, John Collier and Russell Lee. See PC source #6170. The full archive is held at the University of Louisville (KY) University Libraries.

The Library of Congress Copyright Duplicates Collection

Between 1957 and 1959, as part of an exchange agreement between the New York Public Library and the Library of Congress, the Picture Collection received a large stock of photographs originally sent to the Library of Congress for a copyright claim. A remarkable array of mostly American photographers from Alvin Langdon Coburn, Laura Gilpin, Charles F. Lummis and Herbert George Ponting to numerous amateur photographers from across the country can be found. Dates range from the 1860s to the mid-1950s with most from around the turn of the century. The bulk of the collection, at over 2600 items, is held in the Wallach Division Photography Collection. However, an estimated 15-20 percent of the prints from this series are still serving the public within the Circulating and Reference files of the Picture Collection. See PC Source #11,000.

Transfers from the Picture Collection to other NYPL Divisions

Manuscripts and Archives Division

Picture Collection Records, 1896-1999. Manuscripts and Archives Division, The New York Public Library Archives

Romana Javitz papers, Manuscripts and Archives Division, The New York Public Library

The New York Public Library for the Performing Arts, Dorothy and Lewis B. Cullman Center

The founding of the New York Public Library's Billy Rose Theater Collection is rooted in a major gift NYPL received in 1931 from the estate of David Belasco, the theater promoter and impresario who died that year. This gift, combined with the Picture Collection's holdings of theater and other performing arts graphics gathered to date, constituted a significant collection. Javitz was asked by NYPL Director Harry Lydenberg to visit Yale University and study the organization of their theater holdings. Eventually Javitz recommended her staff theater specialist in the Picture Collection, George Freedley (1904-1967) and he was chosen as its first curator in 1938, a position he held until 1965.

Motion picture stills collection - The historic motion picture stills collection was transferred to the Library for the Performing Arts' Billy Rose Theatre Collection in the 1980's. While a finding aid to the existing 60,000 plus film stills is not yet available, it is estimated that about 10% of these prints (from more notable films) are distributed within the Theatre Collection's clipping and photo file and are filed by film title and format.

The collection consists of hundreds of motion picture films that have been lost by time and deterioration. As one can see in the many Picture Collection annual reports, motion picture studios were regular contributors to the files. These motion picture stills are the only documentation for possibly hundreds of film titles. They were also cherished by the staff and public because motion picture producers spent large sums on historical research for costume and set design. While not historically authentic, the stills gave the designers and illustrators and advertisers of the day the references they needed to perform their own work.

Film stills are still found scattered throughout the circulating and reference files today.

The Schomburg Center for Research in Black Culture

In the 1930's Javitz worked closely with founder Arturo Alfonso Schomburg (1874-1938) to build a photographic archive documenting the black experience. In 1937 Javitz secured over 300 photographs from the RA/FSA files for the Schomburg Center directly from Farm Security Administration's director of the Photographic Section, Roy Stryker. [14] Most are currently online at the NYPL Digital Collections page. Other collections at Schomburg include letters written to Javitz from Arnold C. Hinton whom Javitz sponsored for a trip to Europe and Africa. Hinton worked at the Picture Collection in the early 1960s and is represented in Javitz's personal collection (Yampolsky Collection) as well as in the Romana Javitz Collection in the Wallach Photography Collection.

U.S., Local History and Genealogy Division

Many duplicates of Berenice Abbott's *Changing New York* series were transferred to U.S., Local History and Genealogy Division and incorporated into its comprehensive Photographic Views of New Yok City file. Other large format and panoramic photographs of New York City from the Wurts Brothers, Browning Brothers and other big picture agencies of the day ended up in the Division's files.

14 Javitz to Arthur Schomburg, May 25, 1937, Arthur A. Schomburg Papers, Schomburg Center for Research in Black Culture, New York Public Library.

Appendix II

NYPL Staff News announcements regarding the Picture Collection, 1915–1965; and a chronology of newspaper and magazine coverage of the Picture Collection, 1916-2016

A Chronology of Picture Collection Events drawn from the New York Public Library *Staff News* 1915 - 1962[15]

Publication guide: (Year_Volume_Number),

1915 "The Picture Collection under the care of the Cataloguing Office is now ready for circulation…" Sept. 17, 1915. pp. 127-128. (1915_V5_N38)

1916 "The Library now lends pictures, as well as books…" January 17, 1916. p.18. NYPL Branch Library News.

 (1916_V1_N1)

1928 "Miss Ellen F. Perkins, who had been in charge of the Picture Collection from its beginning, resigned as of September 1. Miss Romana Javitz is now in charge." Oct. 4, 1928. (1928_V18_N40)

1929 WNYC Library Broadcasting: "Miss Romana Javitz will be the representative of the Library to speak over the radio, station WNYC, on Thursday afternoon, May 2, at 5:30. Miss Javitz will talk on aiding the artist." (1929_V19_N17)

1930 WNYC Library Broadcasting: "Miss Romana Javitz will speak over the radio, Station WNYC, on Thursday, January 9, from 5:45 to 6:00p.m., on *"Skyscrapers, Studios, and Books"* in the series of talks by members of the Circulating Dept. Staff on literature for boys and girls of the high school age." (1930_V20_N1)

1931 Talks on Art: Romana Javitz talks on Chinese Art, Metropolitan Museum, April 26. (1931_V21_N15)

15 New York Public Library. Staff News of the New York Public Library, Astor, Lenox And Tilden Foundations. New York. 1911- 2001. Vols. 1-91. https://catalog.nypl.org/record=b11342828~S98

Talks on Art: "Miss Romana Javitz of the Picture Collection is forming a group for a series of informal talks on the history and development of art, with museum and gallery trips. These will be free to members of the Staff... Those interested may contact Miss (Mary) Lorenc, Picture Collection." (1931_V21_N6)

WNYC Library Broadcasting: Romana Javitz talks on WNYC radio *"The Library, as a source of inspiration to the artist."* Mon. May 25 7:15 pm (1931_V21_N21)

WNYC Library Broadcasting: "The Artist in the Public Library." Romana Javitz. Listed in the New York Times Today on the Radio. May 25, 1931.

Picture Collection moves from Room 100 to Room 73, Central Building. (1931_V21_N32)

Exhibit by Lewis Kimball and Horace Day at Picture Collection. (1931_V21_N52)

1932 Exhibit: "The A-B-C of the Picture Collection", Room 73. (1932_V22_N7_p116)

Exhibit by Walter J. Enright. (1932_V22_N8)

Exhibit by George Picken. (1932_V22_N11)

Exhibit by Jose Plaza, Mexican artist. (1932_V22_N14)

Exhibit by watercolors by Lester Gross, lithographs by Minna Citron. (1932_V22_N15)

Exhibit by Staff Artists at Picture Collection. (1932_V22_N17)

Exhibit by Beauford DeLaney. (1932_V22_N19)

1932 Exhibit: "Tropic Islands" prints, photos, movie stills from *Mr. Robinson Crusoe* by Douglas Fairbanks at Picture Collection. (1932_V22_N37)

1933 Loan exhibit of stage and costume designs by Sergeii Soudeikine. First time exhibited in US, including *Chauvre Souris*, *Les Noces* and *Sadko*. February 27 – March 27, 1933. (1933_V23_N8)

1933 Exhibit by Lewis C. Daniel; etchings. (1933_V23_N12)

1933 "In cooperation with the Film Forum, the Picture Collection will hold an exhibit presenting a survey of the history of the moving picture. The "stills" on view will be, for the most part, from the Library's own collections." The exhibit will be on view for one month beginning Apr 17. (1933_V23_N15) (See also exhibit announcement in Film Forum newsletter for April 12, 1933 below)

1933 "Through the courtesy of the Scientific American, the Baltimore and Ohio Railroad, and other railroad companies, the Picture Collection is holding a loan exhibit of photographs relating to railroading." Dec 18, 1933 – Feb 3, 1934 (1933_V23_N15)

1934 Exhibit: "Announcements of Exhibits", includes loans from the Met Museum. (1934_v24_ N50)

1935 Picture Collection sponsored booth at the Leisure League of America's Hobby Round-up held at Port Authority Building 8th Ave. at 15th St. (1935_V25_N18)

 Picture Collection exhibit: "*Peddler, Vendor, Hue and Cry*" (1935_V25_N34)

1936 Exhibit of photographs: "*Soil and Soil Erosion*" made by the Resettlement Administration and presented to the Picture Collection will be on view at the George Bruce Branch thru May 11. (1936_V26_N53)

1937 Loan exhibit: "*The Spot Use of Drawings*" in Picture Collection, Room 73. (1937_V27_N9)

 Exhibit: "*Time and Soil*" selected documentary photographs made by the Resettlement Administration. (1937_V27_N17)

1938 Exhibit: "*Arrivals and Departures*" opens June 15, incl. drawings by William Steig of The New Yorker. Extended to Oct. 31 in Picture Collection (1938_V28_N18)

1939 "*W.P.A. Helps the Library.*" Feb 20-28 on ground floor near the elevators. Examples of work done in the Library by the WPA. W.P.A. work in music copying, stage design, scrapbook making, mounting of pictures and compilation of biographies, indices and catalogues of material belonging to the Library will be shown." Continued thru March.

(1939_V29_N10)

1940 Editor's note: Picture Collection budget cuts; The Guild News. Publ.
 monthly by the Artists Guild. Vol. 7, No. 4, 1940.

1941 In cooperation with American Associated Artists, Inc. a circuit exhibit
 of two shows, "*The Faces of America*" and "*Painting the American Scene*"
 will be shown in Branches. Coordinated by Mrs. Howe of the Picture
 Collection. (1941_V31_N15)

 Selection of FSA photographs and several drawings and one painting
 on exhibit April 10 – June 1. "All of these are concerned with some
 detail of small-town life in the United States. The collection of photo-
 graphs is particularly rich in the details of signboards throughout the
 country." (1941_V31_N15)

 Exhibit of prints and posters done in silk screen techniques by artists on
 the New York City Works Project Administration Art Project. Picture
 Collection Oct. thru Jan. 1942. Includes tools and materials used and
 series of progressive proofs. (1941_V31_N41)

1943 Exhibit available for circulation in Branches "*United Peoples*", pre-
 pared by the Picture Collection for Central Circulation. A poster was
 designed to emphasize unity of the different racial groups within the
 United Nations. A popular list of books on the question of racial equal-
 ity is included. (1943_V33_N8)

1947 Miss Romana Javitz was guest of Martha Deane on her radio pro-
 gram (WMCA) Thurs., Apr 10. She spoke of Picture Collection and
 its services and of current budget request of the Circulation. Dept.
 (1947_V37_N6)

 A front-page article "*Pictures: The New York Public Library*" in the Sept.
 issue of the *Society of Illustrators Bulletin*, describes the Picture Collection.
 (1947_V37_N43)

1948 Romana Javitz describes the facilities of the Picture Collection in a talk
 entitled "*Photographic Horizons*".

 WABD Television, on Wed. Dec. 19th. (1948_V38_N47)

1953 Romana Javitz on "*Speaking Volumes*". Jan. 27th program WNYC

Reviewing 3 books: *Words and Pictures* by Wilson Hicks, *Divided We Fought* by Hirst Milhollen, Milton Kaplan and David Donald, and *The Revolt of American Women; a Pictorial history of the Century of Change from Bloomers to Bikinis – from Feminism to Freud*, by Oliver Jensen. (1953_V43_N4)

1957 Romana Javitz teaches two seminars and lecture entitled *"The History of the Use of Printed Pictures as Documents."* At the 48th Annual Convention of Special Libraries Association, Boston, May 27-30. (1957_V47_N25)

1959 Romana Javitz teaches one day seminar at Syracuse University Journalism Center, June 23, 1959. (1959_V49_N27)

1962 Romana Javitz moderates a panel for the Conference of the *"Status of the Picture Archives in the United States."* Including Beaumont Newhall, Edward Steichen. Special Libraries Association, convention May 28, Washington D.C. (1962_V52_N24)

1965 Javitz lectures at Princeton University and in Philadelphia.

Chronology of Newspaper and Magazine Coverage of the Picture Collection, 1916-2016

1916 *"Now Loan Pictures to Library Patrons."* New York Times, June 4, 1916. p. 89.

1922 *"Over a Million Books Circulated by Public Library."* The Evening Star (Washington D.C.), October 6, 1922.

1925 "Picture Library Boon to Artists." New York World, June 30, 1925.

1927 *"Library Pictures Lent Like Books."* New York Times, November 27, 1927.

1928 *"Rare Old 'Stills'."* The New York Times, February 19, 1928.

1928 "The Silent Advisor of All New York." The New York Times, September 16, 1928.

1930 *"Film 'Stills' and Books."* by Frank J. Wilstach. New York Times, January 19, 1930.

1931 *"Public Library is Keeping Accurate Record of Stage."* Brooklyn Daily Eagle, March 29, 1931. p. 60

1931 ""Brief Moments" is Now Part of Public Library." Brooklyn Daily Eagle, December 24, 1931. p.15

1931 *"Public Library is Keeping Accurate Record of Stage."* Brooklyn Daily Eagle. March 29, 1931.

1931 *"Library Helps Make School Studies Vivid with Loans from Large Picture Collection."* New York Times, May 4, 1931.

1931 *'Brief Moment' is now Part of Public Library.* Brooklyn Daily Eagle. December 24, 1931.

1932 *"Paintings by Young Members of Public Library Show originality – Visitors Afford Diversity of Subjects."* Art in Review, *New York Times*, May 5, 1932.

1933 The Film Forum. Program 4. April 12, 1933. "Note: An Exhibition of Motion Picture "Stills" and Posters.

Prepared by the Picture Collection of the New York Public Library in cooperation with The Film Forum. This will be the first exhibit in America of the history of the development of the motion picture. The "stills" and posters on view will be selected to cover film production in all countries. The exhibit will include those films recognized as great and those specially in histories and criticism of film development."

1933 Robbins, L.H. *"The Magical Pageant of the Films. One May Follow in an Exhibition at the Public Library the Fantastic Progress of the Cinema Since the First Drama Flickered for a Nickel Years Ago."* New York Times Sunday Magazine, May 7, 1933. pp. SM10-12.

1934 "Arrivals and Departures." Exhibit announcement. Brooklyn Daily Eagle, December 16, 1934. p.40

1935 *"Promotion of Silk Aided by Store Heads."* New York Herald Tribune. Mar 17, 1935. p. A16.

1936 Art Notes: exhibit announcement: *Index of American Design.* New York Herald Tribune. July 1, 1936 p.17.

1938 *Arrivals and Departures* exhibition notice. New York Herald Tribune. June 13, 1938. p.13.

1940 *"Library Curtails Picture Service."* The New York Times, March 1, 1940.

1940 Book Notes: *"Would Retain Circulating Art."* New York Herald Tribune. April 17, 1940. p. 27.

1941 *"The Library's Picture Collection."* New York Herald Tribune. March 28, 1941. p. 20.

1943 Bugbee, Emma. *"Miss Romana Javitz Shepherds Collection of 1,000,000 Pictures"* New York Herald Tribune. May 10, 1943. p. 7.

1944 *"Motion Picture Research Departments."* by Elenore E. Wilkins. Special Libraries Association, "Special Libraries, February 1944" (1944). Special Libraries, 1944. pp. 46-51. Book 2. Retrieved from: http://scholarworks.sjsu.edu/sla_sl_1944/2

1944 Bronfield, Jerry. "Just Ask For It: In this collection you can find a picture of anything...". New York Herald Tribune (1926-1962); Nov 26, 1944. p. 7.

1944 *"The Picture Collection of Look Magazine."* by W.J. Burke. Special Libraries Association, "Special Libraries, December 1944" (1944). Special Libraries, 1944. pp. 481-486. Book 10. Retrieved from: http://scholarworks.sjsu.edu/sla_sl_1944/10

1945 "The Library at War." New Yorker Magazine. January 6, 1945.

1945 *"The Advertising Agency Library."* by Katherine D. Frankenstein. Special Libraries Association, "Special Libraries, September 1945" (1945). Special Libraries, 1945. pp. 227-228. Book 7. Retrieved from: http://scholarworks.sjsu.edu/sla_sl_1945/7

1946 *"Pictures: The New York Public Library."* Society of Illustrators Bulletin, Cover: September 1947.

1946 *"Library not art snob, picture chief says"* Toronto Globe and Mail, Nov. 30, 1947.

1947 Cahill, Holger. *"Prospect for the Arts."* New York Herald Tribune, April 6, 1947. p. E14.

1949 *"People and Ideas: The Private Lives of Public Books."* by Alice S. Morris. Vogue. New York 114.2 (Aug 1, 1949): 94, 95, 96, 97, 121.

1950 Cramer, Polly. *"New Book on Design."* Cincinnati Post. Oct. 1950.

1950 *"Interesting People: She Keeps the Past: Romana Javitz."* American Magazine. February 1950. p.150.

1951 *"No Glossies of God but... Admen Haunt N.Y. Public Library's Storeroom of 6,000,000 Pictures."* by James V. O'Gara. Advertising Age, December 24, 1951.

1953 *"News Notes."* by Mary C. Lethbridge and Roy Hart. The American Archivist, Vol. 16, No. 3 (July, 1953), pp. 272-288. Society of American Archivists. http://www.jstor.org/stable/40289183

1954 Glamour Magazine. Profile piece on Romana Javitz. January 1950.

1956 *Critics Meet With Authors.* Atlanta Daily World (1932-2003); Nov 30, 1956; ProQuest Historical Newspapers: Atlanta Daily World. pg. 4. "New York – (ANP) – The National Urban League held an "author meets critic" discussion at the Countee Cullen Library Friday night, the subject being "A Pictorial History of the Negro in America," the new book by Langston Hughes and Milton Meltzer. Hughes and Meltzer attempted to reply to the observations of John Hope Franklin, head of the Department of History at Brooklyn College and Romana Javitz, superintendent of the Picture Collection at the Library. The spirited exchange was generally voted most informative."

1956 *"It Happened In New York: Africa in the Spotlight."* by Gladys Graham. Philadelphia Tribune. December 8, 1956. p. 10.

1958 *Fashions Live Forever in Wardrobe of Pictures".* by Sanka Knox. New York Times, Aug. 30, 1958. p. 12.

1959 Special Libraries Association, its first fifty years, 1909-1959. Edited by Alma Clarvoe Mitchill. Special Libraries Association. New York. 1959. pp. 96-98.

1960 *"Searchers for Unusual Pictures Can Find Them at Main Library"* by Cynthia Kellogg. New York Times, November 3, 1960. p. 41.

1961 Crosby, Alexander L. *"The library is a many-splendored place...".* New York Herald Tribune. January 22, 1961. p. F6.

1963 *"Finnegans Wake filmed"* Film Comment. Film Society of Lincoln Center. 1963. p. 53.

1965 *"Library not art snob, picture chief says".* Interview with Romana Javitz. The Globe and Mail (Toronto). November 30, 1965. pg. 11.

1967 *"Graphic Arts Group Honors Library's Picture Curator."* The New York Times, December 7, 1967.

1972 Book review: "Folk-Art Treasury Evokes Bygone America." by Sanka Knox. New York Times. Nov. 12, 1972.

1995 *"Words, Worth a Thousand."* by *Art Spiegelman.* The New Yorker, February 13, 1995. See: https://www.newyorker.com/magazine/1995/02/20/words-worth-a-thousand

1997 *"Strange Bedfellows: The Seduction of Modernist Art by American Advertisers in the 1920s."* by Mamie Vihonen, B.A. (thesis) Master of Arts Department of Communication, Carleton University, Ottawa, Ontario. 1997.

1998 Exhibition: "Subject Matters: Photography, Romana Javitz and the New York Public Library" Stokes Gallery, 3rd floor. March 1998. Curated by Anthony T. Troncale and Julia Van Haaften. See review: *A Picture Album in an Archive Never at a Loss for Words* by Grace Glueck. The New York Times, January 30, 1998. Section E, p. 35. https://nyti.ms/32KfwpQ

2012 *A Historic Photo Archive Re-emerges at the New York Public Library.* By James Estrin. The New York Times Lens Blog, June 6, 2012. See: https://lens.blogs.nytimes.com/2012/06/06/a-historic-photo-archive-re-emerges-at-the-new-york-public-library/

Bibliography

Published texts by Romana Javitz

Javitz, Romana (1903-1980). *The Library and the Anniversary of Printing.* 500 Years of Printing - A Collection of Articles on the History of Printing Since the Invention of Movable Type: Reprinted from the Publishers' Weekly (1940). Frederic G. Melcher. ISBN 10: 144744552X / ISBN 13: 9781447445524. Published by Read Books, United Kingdom, 2012

_____. *Words on Pictures.* A speech to the convention of the Massachusetts Library Association, Boston, Massachusetts, January 28, 1943. As published in the Massachusetts Library Association Bulletin, 1943. pp. 19-23. (See Chapter 5)

_____. *Images and Words.* Wilson Library Bulletin. Vol. 18, No. 3 (November 1943): 217-221.

_____. *The Public Interest, Work for Artists. What ? Where ? How ?.* Edited by Elizabeth McCausland. American Artists Group. 1947. pp. 27-35. See also book reviews below by Holger Cahill and Arthur Millier.

_____. *Put Accent on Pictures.* Special Libraries Journal, pp. 1235-1236. September 15, 1949.

_____. *Picture Research.* Special Libraries Association, "Special Libraries, July-August 1952" (1952). Special Libraries, 1952. Book 6. pp. 209-210. Retrieved from: http://scholarworks.sjsu.edu/sla_sl_1952/6

_____. *Care of Documentary Photographs.* Letter to the Editor. Summary: "A comment in your editorial on the Gettysburg photograph dramatizes for the public the urgent need for the recognition of the importance of documentary photographs." New York Times. February 13, 1953. p. 30.

_____. *Books in a Picture Collection* by Romana Javitz. (Bibliography) SLA Picture Division Issue. pp. 291-296. Special Libraries Association, Vol. 45, No. 7.

September 1954. Book 7. Retrieved from: http://scholarworks.sjsu.edu/ sla_sl_1954/7

_____. *Pictures from Abacus to Zodiac*. The Story of Our Time: An Encyclopedic Yearbook, 1955. New York: The Grolier Society, Inc. pp. 334-335.

_____. "Still Pictures." Picturescope, Special Libraries Assn. l5:2-6. No.1, 1967.

Related New York Public Library Archives, Publications and Exhibitions

Books and the War. The New York Public Library in 1941. The New York Public Library. New York. 1942. New York Public Library. New York. pp. 16-18.

Lydenberg, Hopper and Beals General Correspondence, The New York Public Library Archives, Record Group 6. The New York Public Library, Astor, Lenox and Tilden Foundations. http://archives.nypl.org/nypla/4952#overview

New York Public Library. Bulletin of the New York Public Library, Astor, Lenox And Tilden Foundations. New York, See Hathi Trust web site for access to full texts. https://catalog.hathitrust.org/Record/000055341

New York Public Library. Staff News of the New York Public Library, Astor, Lenox And Tilden Foundations. New York. 1911- 2001. Vols. 1-91. https://catalog.nypl.org/record=b11342828~S98 (Digital conversion underway Aug. 2020)

New York Public Library Picture Collection records, 1896-1999. Manuscripts and Archives Division, The New York Public Library. http://archives.nypl.org/ nypla/5850

New York Public Library Visual Materials. Record Group 10-5928, The New York Public Library Archives, The New York Public Library, Astor, Lenox and Tilden Foundations. http://archives.nypl.org/mss/5928#overview

Romana Javitz papers, 1923-1980. Manuscripts and Archives Division, The New York Public Library. http://archives.nypl.org/mss/6197

Troncale, Anthony T. *Worth Beyond Words: Romana Javitz and The New York Public Library's Picture Collection. Biblion*: The Bulletin of The New York Public Library. Vol. 4, No. 1, Fall 1995. Anthony T. Troncale. pp. 115-138. Original imprint retrieved from: https://web.archive.org/web/20000304043340/http://www.nypl.org/research/chss/spe/art/photo/pchist/pchist2.html

Van Haaften, Julia. *Original Sun Pictures: A Check List of the New York Public Library's Holdings of Early Works Illustrated with Photographs, 1844-1900.* The Bulletin of the New York Public Library. Spring 1977. New York Public Library. pp. 355-415.

Related Exhibitions

Words at War. The New York Public Library 1943. June 18-July 31, 1943. New York Public Library. New York.

Subject Matters: Photography, Romana Javitz, and the New York Public Library. An exhibition curated by Anthony Troncale and Julia Van Haaften. January 17 – March 28, 1998. I.N. Phelps Stokes Gallery, The New York Public Library Center for Humanities, Fifth Avenue and 42nd Street.

100 Years of the Picture Collection: From Abacus to Zoology. Nov.14, 2015 - May 15, 2016. Curated by Billy Parrott. Stephen A. Schwarzman Building, Sue and Edgar Wachenheim III Gallery.

Public Eye: 175 Years of Sharing Photography. Dec. 12 – Sept. 4, 2015. Curated by Stephen Pinson. Gottesman Exhibition Hall, Stephen A. Schwartzman Bldg.

Selected books, journals, citations, websites and other publications

Agee, James. *Let Us Now Praise Famous Men. With photographs by Walker Evans.* Boston: Houghton Mifflin Co., 1941 (Cambridge, Mass.: Riverside Press) xvi, 471 p., [31] p. of plates: ill.; 21 cm.

Appel, Mary Jane. *The Duplicate File: New Insights into the FSA.* by Mary Jane Appel. Archives of American Art Journal. Spring 2015. Vol. 54, No. 1. The University of Chicago Press on behalf of The Archives of American Art, Smithsonian Institution. pp. 4-27. Retrieved from: https://www.jstor.org/stable/10.1086/683147

Arbaugh, Dorothy. *Motion Pictures and the Future Historian.* The American Archivist, Vol. 2, No. 2. April 1939. pp. 106-114. Society of American Archivists. Retrieved from: http://www.jstor.org/stable/40288151

Carleton Beals. *The Crime of Cuba.* J..B. Lippincott Company, 1934. 441 p.

Beaudoin, Joan E. and Brady, Jessica Evans. "Finding Visual Information: A Study of Image Resources Used by Archaeologists, Architects, Art Historians, and Artists" Art Documentation: Journal of the Art Libraries Society of North America 30, No. 2 (Fall 2011): 24-36.

Benjamin, Walter. "Unpacking My Library," Illuminations, trans. Harry Zohn (New York: Schocken Books, 1969).

_____. "Little History of Photography." In Walter Benjamin: Selected Writings Volume 2 1927-1934. Cambridge, MA: Harvard University Press, 1999: 507-530.

_____. "The Work of Art in the Age of Technological Reproducibility." in Walter Benjamin: Selected Writings, Volume 2, Part 1. Cambridge, MA: Harvard University Press, 2005: 101-133.

Blausen, Whitnet. *Ruth Reeves' Personal Prints. Printed textiles from the 1930s and 40s.* Textile Society of America Proceedings, 1992. pp. 163-168.

Blum, Andre. *The Origins of Printing and Engraving.* translated by Harry Miller Lydenberg. New York: Scribner's. 1940. p. 54.

Boas, Franz. *Primitive Art*, Franz Boas. Oslo & Cambridge, Mass.: H. Armstrong Aschehoug, Harvard Univ. Press, 1927.

Boas, Fanziska. The Function of dance in human society. Brooklyn, N.Y. : Dance horizons. 1972. Republication of the 1944 ed. published by the Boas School, New York, with a new introduction.

Brodel, Max. *Medical Illustration. Journal of the American Medical Association.* Chicago. Vol. 117, No. 9. Aug. 30, 1941. pp. 668-672

Burke, Peter. *Eyewitnessing: The Uses of Images as Historical Evidence.* Ithaca, NY: Cornell University Press, 2001.

Cahill, Holger. *American Folk Art.* American Mercury, Vol. 24, No. 93. September 1931. pp. 39-46.

_____. *Prospect for the Arts.* New York Herald Tribune. April 6, 1947; ProQuest Historical Newspapers: New York Tribune / Herald Tribune. pg. E14

Carter, John E. *The Trained Eye: Photographs and Historical Context.* Public Historian 15. Winter 1993. pp. 55-66.

Christensen, Erwin O. *The Index of American Design.* Introduction by Holger Cahill. National Gallery of Art, Smithsonian Institution, Washington, D.C. Macmillan: New York. 1950. 229 p.

Clayton, Virginia and Elizabeth Stillinger, Erika Doss, Deborah Chotner. *Drawing on America's Past. Folk Art, Modernism and the Index of American Design.* National Gallery of Art, Washington, D.C. The University of North Carolina Press. 2002. 265 p.

Coventry, Michael and Peter Felten, David Jaffee, Cecilia O'Leary, and Tracey Weis, with Susannah McGowan. *Ways of Seeing: Evidence and Learning in the History Classroom.* Journal of American History 92, no. 4. March 2006. Downloadable PDF: http://www.iub.edu/~tchsotl/part3/Ways%20of%20Seeing.pdf

Dana, John Cotton. *Pictures in Place of Objects.* VI. Library Journal, Vol.47, 1922. New York, R. R. Bowker Co., etc. pp. 705-708. Retrieved from: http://hdl.handle.net/2027/mdp.39015036909698

DeVoto, Bernard. *The Modern Keyhole*, editorial, in *The Saturday Review of Literature.* New York. v.15, no.25. April 17, 1937. p.8.

Dewey, John. *Art as Experience.* New York: Minton, Balch. c.1934.

Dewey, Melvil. "Library Pictures." Public Libraries 11 (1906): 10-11.

Dumaux, Sally. *Motion picture and television research libraries in the Los Angeles area.* Special Libraries, Vol. 70, No. 2, February 1979. pp. 63-70.

Eakins, Rosemary. *Movie stills for publication.* ASMP Bulletin. 1980. p.5-7. https://scholarworks.sjsu.edu/sla_sl_1979/2/

Falconer, Vera M. *Filmstrips: A Descriptive Index and Users' Guide.* New York: McGraw Hill. 1948. https://archive.org/stream/filmstripsdescri00falcrich/film-stripsdescri00falcrich_djvu.txt

Faye, Helen. *Picture Research for Motion Pictures: Then and Now.* ASMP Bulletin. 1980. p.3. https://scholarworks.sjsu.edu/sla_sl_1979/2/

Friedman, Milton, others. "Graphic Design in America: A Visual Language History." Walker Art Center, 1989. Harry N. Abrams: New York. 264 p.

Frankenberg, Celestine. *Specialization: Pictures. A Dialogue about the Training of Picture Librarians.* Special Libraries Association, Special Libraries, January 1965, Vol. 56, No. 1. pp. 16-19. Interview with Romana Javitz by Celestine Frankenberg 1965. Book 1. Retrieved from: http://scholarworks.sjsu.edu/sla_sl_1965/1

Gand, Elizabeth Margaret. *The Politics and Poetics of Children's Play: Helen Levitt's Early Work.* Dissertation, History of Art in the Graduate Division University of California, Berkeley. Spring 2011. 214 p.

Gervais, Thierry, editor. *"The 'Public' Life of Photographs.* RIC Books, Reyerson Image Centre: Toronto. The MIT Press: Massachusetts. 2016. 275 p.

Gitelman, Lisa. *Always Already New: Media, History, and the Data of Culture.* Cambridge, MA: MIT Press, 2006.

_____. *Paper Knowledge: Toward a Media History of Documents.* Durham, N.C.: Duke University Press, 2014.

Griffin, Tim. *An Unlikely Futurity: Taryn Simon and The Picture Collection.* pp. 1-15. Originally published in *Taryn Simon: The Picture Collection.* Cashiers D'Art. 2015.

Haas, Pamela. *Museum of Modern Art: Movie Still Archive.* ASMP Bulletin. 1980. p.8-9. https://scholarworks.sjsu.edu/sla_sl_1979/2/

Hambourg, Maria Morris, Jeff L. Rosenheim; Douglas Eklund and Mia Fineman. *Walker Evans.* Metropolitan Museum of Art, New York. Princeton University Press. 2000. 318 p. see pp. 85-86, 103.

Hamerton, Sir Philip G. *The Graphic Arts.* New York: Macmillan & Co., 1882.

Hanson, Carl H. *Librarian at Large: Selected Writings of John Cotton Dana.* Edited and with an Introduction by Carl H. Hanson. Special Libraries Association: Washington, D.C. 1991. 265 p.

Hill, Jason and Vanessa R. Schwartz, editors. *"Getting the Picture: The Visual Culture of the News."* Bloomsbury: London. 2015. 300 p.

Hind, A.M. *The Arrangement of Print Collections. Burlington Magazine.* London. Vol. 9, No. 100. July 1911.

Hind, A.M. *Political and Personal Satires.* Preface, *Catalogue of Prints and Drawings in the British Museum.* London: Printed by order of the trustees, 1870-1938. Vol. 6 (1784-1792). p. vii.

Hofer, Philip. *The Illustration of Books.* Chapter 13 of *A History of the Printed Word*, edited by L.C. Wroth. New York: Limited Editions Club, 1838.

Hornung, Clarence P. *Treasury of American Design : a pictorial survey of popular folk arts based upon watercolor renderings in the Index of American Design, at the National Gallery of Art.* New York : Harry N. Abrams, [1972] 2 Vols. 846 p.

Ireland, Norma Olin. *The Picture File in School, College, and Public Libraries.* F. W. Faxon Co., 1952. pp. 47-48.

Ivins, W. Mills. *Prints and Books. Informal papers.* Cambridge, Mass.: Harvard University Press. 1927. 375 p.

____. *Prints and Visual Communication.* Cambridge, Mass.: Harvard University Press. (1953). 190 p.

Jeffers, Wendy. *Holger Cahill and American Art.* Archives of American Art Journal, Vol. 31, No. 4 (1991), pp. 2-11. The University of Chicago Press on behalf of The Archives of American Art, Smithsonian Institution. Retrieved from: https://www.jstor.org/stable/1557706

Kamin, Diana. *Mid-Century Visions, Programmed Affinities: The Enduring Challenges of Image Classification.* Journal of Visual Culture, Vol. 16, No. 3. SAGE Publications, 2017. pp. 310-336. https://doi.org/10.1177/1470412917739739

_____. *Picture Work: On the Circulating Image Collection.* (dissertation, NYU 2018) Department of Media, Culture, and Communication, Steinhardt School of Culture, Education, and Human Development. New York University, 2018. 476 p.

Karpel, Bernard. "The Library," The Bulletin of the Museum of Modern Art 11, No. 3 (Jan., 1944): 3-9.

_____. "A Talk on Images & Words in a Library." Picturescope 11.1 (April 1963): 6-7.

Katzman, Laura. *Source Matters: Ben Shahn and the Archive.* Archives of American Art Journal, Vol. 54, No. 2. September 2015. The University of Chicago Press on behalf of The Archives of American Art, Smithsonian Institution. pp. 4-33. Retrieved from: https://www.jstor.org/stable/10.1086/684540

Laurence, W.J. *Theatrical Prints as Historical Evidence.* Connoisseur. London. Vol.13. September 1905.

Library Journal. *The Portrait Catalog, Richard G. Wagner in the Library Journal.* New York. Vol. 66, No. 6. March 15, 1941. pp. 250-251.

Lichten, Frances. *Art Libraries and Librarians: Observations of a User.* Special Libraries, March 1959, Vol. 50, No.3. pp. 102-105. Book 3. Retrieved from: http://scholarworks.sjsu.edu/sla_sl_1959/3 .

Loveman, Amy. *Knowledge and the Image,* editorial, signed A.L. (Amy Loveman) in *The Saturday Review of Literature.* New York. Vol. 23 No. 16. Feb. 8, 1941. p.8.

Lozowich, Louis. *The Americanization of Art.* The Machine-Age Exposition. Catalogue. Fernand Léger and Jane Heap. [New York] : [publisher not identified], [1927]. p. 18-19.

MacLeish, Archibald. *Land of the Free.* New York: Harcourt, Brace. 1938.

Malraux, André. Museum Without Walls. The Bollingen Series, XXIV, New York: Pantheon Books, 1949.

May, Jessica Lee. *Off the Clock: Walker Evans and the Crisis of American Capital, 1933-38.* Dissertation, University of California, Berkeley. Fall 2010. 233 p.

Millier, Arthur. *Wider Field for Artists Surveyed: Majority of Observers See Improvement in Industrial Opportunity*. Los Angeles Times, July 20, 1947; ProQuest Historical Newspapers: Los Angeles Times. pg. C4.

Moore, Anne Carrol. *The Place of Pictures in Library Work for Children*. Library Journal, Vol. 25, No. 4. Apr. 1900.

Moore, William D. *You'd Swear They Were Modern: Ruth Reeves, the Index of American Design, and the Canonization of Shaker Material Culture*. Winterthur Portfolio, Vol. 47, No. 1. Spring 2013. pp. 1-34. Retrieved from: https://www.jstor.org/stable/10.1086/670158

National Broadcasting Company. [N.B.C trade releases] "Project 20", March 10, 1961. [New York, N.Y. : National Broadcasting Company] https://archive.org/details/nbctraderelease1961nati_1/page/n115/mode/2up?q=%22Romana+Javitz%22

Newhall, Beaumont. *Documentary Approach to Photography*. Parnassus, Vol. 10, No. 3. March 1938. pp. 3-6.

Newhall, Nancy. *The Mutual Relation of Words / Photographs*. Aperture. 1952. pp. 17-29.

Neustatter, Otto. *Mice in Plague Pictures*. *Walters Art Gallery Journal*. Baltimore, Md. Vol. 4. 1941. pp.105-113.

Ozenfant, Amedee. *Foundations of Modern Art*. Brewer, Warren & Putnam, New York. 1931.

Patterson, J.R. *Moving Pictures and the Library*. Bulletin of the American Library Association, Vol. 22, No. 9, Papers and Proceedings: 50th Annual (September 1928), pp. 134-439. American Library Association. Retrieved from: http://www.jstor.org/stable/25686906

Peterson, Olga M. *A Central Picture Clearing House*. ALA Bulletin, Vol. 35, No. 6. June 1941. pp. 384-386. American Library Association. Retrieved from: http://www.jstor.org/sof Contents/25690769

Philips, Christopher. *The Judgment Seat of Photography*. October, Vol. 22. Autumn, 1982. pp. 27-63.

The MIT Press. Retrieved from: https://www.jstor.org/stable/778362

Plummer, M.W. "Circulation of Mounted Pictures." Public Libraries 8, 1903: 107.

Pope, Daniel. *Making of Modern Advertising*. New York: Basic Books, Inc.. Publishers, 1983.

Rathbone, Belinda. *Walker Evans: A Biography.* Houghton Mifflin: New York. 1995. 358 p. see pp. 83, 206.

Rose, Gillian. *Visual Methodologies: An Introduction to the Interpretation of Visual Materials*. London: Sage Publications, 2001.

Ruzicka, Rudolph. *On Reproductions and the Colotype Process. Print; a quarterly journal of the graphic arts* (New Haven: Rudge) Vol. 1, No. 4. March-May 1941. pp.47-50.

Sandeen, Eric J. *Picturing an Exhibition: The Family of Man and 1950s America*. Albuquerque: University of New Mexico, 1995.

Saretsky, Gary. Interview with Sol Libsohn. Date of Interview: January 28, 2000, Mr. Libsohn's home, Roosevelt, NJ. *Remembering The 20th Century: An Oral History of Monmouth County.* https://www.visitmonmouth.com/oralhistory/bios/LibsohnSol.htm

Shaykin, Rebecca. *Edith Halpert, the Downtown Gallery, and the Rise of American Art.* Yale University Press: New Haven. 2019. 232 p.

Shatford, Sara. "Analyzing the Subject of a Picture: A Theoretical Approach." Cataloging & Classification Quarterly 6, no. 3 (1986): pp. 39-62.

Special Libraries (1910 – 1996) , journal of the Special Libraries Association. See full archive at: https://scholarworks.sjsu.edu/sla_sl/

Special Libraries Association. *Picturescope.* Quarterly newsletter of the Picture Division, Special Libraries Association. Vol. 1-32; Feb. 1953-winter 1987. Special Libraries Association. Washington D.C.

Stange, Maren. *A Good, Honest Photograph: Steichen, Stryker, and the Standard Oil of New Jersey project*. Aperture. Fall 1988. pp. 2-12.

Szarkowski, John. *Photography and the Mass Media*. Dot Zero. Spring 1967.

Te Heesen, Anke. *The World in a Box: The Story of an Eighteenth-Century Picture Encyclopedia*. Trans. Ann M. Hentschel. Chicago: University of Chicago Press, 2002.

Thompson, Ruth. *The Collection and Preservation of Local Historical Pictures in the Minneapolis Public Library.* The American Archivist, Vol. 9, No. 3. July 1946. Society of American Archivists. pp. 219-225. Retrieved from: http://www.jstor.org/stable/40288517

Tunstell, Douglas. "Visual Indexing." Special Libraries 39 (February 1948): 39-42.

Van Haaften, Julia. *Berenice Abbott: A Life in Photography*. W.W. Norton & Co.: New York. 2018. 634 p.

Vihonen, Marine. *Strange bedfellows: The seduction of modernist art by American advertisers in the 1920s.* 1998. Dissertation. ProQuest Dissertations Publishing. ISBN: 061226971X; ISBN: 9780612269712.

Vitray, Laura. *Pictorial Journalism*. New York: McGraw-Hill. c.1939.

Webb, Virginia-Lee. "Art as Information: The African Portfolios of Charles Sheeler and Walker Evans." African Arts 24.1, January 1991: 56-104.

Weitenkampf, Frank. *The Illustrated Book*. Cambridge Univ. Press. 1938.

Wells, H.G. *World Brain*. Garden City, NY: Doubleday, Doran & Co., 1938, eBook edition by Project Gutenberg Australia. http://gutenberg.net.au/ebooks13/1303731h.html.

Wright, Alex. *Cataloguing the World: Paul Otlet and the Birth of the Information Age*. New York: Oxford University Press, 2014.

Wright, Richard. *Twelve Million Black Voices*. Photo-editing by Edwin Rosskam. The Viking Press. 1941. 152 p.

Zinkham, Helena. *Reading and Researching Photographs*. Archival Outlook. (Jan./Feb. 2007): 6-7, 28. Retrieved from: http://files.archivists.org/periodicals/Archival-Outlook/Back-Issues/2007-1-AO.pdf

Illustration Credits

Cover and jacket – [Display board being assembled for Picture Collection exhibit.] 1947. Wurts Bros. (New York, N.Y.). Museum of the City of New York. X2010.7.1.

Frontispiece – *Marion*. Subject heading: Curiosity. engraving, ca. 1850. Stahlstich v. Carl Mayer's Kunst-Anstalt in Nürnberg. The Miriam and Ira D. Wallch Division of Art, Prints and Photographs: Picture Collection, The New York Public Library.

Page 3 Introduction – [Romana Javitz at Ben Shahn's studio, Roosevelt, NJ.] ca. 1953. Yampolsky Collection. Courtesy, estate of Sol Libsohn. Yampolsky Collection.

Page 10 Chapter One – *Bronze head of a young girl. Benin*. ca.1939. The Miriam and Ira D. Wallch Division of Art, Prints and Photographs: Picture Collection, The New York Public Library. From the collection of the Penn Museum Benin bronze - Cat# AF5102 https://www.penn.museum/col-lections/object/38613. Photograph by Reuben Goldberg. For more about Goldberg see: https://www.penn.museum/documents/publications/expedition/PDFs/46-1/From%20the%20Archives.pdf.

Page 16 Chapter Two – Hudson Park, Miss Cutler teaching children how to look at picture books. Lewis Wickes Hine (1874-1940) . The New York Public Library Archives, The New York Public Library. Retrieved from http://digitalcollections.nypl.org/items/510d47d9-8217-a3d9-e040-e00a18064a99 Image ID 100799

Page 23 Annual Report – 1931. [Vaudeville Theater advertising the silent movie *Tigris* next to the Brill Building at 46 Broadway, Times Square.] c.1913. Yampolsky Collection.

Page 27 Annual Report – 1933. [Advertisement for a lottery.] June 1808. Engraving. Swift & Co. London. Yampolsky Collection.

Page 42 Annual Report – 1939. *Entree du Duc D'Alencon's arrival, Antwerp. 1581. Engraving, printed 1914. Le* musée *Plantin Moretus; contenant la vie et l'oeuvre de Christophe Plantin et de ses successeurs les Moretus, ainsi que la description du* musée *et des*

collections qu'il renforme. Antwerp: G. Zazzarini, 1914. Subject heading: Arrivals and Departures. The Miriam and Ira D. Wallach Division of Art, Prints and Photographs: Wallach Picture Collection, The New York Public Library.

Page 43 Normandie, North River, Manhattan, from Pier 88, French Line, Manhattan. Berenice Abbott (1898-1991). The Miriam and Ira D. Wallach Division of Art, Prints and Photographs: Photography Collection, The New York Public Library. (1938). Retrieved from http://digitalcollections.nypl.org/items/510d47d9-4e72-a3d9-e040-e00a18064a99 Image ID 482604

Page 46 Chapter Three – [Bonnets.] Left to right: Row 1: Fanchon Larzelere, American, active c. 1935. Bonnet, c. 1937. watercolor, graphite, and colored pencil on paper overall: 29.8 x 22.7 cm (11 3/4 x 8 15/16 in.) Index of American Design 1943.8.3113 IAD-20130723-0064.jpg; Peter Connin, American, active c. 1935. Silk Bonnet, 1935/1942. watercolor, graphite, and pen and ink on paperboard overall: 35.6 x 25 cm (14 x 9 13/16 in.). Index of American Design 1943.8.1077 IAD-20130723-0057.jpg; Lillian Causey, American, active c. 1935. Bonnet, c. 1940. watercolor and graphite on paper overall: 44 x 35.2 cm (17 5/16 x 13 7/8 in.). Index of American Design 1943.8.1070 IAD-20130722-0059.jpg;

Row 2: Lucien Verbeke, American, active c. 1935. Bonnet, c. 1937. watercolor and graphite on paper, overall: 40.8 x 32.3 cm (16 1/16 x 12 11/16 in.) Index of American Design 1943.8.1065 IAD-20130723-0035.jpg; Margaret Concha, American, active c. 1935. Bonnet, c. 1936. watercolor and graphite on paper overall: 30.2 x 23.5 cm (11 7/8 x 9 1/4 in.) Index of American Design 1943.8.1124 IAD-20130722-0075.jpg; Stella Mosher, American, active c. 1935. Bonnet, c. 1942. watercolor and graphite on paper overall: 60 x 45 cm (23 5/8 x 17 11/16 in.) Index of American Design 1943.8.2669 IAD-20130821-0001.jpg;

Row 3: Doris Beer, American, active c. 1935. Bonnet, c. 1937. watercolor and graphite on paper overall: 29 x 22.7 cm (11 7/16 x 8 15/16 in.). Index of American Design 1943.8.1154 IAD-20130723-0012.jpg; B. Berndt, American, active c. 1935. Black Silk Bonnet, c. 1936. watercolor, graphite, and heightening on paper overall: 34 x 27.1 cm (13 3/8 x 10 11/16 in.) Index of American Design 1943.8.1042 IAD-20130827-0019.jpg; Frank Nelson, American, active c. 1935. Bonnet, c. 1937. watercolor, graphite, and gouache on paperboard overall: 31 x 23.1 cm (12 3/16 x 9 1/8 in.) Index of American Design 1943.8.3098 IAD-20130722-0071.jpg

Page 51 – American 19th Century. Teapot, 1935/1942. watercolor, graphite, and colored pencil on paper. overall: 20 x 25.4 cm (7 7/8 x 10 in.) Index of American Design. 1943.8.16986. National Gallery of Art, Washington, D.C.

Page 51 Bandbox design (Grouse), 1937. watercolor, gouache, and graphite on paper overall: 40.4 x 46.8 cm (15 7/8 x 18 7/16 in.). Harold Merriam. American, 1910–2002. Index of American Design. 1943.8.8270. National Gallery of Art, Washington, D.C.

Page 58 Chapter Four – Newsstand, 32nd Street and Third Avenue, Manhattan. (1935). Berenice Abbott (1898-1991) The Miriam and Ira D. Wallach Division of Art, Prints and Photographs: Photography Collection, The New York Public Library. Retrieved from http://digitalcollections.nypl.org/items/510d47d9-4f7e-a3d9-e040-e00a18064a99 Image ID 482798

Page 62 *Laocoön*, c. 1610/1614. El Greco (painter) Greek, 1541 – 1614. oil on canvas, overall: 137.5 x 172.5 cm (54 1/8 x 67 15/16 in.) Samuel H. Kress Collection. Accession Number 1946.18.1. Courtesy National Gallery of Art, Washington.

Page 62 *The Bathers (Small Plate)*. colored lithograph, 1897. Paul Cézanne. Rosenwald Collection. Accession Number 1943.3.2772. Courtesy National Gallery of Art, Washington.

Page 64 *Booker T. Washington*. silver gelatin print, n.d. approx. 4 x 5 in. Yampolsky Collection.

Page 68 Walking In The Snow. Hervieu, Auguste (Illustrator) Ducôté, A. (fl. 1829-1832) (Lithographer). The Miriam and Ira D. Wallch Division of Art, Prints and Photographs: Picture Collection, The New York Public Library. Retrieved from http://digitalcollections.nypl.org/items/510d47e0-d10c-a3d9-e040-e00a18064a99 Image ID 801946

Page 73 Caption: *"Boston Police Break Up Radical Rally. Mary Donovan, recording secretary of the Sacco-Vanzetti Committee, showing signs which caused police of Boston, Mass., to break up a monster Sacco-Vanzetti rally on the Boston Common. Several of the Communist leaders were placed under arrest."* n.d. (ca. 1927) ACME news photograph. Yampolsky Collection

Page 100 Chapter Five – Reading war news aboard streetcar. San Francisco, California (1941). John Collier (1913-1992).The Miriam and Ira D. Wallach

Division of Art, Prints and Photographs: Photography Collection, The New York Public Library. Retrieved from http://digitalcollections.nypl.org/items/84f6ffa0-2289-0132-7d4f-58d385a7bbd0 Image ID 5164596

Page 110 Chapter Six – Annual Report – Fitted coat. designed by Pearl Levy Alexander. 1939. Photo by Andre Fashion Illustrations. 1940. © The Miriam and Ira D. Wallch Division of Art, Prints and Photographs: Picture Collection, The New York Public Library. Retrieved from http://digital-collections.nypl.org/items/8abee0eb-5c60-bba0-e040-e00a18065f0b Image ID 1948605

Page 114 Identification marks on wings of Army pigeon. U.S. Signal Corps. photograph, n.d. Subject heading: Birds – Pigeon – Carrier. The Miriam and Ira D. Wallch Division of Art, Prints and Photographs: Picture Collection, The New York Public Library.

Page 123 Annual Report – 1944 Arlington cemetery, Arlington, Va. 1943. Decorating a soldier's grave in one of the Negro sections on Memorial Day. Office of War Information #29814-E. Esther Bubley (1921-1998). The Miriam and Ira D. Wallch Division of Art, Prints and Photographs: Picture Collection, The New York Public Library.

Page 152 Trucking story. *John Oxenrider (left) and Mehlon Focht, local farmers, in Shartlesville, Inn, Shartlesville, Pa.* ca. 1946. Sol Libsohn (1914-2001). Standard Oil Co., (N.J.) #23677. Yampolsky Collection.

Page 162 *Picture Collection Room, The New York Public Library, 42nd St. at Fifth Avenue, New York*, 1955. © The New York Public Library Archives, The New York Public Library. Retrieved from http://digitalcollections.nypl.org/items/92ac9a60-4204-2f3d-e040-e00a18066ca6 Image ID nypl_mss_898

Page 166 Chapter Seven – *S. Ting Hand Laundry.* ca. 1950. Sol Libsohn (1914-2001). Courtesy, estate of Sol Libsohn. Yampolsky Collection.

Page 172 Chapter Seven – *Ringling Brothers, Trenton, N.J.* 1954. Sol Libsohn. Courtesy, estate of Sol Libsohn. Yampolsky Collection.

Page 179 Chapter Seven – Circus clown. 1950's. Sol Libsohn (1914-2001). Courtesy, estate of Sol Libsohn. Yampolsky Collection.

Page 182 Chapter Eight – [Lady in masquerade]. etching, ca. 1620. Jacques Callot. (c. 1592–1635) Yampolsky Collection.

Page 202 Chapter Nine – Nineteenth-century shop front. Charleston, South Carolina. March 1936. Evans, Walker (1903-1975). Yampolsky Collection.

Page 207 Francisco de Goya (1746-1828). *La seguridad de un reo no exige tormento (The Custody of a Criminal Does Not Call for Torture)*, c. 1810. etching and burin [trial proof printed posthumously before 1859] R-20120207-0001.jpg Rosenwald Collection 1951.10.41 National Gallery of Art – Open Access Images

Page 215 Grandmother from Oklahoma and her pieced quilt. California, Kern County (1936). Dorothea Lange (1895-1965). The Miriam and Ira D. Wallach Division of Art, Prints and Photographs: Photography Collection, The New York Public Library. Retrieved from http://digitalcollections.nypl.org/items/288bf160-73d9-0136-a850-57af6c4294ff Image ID 57570769

Page 224 The Miriam and Ira D. Wallach Division of Art, Prints and Photographs: Photography Collection, The New York Public Library. (1940). *Mrs. Bill Stagg with state quilt she made. Mrs. Stagg helps her husband in the fields with plowing, planting, and weeding corn and harvesting beans, and quilts while she rests during the noon hour. Pie Town, New Mexico* Retrieved from http://digitalcollections.nypl.org/items/d71a0f70-5576-0137-e51a-091f4b88d49c

Acknowledgements

During the course of my research for this publication I was assisted by a variety of librarians, archivist and administrators in the New York Public Library whose *patience and fortitude* allowed me to review a myriad of materials. Chief among those are the librarians and archivists in the Manuscripts and Archives Division whose diligence and perseverance in retrieving archival materials for my research are commended. I am also thankful to Zulay Chang and David Lowe of the Miriam and Ira D. Wallach Division of Prints and Photographs who have consistently helped me in reviewing their holdings. I am also grateful to the following individuals at the New York Public Library for their sage advice and counsel: Joshua Chuang, Miriam & Ira D. Wallach Associate Director for Art, Prints and Photographs, Jessica Cline, Supervising Librarian, Picture Collection and reference librarian Raymond Kahn; Jeremy Megaw from the Billy Rose Theater Collection, Tom Lisanti, Manager, Permissions and Reproduction Services and Melanie Locay, Research Study Liaison at the Shoichi Noma Reading Room were very generous with their time and assistance.

I would also like to recognize and thank all the previous supervisors of the Picture Collection that I have consulted over the years: Lenore Cowan, Diane Powers, Mildred Wright, and Constance Novak, Susan Chute and Billy Parrott all whose recollections helped me tremendously in gathering a "picture" of the Picture Collection's past. All of them are stalwarts who ensured that the Picture Collection's legacy endured and that the pioneering work Javitz accomplished would be recognized and preserved.

Other individuals outside NYPL also are recognized for their crucial contributions to this publication: Dr. Philip Yampolsky for giving his unwavering support and participation and giving me access to Romana Javitz's archive; Sara Prestopino for giving me the proper permissions to publish the work and words of Sol Libsohn; Ron Seybold and Luann Toth for expert copy-editing; Julia Van Haaften for her institutional memory and years of mentorship and advice; and Acacia Thompson for her transcription; and Robert Sink, Mary Panzer, Dr. Diana Kamin and Alfred Carlton Willers for helping me talk things through.

I want to especially thank the New York Public Library for their generous coop-

eration in granting permissions to reprint and to publish the transcripts, reports and interviews that make up a critical part of this publication. I am also indebted to the Archives of American Art, Smithsonian Institution for permission to reprint the Doud interview (Chapter 9) and the Massachusetts Library Association and EBSCO Information Services for reprinting of Javitz's speech, *Words on Pictures* (Chapter 5). All of these fine institutions helped make this project come together.

Finally, to my ever-supportive spouse Paulette Toth who has always encouraged and prodded me to keep moving forward.

Anthony Troncale
August 2020

Index

Page numbers in italics refer to illustrations. Full keyword searching available
on e-book version of this title: Identifiers ISBN 978-1-7346409-1-5

Colophon

Typography, book design, and cover design by Asya Blue.

This book was set in Baskerville, a serif typeface designed in the 1750s by John Baskerville (1706–1775) in Birmingham, England. Montserrat is the secondary typeface used in this book, designed by Julieta Ulanovsky who was inspired by old posters and signs in the traditional Montserrat neighborhood of Buenos Aires.

CPSIA information can be obtained
at www.ICGtesting.com
Printed in the USA
BVHW020738020421
603711BV00040B/1783/J